# photographic lighting

RALPH HATTERSLEY, one of the leading figures in the world of modern photography, has written numerous articles for *Popular Photography* and other well-known photography magazines and journals. He is also the author of *Discover Your Self Through Photography, Beginner's Guide to Photography, Beginner's Guide to Darkroom Technique,* and *Photographic Printing*.

**RALPH HATTERSLEY**

# photographic
# lighting
## learning to see

A SPECTRUM BOOK

PRENTICE-HALL, INC., Englewood Cliffs, New Jersey 07632

*Library of Congress Cataloging in Publication Data*

Hattersley, Ralph.
   Photographic lighting.

   (A Spectrum Book)
   Bibliography: p.
   Includes index.
   1.   Photography—Lighting.      2.   Visual perception.
I. Title.
TR590.H34          778.7          79-1310
ISBN 0-13-665323-5
ISBN 0-13-665315-4 pbk.

A SPECTRUM BOOK

10   9   8   7   6   5   4   3   2   1

Printed in the United States of America

Prentice-Hall International, Inc., *London*
Prentice-Hall of Australia Pty. Limited, *Sydney*
Prentice-Hall of Canada, Ltd., *Toronto*
Prentice-Hall of India Private Limited, *New Delhi*
Prentice-Hall of Japan, Inc., *Tokyo*
Prentice-Hall of Southeast Asia Pte. Ltd., *Singapore*
Whitehall Books Limited, *Wellington, New Zealand*

*To Wes and Lynne Kemp*

# Contents

*Preface*

**PART ONE: LIGHT AND SEEING     1**

**1**   The Nature of Light     3

NOT THINGS BUT LIGHT     3
A LINGUISTIC ERROR     4
SOURCES OF LIGHT     4
WAVES OR PARTICLES     5
LIGHT AND PHOTOGRAPHIC MATERIALS     8
THE KELVIN AND MIRED SCALES     8
WHAT LIGHT DOES FOR US     11
LIGHT AND TIME     12
LIGHT AND SPACE     14
PHOTOSENSITIVITY     16
SOME INTENTIONAL CONFUSION, BUT NOT MUCH OF IT     18

**2  GOOD SEEING  21**

A Definition of Good Seeing  22
Mechanical Seeing  23
A Vocabulary for Good Seeing  24

**3  GESTALT PSYCHOLOGY, SPACE PERCEPTION, AND PHOTOGRAPHY  26**

Seeing A Stable Reality  27
Sharpness and Awareness  28
Visual Gestalts  29
The Visual Intake  30
Preoccupation With Space  31
Space and Photographs  33
Empty Space and Filled Space  34
Reality and Photographs  35
The Feeling of Space  36
Increasing Your Space Response to Pictures  37

**4  NONPHOTOGRAPHIC SPACE CUES  39**

Binocular Vision  39
Head Movement  41
Zoom and Unzoom Vision  42
Computerized Scanning  43

**5  OBJECTS, SPACE, AND CONTRAST  44**

Solid Objects  44
Objects and Their Surroundings: Similarity and Difference  48
What Is an Object?  49
Contrast  49
Tonal Range  53
Contrast Push, Similarity Squeeze  54
The Three-Way Contrast Push  57
Contrast Variation and Relative Visibility  57
Contrast and Fine Detail  58
Contrast and Emotion  59

**6  THE GEOMETRY OF SPACE  60**

The World as Geometry  61
Perceptual Habits  65
Regular Shapes: The Laws of Visual Habit  65

Space-Compulsive Shapes   71
For Your Awareness   72
Provers   72
Size Constancy   74
Seeing Too Much Similarity or Constancy   74
Space Gradients   77
Cast and Form Shadows   78
The Stepping-Stone Effect   80
Special Space Tricks for Photographers   82
Tonal Weight   82
Space and Camera Lenses   83
Selective Focus   85
Photographic Lighting   86
The Tunnel Effect   87
Black Space   87
Contrast Push   88
Frame Effects   88

**7   AWAKEN YOUR COLOR VISION   90**

A Short Color Vocabulary   91
A Universal Color Wheel   92
Gray Adaption: Sleeping Eyes   93
Color Awareness Test   95
Project One: Color Names   97
Project Two: Quick Pigment Check-Out   100
Project Three: Quick Mixture Check-Out   101
Project Four: Color Wheels   101
Project Five: Value Scales   101
Project Six: Ten-Step Black-and-White Value Scale   102
Project Seven: Color-Complements Chroma Scales   102
Project Eight: Chroma Scale for Yellow and Blue   103
Where You Are   103
Project Nine: Collecting Color Samples   104
Project Ten: Matching Color Samples   104
Project Eleven: A Library of Color Samples   104
Project Twelve: Choosing Color Combinatons   105
Project Thirteen: Afterimages   105

**8   COLOR, OBJECTS, AND SPACE   108**

The Problem of Prettiness and Ugliness   108
Color Coding   109
Aggressive and Passive Colors   109
Warm and Cold Colors   110
Advancing and Receding Colors   110

Simultaneous Contrast   111
About Light   112
Expanding and Shrinking Colors   113
Color-Based Judgements   113
Color Constancy   114

## PART TWO: PHOTOGRAPHIC LIGHTING   115

### 9   A LOVE AFFAIR WITH LIGHT   117

Respect for Light   118
Respect Your Own Eyes   118
Intentional Poverty of Light   119
Responsibility for Light   121
Simplicity and Economy   122
The Problem of Lazy Eyes   123
Shooting and Printing   124

### 10   THINGS TO LOOK FOR: WAYS OF LOOKING   125

Tricks for Seeing Better   128

### 11   BASIC EQUIPMENT   131

The Work Philosophy   131
The Omission of Electronic Flash   132
Basic Shooting Equipment   132
Basic Lighting Equipment   134
Other Basic Supplies   135

### 12   EXPOSURE DETERMINATION   137

Exposure   137
Film Speed   138
Exposure Meters   138
The Average Tone   138
Reflectance Readings: Brightness-Range Method   139
Gray-Card Readings   139
Hand Readings   140
Substitute Readings   140

White-Card Readings    141
Built-In Meters    141
Incident-Light Readings    141
Exposure Bracketing    142
Tri-X Plan    143

**13**    A GLOSSARY OF LIGHTING TERMS    145

**14**    LIGHTING PROJECTS    162
Project One: Cubes    162
Project Two: White-On-White    175
Project Three: Black-On-Black    179
Project Four: White Eggs    183
Project Five: Scale, Size, and Distance    186
Project Six: Very Small Objects    191
Project Seven: Polished Metal    196
Project Eight: Glassware    201
Project Nine: Development Contrast Variations    207
Project Ten: Perspectives    209
Project Eleven: Candles    214
Project Twelve: Painting with Light    218
Project Thirteen: Lighting Informal Portraits    225
Project Fourteen: Figure Photography    234
Project Fifteen: Creative Copying    238

# Preface

This book is primarily for intermediate students in photography, people who already have a good idea of what photography is all about and are ready for the next step. However, there is an abundance of material that will be of interest to both beginners and advanced workers. The text examines the nature of visual perception from the photographic point of view, a subject that should be of interest to all would-be photographers.

The projects are specially designed for college courses in basic studio photography, but they can also be done at home. They can be done with either hand cameras or view cameras. In line with the learning philosophy in this book, they require only a minimum investment in lighting equipment.

The primary objective of the book is to provide people with a blueprint for teaching themselves to see. Learning to see is the most important step to take in the process of becoming a good photographer.

# photographic lighting

# Light and Seeing

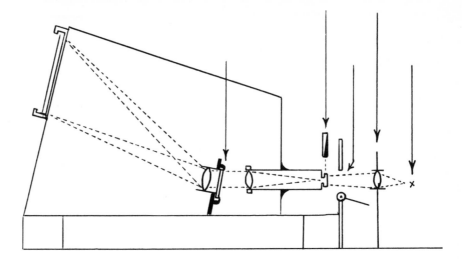

# 1 The Nature of Light

Nobody knows what light is. Though we know quite a few things about it, it is still essentially a mystery and seems likely to remain that way. Unless it is coming directly to the eye, this strange substance or essence (whatever it is) is entirely invisible, yet it makes the world visible. Or we could say that the world makes light visible by reflecting it into the eyes. Actually, we don't see *things* at all; we see only the *light* that they reflect, emit, or transmit.

## NOT THINGS BUT LIGHT

Yes, we see nothing but light, for there is nothing else to see. If our eyes were constructed differently we might see sound, but obviously we do not — and it doesn't help to say that light may be a form of sound. Indeed, our eyes were made to serve but one master: light. Thus vision as we know it consists entirely of the brain's reaction to light after light's energy has been transmitted to it from the eyes. As you will see later, other explanations of vision are possible, but we will stick with **3** this one for a while.

The point we are getting at here is that normal everyday vision is an experience with light — nothing more, nothing less.

## A LINGUISTIC ERROR

The notion that we see *things* (not light) is a linguistic error of great magnitude that makes it very difficult to understand reality. We base our idea of reality on this error and in fact depend on it heavily. Indeed, it seems to be an idea we can't do without in our present stage of evolution. We insist to ourselves that we see *things,* whereas our eyes are only constructed to see *light*. In truth, nothing else is visible.

I don't pretend to know all the consequences of this enormous misapprehension, but they must be very serious. Undoubtedly, we are prevented from getting an accurate picture of ourselves and the reality we live in. For example, we think we see substance, when we actually see energy. Confusing the two (as we do all the time) will surely make us see the world upside down.

This terrible mistake is so deeply imbedded in the English language that there is no way to escape it in everyday speech, though it can be avoided in the language of science. Since this book must be written in everyday language to make it coherent to the readers for whom it is intended, we will constantly find ourselves tangled up in this universal error, the notion that we see things (not energy). Perforce, I will have to talk about seeing this thing and that, but I will remind you now and then that vision consists entirely of reactions to energy.

## SOURCES OF LIGHT

Every visible thing is a light source unless it is black. If that were not so, our world would be invisible to us. There are, however, primary sources and secondary ones, the former emitting light and the latter reflecting or transmitting it. When we say "light source" in photography we almost always mean a primary source. But, it is important to remember that nearly everything we see — everything that is not black—is also a source, a point of departure from which light reaches our eyes. For example, when you "see another person" you are responding to a secondary light source, a point of departure for reflected light rays. This person is visible only because he or she is a light reflector and, as such, can reflect light to other things, which also become secondary sources.

As you know, many light sources are objects with which one can generate light. For example, one can light a candle or turn on a flashlight or tungsten bulb. The question is, what makes light come out of them and go elsewhere? It is generally assumed that light is what

results when energy is speeded up to a certain point—the energy turns into light and escapes the gravitational pull of the light source, although apparently there are gravities that light can't escape. Such gravities are studied by astronomers, though they may also exist in our everyday world.

When light leaves a source, primary or secondary, it is assumed to be traveling at great speed—186,000 miles per second, which suggests that something has surely gotten speeded up. This particular figure is one of the cornerstones of modern science, though it doesn't fit in *everywhere* with science. For example, certain physicists tell us that both time and space are strictly illusions. In this sense, light has no speed (for that would involve time) and doesn't travel from one place to another (which would involve space). In other words, the light you see was always here. If you think about this proposition for a moment, it will seem that it is impossible to live with because it means that everything in the past, present, and future must be happening all at once in the very same place. However, it is probably true.

So we cheerfully go back to the illusions of time, space, and the speed of light. Even if they are illusions, we can do a great deal with them in photography. For example, we will be much involved with the geometry of lighting, which has much to do with our perception of both time and space. We are, then, perceiving illusions? Perhaps so, but that is the nature of the world as we comprehend it.

The main purpose for this discussion is to help you develop a sense of wonder with respect to light sources. Until now they have probably seemed ordinary and uninteresting. In truth, a light source of any kind represents one of the great puzzles of the universe. We haven't the foggiest notion of what is really going on.

We know that a primary light source is a place where energy gets speeded up, and a secondary source is something that deviates light from its original path from a primary source. But we don't really know what energy is, nor do we really know what it means to speed it up. You should therefore regard light and light sources as mysteries. Oddly, this is one of the most important secrets for learning to become a fine photographer, because it helps you relate to light on an emotional level.

## WAVES OR PARTICLES?

A number of brilliant people have spent their lives trying to figure out what light is, and their work hasn't been easy. It is fairly obvious that light is energy of some kind—it supports all life on earth and, furthermore, is easily changed into heat, a measurable form of energy that man has used for millennia. Light and heat, of course, are often generated at the same time, as in a candle flame. But these rather primitive observations don't get us very far.

In time, science evolved two useful theories concerning the nature of

light. Though they don't go together very well, they can be handled separately to tell us much of what we want to know. One theory is that light seems to be a wave phenomenon, the other that it is a rarified substance made up of extremely minute particles speeding through space.

The wave idea is usually demonstrated by dropping a pebble into a pool of still water, thus producing circles of waves that radiate out from the point of contact. The waves are not the water any more than a sneeze is the sneezer but are merely something that the water *does,* obviously under the influence of some kind of energy. What we see is the energy generated by the fall of the pebble creating waves on the surface of the water and spreading in all directions from the source. In a sense, the waves *are* this energy, but it is much better to think of them as a graphic demonstration of it in action.

At any rate, scientists decided long ago from various kinds of observations that all energy that is free to move in a straight line (light, heat, radio waves, and so on) can be thought of as moving in waves, even though it may not actually move this way. Using various measuring devices they were able to attribute wave lengths to each form of radiant energy. Whether or not energy actually moves this way, the wavelength theory has proved to be extremely useful.

Now, radiant energy is that produced, transmitted, or reflected by a primary or secondary energy source and is free to travel through space. The wavelength of a single "ray" of energy is the distance from the peak of one wave to the peak of an adjacent wave. I repeat, though energy may not travel in waves it is nonetheless possible to measure something that can logically be called its wavelength. We are measuring *something* and getting coherent and useful answers when we employ the data, and that is what we rely on. Finding out what we are actually measuring is a problem still to be solved.

**Figure 1.1.** A graph of the electromagnetic spectrum showing the wavelengths of various kinds of energy. As you can see, the visible spectrum is a very small part of the whole. Even so, it accounts for our visible world in its entirety.

The wavelengths of most types of radiant energy have all been fitted together to make up what is called the electromagnetic spectrum, a spectrum being an orderly display ranging from one point to another. The energies are called electromagnetic because they all seem to relate to both electricity and magnetism, though it is not understood what either of these things is.

On a typical chart of this spectrum you will find cosmic rays, gamma rays, x-rays, ultraviolet, visible light, infrared rays, short Hertzian waves, radio waves, and long electrical oscillations. The wavelengths of these energies range from about one trillionth of a centimeter (cosmic rays) to about 620 miles (long electrical oscillations). One centimeter is less than half an inch, so you can see that the wavelengths for some cosmic rays are very short indeed.

Visible light fits about midway in the electromagnetic spectrum, each color having its own short spectrum of wavelengths. Together, the colors of light make up so-called white light, which sunlight approximates very well. In the order in which they occur on the electromagnetic spectrum, the colors are violet, indigo, blue, green, yellow, orange, red, and deep red, with wavelength ranging from 400 to 700 nanometers. Since a nanometer is 1/10,000,000 of a centimeter, you can see we are working with very short distances. Even so, science has undoubtedly determined wavelengths rather accurately. Our use for them in photography will be discussed later.

Another theory—that light is some kind of an attenuated substance—is called the corpuscular theory. According to this idea, light contains minute particles (corpuscles) known as photons. In a vacuum these photons apparently travel at the rate of 186,000 miles per second, but they are slowed down somewhat in air and quite a bit more in glass. This slowdown is what makes photographic lenses possible. If light strikes glass at an angle, its slowdown is accompanied by a deviation from its path—it is bent, so to speak—and this deviation makes it possible to use it to form images.

The deviation varies according to the color of the light, with violet, indigo, and blue being deviated most and red and deep red least. It was this phenomenon that led to the discovery that the sun's white light is made of many colors — Sir Isaac Newton was the first to prove this. He passed sunlight through a prism and fragmented it into its many colors, then passed the colors through another prism and re-created sunlight. This experiment seemed to prove that the colors were indeed in the sunlight and not characteristic of the prism itself. Though there are some who claim that re-created white light is not like real sunlight, Newton's conclusion is generally considered to be true.

These high-speed particles, or photons, that stream through that highly rarified gas that we call light are also called quanta, or energy packets — a quantum being simply a quantity of energy. These quanta will penetrate certain things, their energy changing some of those things physically or chemically. For example, black cloth will absorb

sunlight and turn warm. For another example, plants use light in the formation of chlorophyll, thus chemically changing themselves. In photography we are mainly interested in the action of these energy quanta on certain silver compounds, though they also have an effect on certain other materials.

## LIGHT AND PHOTOGRAPHIC MATERIALS

A photographic film or paper is generally coated with a thin layer of hardened gelatin containing crystals made by combining silver with bromine, iodine, or chlorine or a mixture of such crystals. Until it has been thoroughly exposed to light, this mixture (or emulsion) is light sensitive, which means that it can be chemically changed by light. A silver crystal absorbs enough quanta of light to make it vulnerable to being changed by a developer, which then reduces it to black metallic silver. Photographic images are formed of this black silver.

A favorite theory concerning what happens during a photographic exposure is that each light-sensitive crystal has in it an extremely minute speck of a silver sulfide, generally called the sensitivity speck. A sufficient number of light quanta will modify the electronic geometry of the speck, thus making the whole crystal easily developable. Though light alone will reduce a crystal to silver, it takes so long that it reduces the usable speed (light sensitivity) considerably. Since a developer will finish what light has merely started, its use gives the material an effectively greater speed.

The notion that a developer only finishes what light has started (when development takes place within certain limits of time and temperature) is a useful one. It has been used to learn a great deal about light itself. Indeed, much of our knowledge of light was discovered by photographic means. Because photography is to a large degree a known quantity, it provides a basis for stepping off into the unknown. From our knowledge of what light does to photographic materials we can begin to deduce what it is.

On a more everyday level, you might regard a negative, say, as a very accurate record concerning the nature of light. It clearly shows some of the things that light was doing to the subject or, conversely, what the subject was doing to light. For example, it shows in terms of differences of tone how light communicates to us the reality that we know. Without these differences we are blind.

## THE KELVIN AND MIRED SCALES

In trying to understand what light is, it is useful to look at the ways in which some of its characteristics have been described, especially those characteristics we work with in photography. For example, a light

source is said to have a "color temperature," which is expressed in *degrees Kelvin* (K) and can be converted to *mireds.* You will encounter these two terms fairly often in photography, especially if you shoot color film, but what do they mean?

A Kelvin is named after the British physicist W. T. Kelvin, who constructed the Kelvin scale. His work was based on the observation that certain things give off light when they are heated and that there may be a definite relationship between the amount of heat present and the color of the light. Thus we can describe color in terms of temperature and temperature in terms of color, combining both factors in the expression "color temperature." However, we apply this terminology only to things that can give off white light when heated sufficiently. The Kelvin temperature scale accurately describes the color of the light, a more difficult problem than it might seem.

The basic color-temperature scale (the Kelvin scale) was constructed on the basis of something that doesn't even exist as far as we know — the so-called ideal blackbody. This is a substance so utterly black that it will generate and simultaneously radiate all wavelengths of light when heated to various temperatures. You see, sheer blackness is both the ideal light absorber and the ideal light radiator. Substances that are not ideal blackbodies will absorb some of the light they generate. That is true even of the sun (usually considered to be a good blackbody), which absorbs some of the wavelengths of light passing through its atmosphere. In contrast, the *ideal* blackbody will radiate all possible wavelengths. Though there is no such thing it is a very useful starting point.

If you make a graph of light waves radiated by a blackbody, you will see a continuous spectrum. That is, the waves on the graph will be tightly packed together with no gaps in between. When you graph radiations from things that are not blackbodies, however, you will get discontinuous spectra because certain wavelengths of light are being absorbed rather than radiated. On graphs these absorbed wavelengths show up as lines, which are commonly called absorption lines. In science these lines are very important because they enable us to identify the elements that are causing the absorption, even at a great distance or in extremely small quantities.

Though many heated substances will give off light, the notion of color temperature is applied only to light sources that radiate continuous spectra, for example the tungsten filament of a light bulb. Thus it applies only to incandescent solids, to liquids, and in part, to highly compressed gases. Gases at nearly normal pressure do not produce continuous radiation but instead radiate light wavelengths that are usually widely separated on the spectrum, with little or no energy being emitted at intermediate wavelengths.

As we have seen, the notion of color temperature comes from the fact that certain heated things give off light, though it is strictly applied only to substances that, like blackbodies, give off continuous spectra.

To go with this idea we have a temperature scale called the Kelvin (K) or absolute scale, which is based on the concept of absolute zero, or minus 273 degrees Celsius. The idea is to use the lowest possible temperature as the starting point. Thus the coldest point on the Kelvin scale is 0 degrees K, or minus 273 degrees Celsius.

Certain tungsten light sources are designed to burn at specific absolute temperatures, say at 3200K. (If you want to know how hot one is in ordinary terms — a fairly useless piece of information — you can easily convert the color temperature to the common Celsius scale by subtracting 273 from it.)

Why all the hassle to use the Kelvin scale for light bulbs used in photography? One light looks about the same as any other when it is lit: they all look white. Yes, they all look that way, because the eye is very adaptable to changes in illumination and tends to see colors as unchanging. However, so-called white light bulbs produce colors ranging from very reddish yellow to bluish white, depending on the temperatures at which they burn. Though the eyes don't see the differences, color films "see" them clearly; black-and-white films do not.

Indoor color films are specifically designed to be exposed at certain color temperatures, usually either 3200 or 3400K. Say a film is designed for 3400K — at a lower temperature it will come out too reddish (often very obviously so) and at a higher temperature too bluish. If you want the colors in your pictures to look realistic, it is absolutely necessary to match up your film with the color temperature of illumination for which it was designed.

Now we come to the mired scale, which is an adaption of the Kelvin scale. It is used mainly to make easily predictable changes in the color temperature of light before it reaches the film, usually with colored filters placed over the camera lens. We use filters ranging from yellowish to bluish, calibrated in ten-mired (decamired) units—yellowish filters to lower the color temperature, bluish ones to raise it.

The term *mired* was coined from *microreciprocal degree,* which is defined as the reciprocal of the color temperature (K) multiplied by one million — or 1,000,000/K. A light source may be described in terms of decamireds. For example, a 3200K bulb is designated as a 31.25 decamired light source. For color photography, a variation of half a decamired (5 mireds) produces a detectable color change in the image, regardless of the color temperature of the light source being used.

Furthermore, a color-compensating or correcting filter always produces the same mired change, no matter which continuous spectrum light source it is used with. If two or more filters are superimposed in front of either the light source or the camera lens, their effects are additive when expressed in mireds or decamireds. For example, a filter designated as B2 in decamireds would have a bluish color and produce a color change of 2 decamireds (20 mireds) when used with a light source of any color temperature. From a practical point of view, this means that you can use almost any tungsten light source for color

photography, provided that you know its Kelvin temperature and have the proper correction filter.

Why make this seemingly complicated conversion from degrees Kelvin to mireds? The reason is that for light sources similar to a blackbody (e.g. tungsten) a significant change in microreciprocal degrees (mireds) has the same value over the whole mired range. In comparison, for color temperature (K) the significance of a given amount of change varies with the light level. Thus a change of 100K wouldn't have the same significance at 3000K as at 5000K. Keeping track of the constantly shifting significance would be quite a problem, one that is avoided with the mired system, in which the significance is stabilized.

Before leaving this section I must point out that a tungsten light source designated as, say, 3200K doesn't always burn at that temperature. If the voltage drops below 110, or the bulb has seen quite a bit of use, or your light cords are too small a gauge, it may burn at a lower and more reddish yellow temperature.

As you can see, the Kelvin and mired systems are of use primarily in color photography, and even there you can get along quite well without them. For black-and-white photography they are of practically no value at all. My main reason for bringing them to you is to give you a taste of just two of the thousands of ideas that have been developed in the age-long struggle to understand what light is all about. In a sense, color temperature mainly concerns measuring and describing the whiteness of white, and that is a problem because where whiteness is concerned we simply don't know up from down.

Another slippery aspect of the concept of color temperature is that it is based on the notion of heated blackbodies, which may never have been black at all. For example, our sun is quite a good blackbody (except for its atmosphere). It has never been black and never will be, unless it turns into a black star, in which case it will radiate no light at all. Thus it would seem that the blackest possible thing (a black star — the ideal blackbody?) can't radiate light, though we define a blackbody as radiating all wavelengths of it. It is also clear that we are using some kind of hypothetical blackness (not the real stuff) as a description not of color but of the ability to generate and radiate light energy. Thus a white substance may turn out to be a very good blackbody. These are some of the problems and paradoxes that arise when we try to deal coherently with light.

## WHAT LIGHT DOES FOR US

We can try to define light in terms of what it does for us. However, it is so readily available, so commonplace and all-pervasive that it is hard to imagine its doing anything but helping us find our way around town. Except for farmers, who know their dependence on it, most people treat

light with little respect. Without light, of course, we couldn't even exist. Some of the reasons for this are fairly obvious, others are not.

It is well known that nearly all plants depend on light and that they are the bridge between the lifeless mineral kingdom and the animal kingdom to which we belong. From light and chemicals plants create chlorophyll, which is the basis of the food chain on which we all depend. If chlorophyll were to disappear, life as we know it would disappear, too. But light continues to create it — quietly and unobtrusively. Nowadays the sun gets little thanks for this; in earlier times it was worshipped.

There is good reason to believe that light was a big factor in the creation of the mineral kingdom, too, though minerals can now get along very well in the dark (we think). Indeed, all the energies we know about went into this creation as well as many that we still don't know about.

Perhaps a universe could be created without light — we just don't know about such things — but it surely would be totally unlike the universe that we know. However, it is useless to speculate because our understanding of what light is and what it does is so very fragmentary.

Perhaps light has many forms instead of just one. Maybe darkness as we know it is literally filled with light — in some form. Perhaps we ourselves generate light, some of it being used to illuminate dreams and visual imagery. And maybe everything whatever is a form of light. This last notion has prevailed among many wise men for millennia, though there has never been a way to test it. All scientists agree that our very existence depends on light and that very little is known about it.

So what does light do for us? Possibly *everything*, especially if all energies are forms of light — a point of view that many intelligent people hold. This concept says that except for their rates of vibration all the energies on the electromagnetic spectrum (and others we have yet to discover) are one. Considering the vast amount of energy that has been converted from one form into another, it seems that this hypothesis is probably true. At any rate, there is no doubt of our utter dependence on light. And there is also no doubt that light is one of the great mysteries of human experience.

## LIGHT AND TIME

It is easy to forget that our concepts concerning time — in hours, days, and years — derived directly from our geometrical relationship to a constantly moving light source: the sun. Mankind used the passage of the sun through the sky as a means for creating a public time scheme in which all could share. Otherwise, time is the most private thing, each person experiencing it in his or her own way.

The time it took the sun to circle the earth and return to the zenith

was called a full day, and it was divided into twenty-four hourly intervals, thence into minutes and seconds. Now we have measurable intervals shorter than nanoseconds — or billionths of a second — which seem to have nothing whatever to do with the movement of the sun. For millennia, however, people associated light, movement, and time, for hours were marked by ever-changing shadows cast by sundials. A shadow of a certain length meant that it was 3 o'clock, and a longer one meant 4 o'clock.

With the invention of the hourglass and water clock, everyday dependence on the sun for telling time was lessened. One could tell the correct time even on overcast days, when there was no shadow to guide him. Through the centuries we developed mechanical clocks, and finally electronic ones. Though precision clocks are set on the basis of stellar observations, they still employ as their basic unit the twenty-four-hour period of the earth's rotation. A day represents an ever-changing geometrical relationship between the surface of the earth and the sun.

Light, geometry, and time — how well they go together, for geometry and time are children of light. Yet we have forgotten this while becoming slaves of time, ruled by every clock and wristwatch. Time has become impersonal, an implacable master sprung up out of nowhere. We time our lives — second by minute by hour — not remembering that time was born of light.

Many photographers feel that their pictures, made by light, are also very much about time — which seems to indicate that the age-old idea of the relativity of light and time is not quite dead. When these photographers look at pictures, they see only patterns of reflected light, but they experience time. None of them can explain this phenomenon, but many say that it happens to them. Though a photograph "freezes time" — say with an exposure of 1/100 of a second — that is not what they are talking about. Photographers experience time with just about any kind of picture you can imagine. That they can experience it in such a wide variety of images is inexplicable, though with some images it is easy enough for anyone to see.

For example, a picture made at sunset will often seem to embody that time of day, and you can make an indoor picture on a tabletop that will seem to do the same thing. The trick is to use the same lighting geometry for both scenes, with the light striking them from a low angle and possibly with the light sources included in the pictures.

For another example, we sometimes see newly made pictures that look as if they had been made a century ago. It is usually easy enough to figure out what impresses the mark of time upon them — such things as old-fashioned subject matter, costumes, ways of using lighting, poses, expressions, and printing styles. Thus a time or an era is represented by certain symbols with which most of us are familiar, consciously or unconsciously.

The mystery is that so many people experience time in pictures that lack such symbols. Now, a picture in its entirety is nothing but a

geometric configuration of tones, and our only contact with it is through light — light that is reflected into the eyes from the image. Thus on the retina of the eyes is a geometrical light pattern, which is apparently able to give us the experience of time. It is sometimes said that geometry is the only form of mathematics in which time can be adequately described, and if you listen to certain photographers it would seem that *all* geometry says something about it, because every picture does. All I can say is that I wouldn't be surprised if that were true.

Let us now turn to the notion that time per se is an illusion, a notion for which there is now considerable scientific basis. Let us also say that light is *not* an illusion though it may well be. So if light is real and there is no time, what does our famous experience of time consist of? *Movement* may be the best answer — perhaps movement relative to light, or maybe just *light* movement. This approach has the virtue of fitting in with how people made up the idea of time in the first place — by watching the sun move across the sky. It would also fit with geometry, which can be said to represent movement. And when the eye looks at a picture it almost constantly moves. Perhaps the eye itself creates the time.

Another way of looking at the notion that time is an illusion is to consider the fact that a photograph is a product of light and time (Exposure = Light Intensity × Time) in which a given image is produced by light of a certain intensity falling upon a photosensitive material for a certain amount of time. In this sense, all photographs embody time. Perhaps some people can look at tones and somehow experience the time involved in producing them. When we examine people's inner experiences it is hard to tell what we will encounter. For example, a few people claim to hear light, which doesn't really surprise me at all. As for time, real or an illusion, there may be as many ways to experience it as there are living things.

The main point here is that when you work with light you are always involved with time, and the relationships between them may be many and mysterious. As I've suggested before, regarding light as a mystery will help you get turned on by it. And the same may be said of time, especially the internal time by which you govern your life.

## LIGHT AND SPACE

It is possible to experience space with several of our senses, though we depend primarily on our eyes. The sense of sight is apparently a very sophisticated outgrowth of the sense of touch. That is evident in the human fetus, which as it develops is a living record of mankind's past. In the growing fetus we see skin cells — meant for touching — develop into eyes. Thus it is a good bet that in our evolutionary development touch preceded sight and was the basis for it. We might even call sight

"touching at a distance." Actually, light is the thing that does the touching — it is the necessary intermediary.

Though space is perceived visually by means of light alone, certain things have to happen to light in order to make space perception possible. In other words, light as such won't do the job. For example, we have the phenomenon of the whiteout, experienced by Eskimos in heavy snowstorms and also by some people with cataracts. They see abundant light but no space whatever. Light reaching the retinas of their eyes is totally uniform because of a heavy cloud cover over the snow or because of lenses that are clouded by the cataracts — and space perception depends on nonuniformity.

In the world around us the necessary nonuniformity has several sources, one of them being that different things reflect different percentages of the light falling upon them. For example, a black object reflects little or no light, a gray one a moderate amount, and a white one most of it. Thus the relationship of the three objects will provide tonal nonuniformity.

Additional tonal difference in the light that reaches the eye is provided by scatter. Certain things, including rough surfaces and gases containing small particles, reflect light in all directions — they scatter it. The sky is a good example. Smoother surfaces promote less scattering and polished surfaces little or none. In terms of space perception, what counts is the different intensities of light reaching the lens of the eye, and scatter contributes to these differences.

The geometric relationship between various objects in an environment and a light source can contribute still more nonuniformity. For example, in a room lit by a single light bulb, objects near the bulb will receive (and reflect) more light than distant ones. The angular relationship of objects and a light source also makes a difference, partly because lower angles of illumination promote scattering. Furthermore, a ray of light striking a surface at an angle is distributed over a larger area than one that strikes at right angles.

Shadows, of course, help create visible differences in the outside world. Here we must consider both cast shadows and form shadows. A cast shadow is created on a surface when part of the light from a source is totally blocked by an intervening object. A form shadow is created on an object as its surface progressively turns away from the light source. Shadows have much to do with space perception, and we will get into this in some detail in the second part of the book.

So there are various reasons why nonuniform light patterns reach us from our environment, but they are still not sufficient to account for space perception. A nonuniform pattern can do as much to destroy space as to create it — the patterns have to be of the right kind. Even more important, the light reaching the eyes has to be bent from its path (refracted), or we will have no perception except that of brightness. Remember, images are formed by refraction.

Since light is refracted by passing from one transparent medium to

another, the cornea and lens of the eye take on the job of bending light patterns in such a way as to bring them into focus on the retina, thus forming images. Understand that these images consist entirely of focused light patterns originating from without. Except for black areas, which are seen only in their contrast with lighter areas, the images consist of nothing but light — in our heads. Somehow, the visual information in the images is translated to a form of energy that flows through the optic nerve to our brains, where we experience visual perception.

## PHOTOSENSITIVITY

In our efforts to get a better idea of what light is we have been looking into some of the things it does, which is probably as close as we will ever come to an answer. In this kind of investigation, photography itself is useful because light does a tremendous number of interesting things to photographic materials. We will look at a few of these things as a way of forming a balanced perspective on what is going on with light.

We have seen that light energy has an effect on certain silver compounds, presumably through the so-called sensitivity speck. Though there are a few other photosensitive substances, we will stick with silver for the sake of simplicity. These silver compounds are called halides because silver is compounded with a halogen ("salt former"), namely iodine, bromine, or chlorine. When a silver halide crystal has been exposed to a sufficient number of light quanta (energy packets), it can readily be reduced to pure metallic silver by a developing agent. This much you already know.

When a photograph emulsion consists only of halide crystals suspended in toughened gelatin, it isn't sensitive to the entire spectrum of light energy. It is sensitive primarily to ultraviolet, which is invisible, and secondarily to the blue end of the spectrum up to blue green. The red end of the spectrum, including green and yellow, has little or no effect on it. Fine pictures can be made with such a film (called colorblind), but red tones from nature reproduce in prints as blacks. For example, red lips come out black. Thus it is desirable to extend its sensitivity to the other end of the spectrum, to convert it into a "panchromatic" film (sensitive to all colors).

This extension of sensitivity (called spectral sensitization) is accomplished by adding mixtures of certain dyes to the emulsion, thus dyeing the surfaces of the silver halide crystals. By this means film sensitivity can be extended to the whole visible light spectrum and well into the infrared, which is invisible. That takes care of the black lips problem and even permits us to take pictures with two kinds of invisible energy: ultraviolet and infrared.

Apparently the dyes work by absorbing wavelengths to which silver halides are normally insensitive and then transferring their energies

to the crystals. Oddly, some of these same dyes will lessen halide sensitivity to the spectrum that halide is normally sensitive to, even though these wavelengths are not absorbed by the dyes. The odd behavior of dyes requires that they be juggled quite a bit, but in general we have been able to accomplish much of what we want to with them. Thus we can fairly well call the play in deciding the sensitivity characteristics of a given emulsion. We even have emulsions that are sensitive only to very narrow portions of the spectrum.

Emulsion chemistry is extremely complex and far beyond the scope of this book, yet I would like you to think of it as a modern form of magic, thus turning yourself on to photography as a remarkable phenomenon. Perhaps a few additional tidbits will help in this. For example, it is known that gelatin itself contributes to the light sensitivity of an emulsion, though the reasons are unclear. Gelatin is made from the hides and hoofs of cows, and what the cows have eaten apparently makes a considerable difference. Through a remarkable piece of chemical detective work it was discovered that photography's best cows dine on the wild mustard plant and have a minute amount of oil of mustard in their skins. Furthermore, an emulsion containing as little oil as one part in 300 million will have considerably more light sensitivity than an emulsion that lacks it. So the next time you smear mustard on a hot dog you might ponder what you are doing to its sensitivity.

Another interesting morsel concerns hypersensitization, which means increasing a film's light sensitivity (speed) well beyond its normal limits. One way of doing it is to bathe it in dilute ammonia before exposure. Isn't it surprising to know that the stuff you use for washing floors will increase film speed? Even odder, the speed in certain wavelengths of some films is increased simply by bathing them in plain water, which doesn't seem to make sense. Photographic scientists, however, see water as so complex a substance that it is hard to account for what it will do.

And some more fun: when a photographic material is exposed to light, the influence of light energy is initially recorded in the so-called latent image, which is invisible. One might consider it an electronic image that is capable of becoming visible through development. This invisible image does some rather interesting things — for example, it is reversible. That is, in time it will simply disappear, though in some kinds of emulsions it will persist for several years. It can also be reversed (solarized) by getting too much light; up to a point light makes it build up, then additional light makes it go away again. And a latent image that has been created by white light will sometimes disappear when exposed to red light. It can also be modified by things other than light, for example heat, humidity, and the fumes from certain solvents. Indeed, a record of the action of light in the form of a latent image is quite fragile, but through the years we have learned how to handle it without any trouble.

As we have seen, development reduces the exposed silver halide particles embodying the latent image to pure metallic silver, which looks black, thus creating the visible image. Actually, the silver, which is in the form of "grains," is white. These grains are extremely "hairy," like a very thick and terribly tangled head of hair. As a result of this infinitely tangled complexity, the white-silver grain traps all the light that falls upon it so that none can be reflected back again — thus we see it as black. It seems odd that a white substance would account for the blackness in images.

The speed (light sensitivity) of silver halide particles may depend to a large extent on their size, which can vary quite a bit. The larger the particle the faster it is — everyone in photography seems to know this rule. Photographic scientists have been working for years to make the faster particles smaller — with considerable success — so this ancient rule will apparently not hold true forever.

You may wonder what difference it makes. Well, large particles make coarse-grain (granular) images, small particles make fine-grain ones. Aesthetically, the latter are generally preferable. They are also scientifically preferable because they will record much more visual information without distortion by the grains themselves. For example, Eastman Kodak scientists say that with our present technology we can record the entire contents of the *Encyclopaedia Britannica* on a single piece of fine-grain film one centimeter square. Part of the great technological dependence on silver is due to this ability to compress data.

## SOME INTENTIONAL CONFUSION, BUT NOT MUCH OF IT

The material on how photography deal's with light has been greatly oversimplified so far, so it is time for an element of confusion. Surely confusion is an important part of education because it confronts students with things beyond their ken and lessens their egotistical propensity to

**Figure 1.2.** These wedge spectograms are for Tri-X Pan Professional film. They show the wavelengths to which the film is responsive and to what degree. They also tell us about the emission characteristics of two kinds of light sources— standard daylight and standard tungsten light.

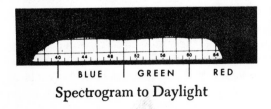

Spectrogram to Daylight

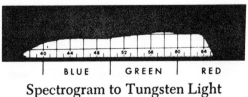

Spectrogram to Tungsten Light

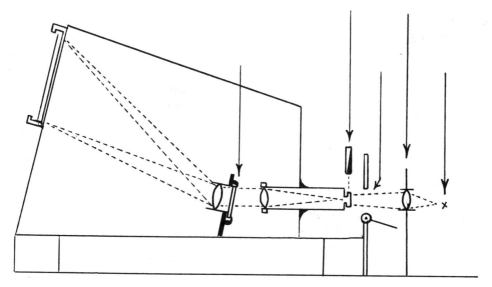

**Figure 1.3.** Diagram of a wedge spectograph. This special camera is for making spectograms, which are used mainly to show the spectral sensitivities of photosensitive materials.

think they know it all. To add a counterbalancing portion of complexity, we will take up the wedge spectogram. The spectogram is a system for showing in graph form the spectral responses of photographic materials to various light sources. The graphs are commonly published in photographic literature with the expectation that the average reader will know how to interpret them, which I very much doubt.

As you see, we are getting confusing already. The making of a wedge spectogram is a way of optically manipulating light in order to learn about the spectral sensitivities of materials and the spectral emissions of light sources. This process has a great many scientific uses. To employ it we use an unusual kind of camera called a wedge spectograph. Besides a lens system, shutter, and film holder it embodies a so-called wedge and a diffraction grating. It is used to take pictures of light sources.

As the light from the source goes through the camera it passes through the wedge. The latter is a plate of glass opaque on one end and gradually getting more transparent until it is totally clear on the other. Thus when the beam of light leaves, it is of graded intensity, the gradation being expressed logarithmically. It then passes through the diffraction grating, which breaks it up into a visible spectrum that also includes ultraviolet and infrared. The latter are invisible but will affect photographic materials. The beam of light, graded in intensity from **19** one side to the other and formed into a spectrum with both visible and

invisible elements, then passes on to the photosensitive material, which it exposes. After it is developed, we see the graph, a wedge spectogram.

This graph shows the spectral sensitivity of a given photosensitive material to a given light source. (Are you still with me?) This sensitivity is defined as the reciprocal of the exposure, expressed in ergs/cm$^2$, required to produce Density (D) above gross fog level when the material is processed as recommended. In turn, one erg is defined as an absolute cgs unit of work done by a force of one dyne acting through a displacement of one centimeter in the direction of the force.

Photographers and photographic scientists have been playing with light for about 140 years now, and this chapter gives you a very small taste of what they have been up to. A larger taste of the heavy technical stuff would be inappropriate here because you really don't need it. Indeed, you can have absolutely no scientific understanding of light and still develop into a splendid photographer. Beyond knowing how to use an exposure meter — and that is easy these days — the basic requirement for excellence is a great awareness of what light does to the appearance of things. The rest of this book is devoted almost exclusively to helping you develop this awareness.

# 2 Good Seeing

Any fine photographer will tell you that the most important part of mastering the art is learning how to see. In terms of ordinary definitions of seeing, most sighted people see extremely well already — so what photographers say doesn't seem to make sense. Why should one learn what he or she already knows how to do? On the other hand, ordinary seeing — indispensable as it is — won't enable one to become a masterful photographer. There has to be something else.

We can start uncovering the nature of this necessary something else by defining good seeing as the photographer understands it. The photographer refers to it as "seeing," "good seeing," and "photographic seeing," using the terms interchangeably. The first two terms are often preferable, because they suggest that good visual perception is a possibility for many, whether or not they are involved with photography. On the other hand, "photographic seeing" suggests that we are dealing with something confined to photographers and useful only to them. Furthermore, photographers tend to use this term to give themselves unwarranted special importance.

Though photographers as a rule see better than others, this talent

doesn't elevate them to divinity. In truth, almost everyone in the visual arts learns to see, and some other artists do it much better than photographers. Photography has yet to produce people who can see as well as Raphael, Leonardo, Rembrandt, Vermeer, or Gainsborough.

## A DEFINITION OF GOOD SEEING

We will start with the ordinary seeing of a person with normal eyes, then see what must be added to constitute "good seeing." Actually, ordinary seeing isn't the least bit ordinary — it is a highly remarkable phenomenon. It can, however, be raised well above its already high level.

Optically, seeing is caused by light rays, mainly reflected by the environment, passing through the lens of the eye and coming to focus on the retina to form images that consist of differential light patterns. The energy from these patterns is transmitted through the optic nerve to the visual cortex of the brain, where we experience visual perception. Though this process is wonderful and endlessly complex it is still very ordinary seeing, because anyone can do it. Even a severely retarded person can let an enormous number of light patterns form in his head — the problem is that he or she can't make sense out of them.

Seeing consists to a large degree of what we mentally do with the light energies that stream into our head. For example, we can be aware of things or not. We can see an object and know what it really looks like, or we can exclude it from awareness. In the awareness area the moron loses out, but so does everyone else to a degree.

Awareness is a chief component of both ordinary and good seeing. In ordinary seeing however, it is usually severely restricted because keeping track of the appearance and meaning of many things at one time can be a heavy tax on the ego and a distraction to the mind — and very little visual awareness is actually necessary for everyday life.

We think of education as being primarily designed to make us aware of things, but that is only half of the truth. It has an opposite and less respectable function of equal importance in which it informs us that most of the visual data accessible to us aren't worth bothering with, aren't worth being aware of. Education ignores most of the visual data and thus encourages us to ignore them. We have developed cultures in which they are not needed, so we can safely ignore them — or so we think. At any rate, education doesn't teach us good seeing and isn't intended to.

The result is that seeing in an ordinary way means being largely unaware of the visual events in the surrounding world, bringing things into awareness only when necessary for comfort or day-to-day survival. Optically, we experience an enormous quantity of visual data every day, but we are aware of very little of it. This lack of awareness does have

a life-simplifying function — the less we are aware of, the less there is to worry about — but many people carry it to an extreme. Thus on the lower levels of ordinary seeing there are those who hardly see anything at all — in terms of being aware of things and assigning meaning to them. So we turn to good seeing, which is quite a different matter and involves much greater awareness. Ideally, a person should be aware of all the optically received visual data that enter his or her head, but that is asking for a minor god. There is simply too much for a person to keep track of. The best that we ordinary mortals can do is to constantly struggle to expand our field of awareness to include more and more of the data brought to us through our eyes. When we have become fairly proficient we can credit ourselves with good seeing, but the person with *really* good seeing is extremely rare.

The term *good seeing* is used mainly in the arts and applies to something artists do, which would be of little interest to most nonartists. For example, good seeing is useful in making pictures, which not everyone wants to do. Some artists, including photographers, like to translate three-dimensional reality to two-dimensional surfaces in the form of paintings or prints. However, they must have good seeing in order to recognize events that will translate well. If a three-dimensional feeling is desired in the picture, the artist must be an expert at seeing and creating space illusions.

The visual artist must also recognize the difference between beauty and ugliness and be able to account for both in terms of tone, line, color, texture, contrast, and so on. It is a great deal harder to do than one might suppose, though the person who really sees can do it with ease.

A part of good seeing is to have a rather profound awareness of how various visible things make people feel. For example, some things make us feel elated, others depressed. Since art is designed in part to manipulate feelings, one must know what the visible world, including art, does to people's emotions.

We will continue our definition of good seeing throughout the book, but we have come far enough for an initial statement about it. We can safely say that good seeing consists of a relatively profound awareness of the visual world, including visual art, in terms of how light functions to present us with the world that we know and why this world affects us the way it does.

## MECHANICAL SEEING

Most of us could be accused of mechanical seeing, or responding automatically to visual data provided by our eyes. Such a habit can be useful at times. For example, mechanical seeing is best and safest when we are driving a car. In a sense, we put ourselves on automatic and are

hardly aware of what we see, responding without thinking to the road, other drivers, and our own car. It is the sensible thing to do. In comparison, if we try to remain acutely aware of a broad visual spectrum our driving safety will be badly impaired — every dog and his Uncle Ike will serve as a serious distraction as they trot across nearby fields. So mechanical seeing is both useful and necessary, but it shouldn't dominate our visual perceptions entirely. To what degree does it dominate in most people? Well, that's hard to tell.

But we can say this: there are millions of people who haven't been aware of their own neighborhoods — or even their own homes — for many years. They wander through them, responding unconsciously to visible space cues, and manage to escape breaking their necks, but as for actually seeing anything, they simply don't. Certainly not if real seeing involves conscious awareness of the things seen. It seems quite probable that the only visual awareness experienced by some people is in connection with their television sets, and even this awareness may be of a low order. Surely such people are carrying mechanized vision too far.

## A VOCABULARY FOR GOOD SEEING

Shifting out of automatic isn't all that easy, as you will find. One of the reasons is that you need a vocabulary relating to the visual world to help you keep your attention focused on it. You have part of this vocabulary already, but you need to expand it somewhat with a few special terms especially designed for waking people up to the visual world. You need some special words and concepts to help you pick things to look at and decide how they are affecting you. Without them, it will be much easier for you to retreat into your own head. Fortunately, a training in any of the visual arts provides the necessary vocabulary for good seeing. It is actually a very simple vocabulary, though a little difficult to master at first. This book will provide the terms common to all the visual arts and a few special ones for photography.

With a knowledge of things to look for and terms with which to label them, it becomes quite a bit easier to maintain a periodic awareness of the visual world, though constant awareness of it is neither possible nor necessary. Even with this help the temptation to retreat entirely into private thought will be strong. People in the arts handle this problem in several ways. For one, they see it as their duty to disconnect from private reverie now and then to see what is going on. Furthermore, they realize that their livelihoods may depend on awareness. And having an adequate vocabulary for thought and observation, they are able to get pleasures from the visual world that other people don't experience. Of course, their pleasure gives them impetus for maintaining awareness.

# TIME AND GOOD SEEING

Automatic seeing takes place at great speed because it is controlled by the unconscious mind, which works extremely fast and has its own highly elevated awareness. Unconscious awareness is very powerful, going far beyond consciousness in what it can do. On some levels of the psyche it even works outside of time, which expands its field even more. In comparison, the consciousness of the ego is very small potatoes.

However, in trying to develop good seeing we are concerned with ego consciousness, and it too has a relationship to time. Indeed, it is largely controlled by time and seldom free of it, though freedom would open up tremendous potentials. This is of concern to us simply because seeing with awareness (good seeing) takes *time*. Since we all seem to have the same amount of time, it would appear that we have an equal opportunity to develop good seeing, but that just isn't so.

Though it is true that we all have the same amount of *clock* time in a day or year, it is not the kind of time that counts. What really matters is *internal* time, which varies from person to person. Some people have an immense amount of it, some practically none, and the rest of us are spread out in between. Now, a person with a lot of internal time can't fry more eggs in an hour than a person with practically none. Some things are limited and governed by clock time, but certain other things are not.

Awareness of sense impressions and quantity of thought are governed only by *internal* time. In both cases the potentials are nearly infinite — if one has enough of this internal time.

# 3 Gestalt Psychology, Space Perception, and Photography

One of the main reasons for learning to see is to understand how human visual perception works, especially our own. Thus good seeing necessarily involves a rather high order of self-knowledge. The basic data we must work with are furnished by the visual world, of course. These data are available to every sighted person, but that doesn't mean that the average person really knows how to see. The crucial factor in learning to see is a special kind of self-observation for which most people are poorly prepared. Their main problem is that they haven't the slightest idea of what to look for.

We must look at the world and see how it affects us — this much is easy enough to understand.

However, the world is an immensity, so we need ways of sorting out what we see so that we can comprehend it. Gestalt psychology is very useful for this purpose, for it has looked at perception carefully from many viewpoints.

Gestalt psychology says that there are definite and measurable reasons for our perceiving reality in the way that we do. For example, we constantly use "space cues" to keep ourselves spatially oriented in reality. Space cues are tangible things that one can both see and

understand. They will be covered in this and the following chapters and will help you understand why and how you see.

## SEEING A STABLE REALITY

You may be aware that only the center of your vision is sharp and that in the peripheral areas vision gets progressively more unsharp. Looking at something is a kind of scanning process. The eye jumps around quite a bit in order that different parts of the image of the thing you are looking at may fall on the *fovea*, the small dimple on the retina entirely responsible for sharp visual perception.

The experience of sharpness is a retinal event that is confined entirely to your eyes and brain, though you don't think of it that way. As the eye moves, the image of the object that is being looked at also constantly jumps around on the retina, with periodic stops when the eye fixes on parts of the subject. Though this is what actually happens it is not the way we perceive it to happen. For very good reasons we don't perceive the jumping images.

If you were aware of images jumping around on your retina you would be in considerable difficulty because your reality would also be jumping around. For example, walking into a room would be like visiting an overanimated funhouse at a carnival. Your visual reality *is* that jumping retinal image, which is your only visual contact with things outside yourself. However, your brain chooses to simplify matters by canceling out your awareness of the image differences, thus giving you the illusion of a geometrically stable reality. Since you know that your visual reality is in your own head, you can perhaps understand intellectually that the stability is an illusion used to describe the actual stability of something outside yourself. At the same time you can't override the illusion and see your inner visual reality as constantly jumping around and changing geometrically. Be thankful that you can't, because it might be asking for trouble of the most serious kind — lunacy, for example.

Your brain doesn't actually make this stability decision. It is your higher self working through your brain, which is a strictly passive instrument. But it is convenient to say that such commands originate in the brain, partly because that is what people assume to be the truth.

So the brain cancels our awareness of most of the retinal image changes in order to give us a stable reality. In line with this action it also makes visual perception a psychologically projective phenomenon. Thus instead of perceiving visual reality as electrical events in our own heads we perceive it as *something happening out there*. Moreover, we perceive vision itself as also happening out there, though it isn't, according to most theories of perception. And we perceive our scanning and eye fixations as something from within ourselves touching upon the surfaces of objects. It is something that happens *out there*.

27

You must understand that such delusional devices (if that is actually what they are) may be highly necessary, mainly because the human ego hasn't developed far enough to be able to keep track of what is really going on in the eyes. The unconscious mind doesn't have this problem, for it is an infinity within itself, and the largest part of brain function is devoted to its purposes. For example, the unconscious controls every atom and molecule in the body, — a project of stupendous proportions. It also controls most of visual perception, the aspects of perception under control of the ego being relatively minute. You might say that the unconscious mind uses so-called visual data to draw pictures that the ego, immature as it is, can understand, which gives us a good reason for all the simplifications and even delusions that it employs. Virtually a child, the ego can handle nothing but toys.

## SHARPNESS AND AWARENESS

In a sense, reality is a play continuously being written and acted by the unconscious, which is simultaneously giving highly selective and partially predigested bits of it to the ego. In order to make good contact with the ego it must use the perceptual apparatus, but it can also operate outside of it. The juvenile ego cannot do that — it must be confined within the system for its own protection.

Sharp foveal vision is mainly an instrument of the ego, which is at present strongly identified with (or attached to) sharpness. That is, the ego is strongly conditioned or programmed to need sharpness. One result is that full awareness of things within a visual field is dependent on their sharpness on the retina. Since the area of sharpness (the fovea) is a very small part of the retina, awareness of visual reality is severely restricted. An attachment to sharpness locks us into this narrow field so that it is hard to escape it. In people with a shortage of internal time (see Chapters 2 and 5) the ego can keep good track of only one thing at a time. It is thus well fitted for being conditioned to foveal vision, which confines both sharpness and awareness to a very small area. When the eye is scanning and fixing, the ego doesn't have to keep track of very much at a given instant. You can visualize how much the ego's job is simplified by imagining a five-inch square of paper being viewed from a distance of ten feet. Its tiny image on the retina would represent the expanse of both foveal sharpness and full conscious awareness.

People who have an abundance of internal time can partly escape the attachment to sharpness, simply because their need for it is less. With lots of time they can keep track of more things in the visual field and need not confine awareness to sharpness. Indeed, it is possible to be aware of things even with very little sharpness.

The unconscious mind, which doesn't need sharpness at all, chooses to operate mainly through peripheral vision, though it can also work through the fovea. Remember that it operates through the perceptual

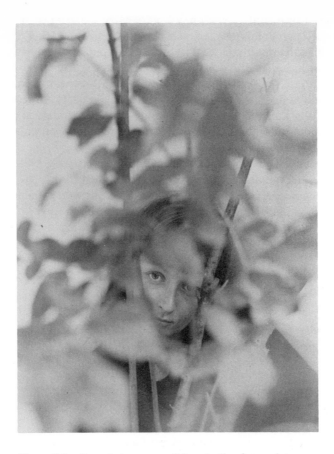

**Figure 3.1.** Foveal sharpness: this selective-focus picture
gives us an approximate idea of what a retinal image looks like.
It is sharp in the middle (the fovea) and unsharp elsewhere. In
the periphery it is very unsharp indeed.

system in order to make good contact with the ego, not all that easy to
do. It also chooses to work as a backup system for the ego, which is
permitted to work as if it were an independent entity. (That is called
free will, incidentally.) Actually, the ego is quite unable to work
independently — though it is given the freedom to think that it can
— and must be constantly fed predigested perceptual data from the
unconscious, usually in the form of gestalts.

## VISUAL GESTALTS

Gestalt is a psychological term meaning group or combination. Thus in
visual perception the term refers to a mental grouping of visual data
received through the eyes. Experiencing a gestalt means perceiving
related things as making up a wholeness or a unified something, rather
than seeing them as essentially isolated from one another. For example,

when looking at a person we generally experience her or him as a gestalt, perceiving that person as a wholeness or all of a piece. Lacking the gestalt-making capability, we would perceive only two eyes, a nose, a mouth, hair, ears, and so on, and not recognize the underlying unity.

A related notion from the field of gestalt psychology is that a gestalt (whole) is always more than the sum of its parts. Thus a man is more than the sum of his features and organs; a forest is more than ten thousand individual trees; and a picture is more than a sum of its lines, textures, and tones.

Because the ego is a finite instrument it sees primarily in gestalts, large and small. Otherwise, it wouldn't be able to cope with the enormous perceptual intake from the visual world. Indeed, without the gestalt capability we would have no chance whatever of making sense of visible reality. So it isn't surprising that we are dependent on gestalts or groupings.

## THE VISUAL INTAKE

In order to properly respect our gestalt capability, it is necessary to have at least a rough idea of the vast amount of visual data handled by the perceptual system. Otherwise, it would be difficult to understand why we have a vital need for gestalts and why we necessarily have a powerful attachment to certain familiar gestalts and to the gestalt-making process itself. For example, there are the gestalts used for space orientation, without which we couldn't survive.

A good way to give you some idea of the vast intake of data is to describe some of the equipment we have for handling it. It is estimated that there are about 130 million light receptors (rods and cones) in the retina of each eye. Each of the receptors is able to respond to several kinds of visual stimulus. Rods require very little light energy to stimulate a response (about five photons or light rays); cones need quite a bit more. When we look at something, everyone of these receptors goes into action, but none of them does exactly the same thing. This suggests that they have an enormous amount of visual data to work with — about 260 million bits of it.

We might say that the ultimate in good seeing would be total awareness of this vast intake, which is obviously beyond the finite powers of the ego at its present state of development. Such an awareness is possible only for the unconscious mind, which is aware of everything happening in the body down to the subatomic level. Indeed, the body itself is an expression of this awareness.

Without the gestalt capability, which is created and governed by the unconscious, imagine all the things you would have to do simply to decipher the information on a pill bottle. Say the visual information came to you at the rate of 260 million bits per second, which is a

moderate guess. It would probably take you several years to read the label — if not forever.

The simplest description of vision, then, is that it is a response to light rays that vary only in wavelength and intensity. But we are unable to form visual realities at this level of simplicity because of the enormous numbers of receptors involved. We need categories (gestalts, groupings, discrete packages of visual data) to help us sort out the data. With these categories we are able to comprehend the visual world as comprised of *things*, and we can cope with *things* very adequately.

## PREOCCUPATION WITH SPACE

At this point it seems advisable to look at one of the main uses we make of the visual gestalts (or groupings of visual data) prepackaged for us by the unconscious. Simply, we use them to keep ourselves oriented in space, which happens to be a life or death matter. That is, we use them to orient ourselves to other things that occupy the same part of space that we do. Essentially, we ourselves create this space, but we must nevertheless keep close track of ourselves while we are within it. Though the space that we know is an illusion of the visual cortex, it has hard and fast rules that we must obey for survival.

**Figure 3.2.** You need several thousand space cues to cross a busy street. With small children in tow, you may have to double the number.

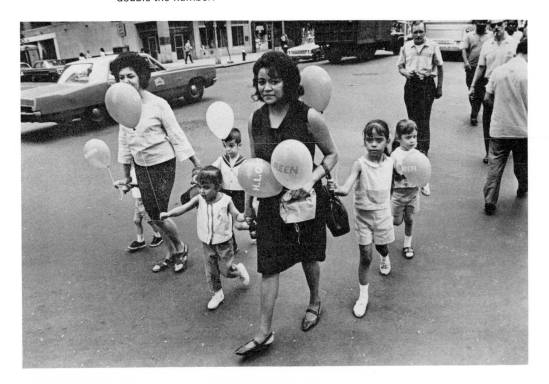

Thus we need numerous space gestalts (sometimes called space cues) to help us keep ourselves right side up, so to speak. Furthermore, we use these conveniently packaged space data almost constantly, even when we are asleep. It is accurate to say that human beings are tremendously preoccupied with space. And we make use of a huge number of space gestalts. For example, we need several thousand in order to walk across a crowded street.

It is fairly obvious that most people are mainly unaware of their tremendous attachment to the practice of space orientation. They don't seem to realize that keeping themselves spatially oriented is one of the prime commandments of reality as we know it. One of the reasons for this surprising lack of awareness is that the unconscious carries almost the entire burden of space discrimination. Understand that the word "unconscious" means exactly what it says it means — not conscious, or beyond awareness. Thus when we say that people are unconscious of their tremendous preoccupation with space orientation, it means that they don't even know about it. Oh, we want to know where the chair is before we try to sit down on it, but that doesn't classify as a heavy preoccupation.

The unconscious mind and its processes are unfamiliar to most people, one reason being that this work consumes an infinitely small amount of energy and generally doesn't give rise to fatigue. Since we use fatigue as a measure of mental work accomplished, lack of it is interpreted to mean that no work was done and, furthermore, that there is nothing present that is capable or working. One of the delusions of the ego, which confuses ego fatigue with mental fatigue, is that the mind in either its conscious or unconscious aspects gets tired. Actually, the unconscious produces such a vast amount of work that it is beyond the ego's power to visualize it. The unconscious works *all* the time, night and day, year after year.

Whether you believe in its existence or not, the unconscious is definitely there doing its thing, part of which is to float the ego in a friendly ocean of space gestalts or cues. The ego recognizes these cues and uses them mainly on the semiconscious level. Because semiconscious mentation uses very little energy, the ego doesn't realize that it too is doing a tremendous amount of work to maintain its visual reality as a constant flow.

Through experience in the visual arts it is possible to make yourself aware of such things. Then you will be able to see that people are indeed deeply preoccupied with space orientation. More accurately, they are preoccupied with space creation, space maintenance, and self-orientation within the spaces created — all being cerebral processes. However, the notion that the mind creates space is almost impossible to handle linguistically, so we must for the most part limit ourselves to the idea that space is something that just happens to be out there and that people are constantly checking their orientation within it.

**Figure 3.3.** This picture has a rather strong feeling of space and will cause a fairly strong space response in the visual cortex. Considering this response, we can say that the picture has depth, though it actually is only two-dimensional.

## SPACE AND PHOTOGRAPHS

Although everything you have read so far has been indirectly about photography, the absence of information on f-numbers, emulsions, and exposure meters may be making you feel deprived. So we will again look directly at photography, but not in the usual way. Instead, we will see it as a psychologically three-dimensional art, much more akin to sculpture than to most other art media. In this sense we might say that photographs consist of events (or things or happenings) in space, or representations thereof. I will also try to make it clear that in looking at photographs, one of our main preoccupations (largely semiconscious) is in orienting ourselves to the kinds of space that they depict.

When we talk about space in photographs, which is commonly done, the linguistic problem becomes very sticky, because space in the real world has to have three dimensions, and pictures have only two — length and width. In this sense there is no space whatever in a photograph, even though we may respond to it as if there were. Thus it is pointless to talk about the space in pictures as if it actually existed.

Though this negative attitude seems reasonable enough, it depends **33** primarily on the notion that a two-dimensional image can't give rise to

a genuine perception of space, which just isn't true. It doesn't consider the fact that space perception is a mental process that involves the creation of an illusion in the visual cortex from a light image recorded on a two-dimensional surface, the retina of the eye. *In perceiving space we always use two dimensions in order to create three.*

This simple fact gives us justification for thinking that a two-dimensional photograph, which is analogous to a retinal image, may give rise to the perception of space. Like a retinal image, a photograph may be thought of as a cause for space perception rather than a direct physical embodiment of space. The thing that matters is that it can stimulate a genuine space response in the brain. Though confronting visible reality will usually lead to a considerably stronger response, the space response to photographs is nonetheless a fact of perception.

As a beginning photographer, you need to realize that you do indeed experience a cortical space response nearly every time you look at a photograph. Until now you haven't properly labeled your visual reactions, because you have lacked the information needed for sorting them out. As a consequence, when you are experiencing a pictorial space response you may not even know that you are. When you get additional information you will see that making photographs consists largely of playing with space at all steps of the photographic process. Though you have already done this, you haven't been fully aware of what you were doing.

## EMPTY SPACE AND FILLED SPACE

One of your problems may be that you think of space as only a kind of emptiness between things. For example, in looking at things around you or at photographs, you may see apparently solid objects in various geometrical arrangements and decide that the nothingness that separates them is the only space involved. Since it is usual to think this way, you can be forgiven for it. However, this everyday notion is limited and is a barrier to understanding visual perception. You must try to comprehend that space is not merely an emptiness; besides empty space, there is filled space. An object is filled space — or something that fills it. Furthermore, the very act of apprehending the existence of an object is a cortical space response to both the space it fills and the way that it fills it.

Thinking of all space as emptiness, you may not have realized how deeply photographers are preoccupied with space or the factors that *cause* space perception. Photographers themselves are generally unaware of their interest in space and believe that they devote their attention primarily to objects. They often need to pay little direct attention to space because in many pictorial situations the empty space in their subject matter will take care of itself: it doesn't need to be

**Figure 3.4.** Filled space: the head and the hat have solidity and reality. As objects, they could be described as filled space.

manipulated and sometimes can't be. But remember, objects are filled space and without them photography isn't even possible.

## REALITY AND PHOTOGRAPHS

The main attraction of photographs is that they are realistic, though the medium can also be used in nonrealistic ways. Where realism is the purpose, the photograph's ability to generate the space perception process in the visual cortex is of supreme importance, for that is what makes things look real.

A realistic photograph should contain objects that are clearly discernible. They should definitely appear to fill space or have apparent volume or solidity. Moreover, they should seem to fill space in exactly the same way as the original three-dimensional objects of which they are records. That is, objects in pictures should appear to look exactly like the originals. Finally, they should seem to be separated by empty space. This emptiness or nothingness should feel real, even though it is invisible. Finally, this realistic photograph should cause quite a strong cortical space response when viewed under the proper conditions, conditions that we will describe in a moment.

**35** We sometimes see photographs in which the space cues are so well

employed that our space responses are very strong. Looking at such a photograph, even under poor viewing conditions, can be like looking through a window frame and seeing a three-dimensional reality beyond it. If you are interested in working at this level of apparent reality, it is necessary to know quite a bit about space cues and how they work. We will come to them in the following chapters.

I have offered no supporting argument for the notion that the realness of photographs is their main attraction. In the American culture, I would hold this argument as self-evident. Though nonrealistic photographs are also popular, their power and influence are marginal.

## THE FEELING OF SPACE

The perception of space involves both intellect and emotion. In one case you see space, in the other you feel it. However, unless you both see it and feel it at the same time there is something missing. Indeed, the only space perception that you can fully trust is intellectual-emotional. As I suggested earlier, accurate space perception is a survival problem with which we are greatly preoccupied on the semiconscious and unconscious levels. One of the purposes of this chapter is to help bring your preoccupations to the surface, where you can become more fully aware of them.

So far, our approach to the problem of space, in reality and in pictures, has been almost entirely intellectual. It is time to look at feeling, or emotion. To feel means to experience something through your emotions. But it also means to *know* something through your emotions, which isn't quite the same thing. For example, you know space through your emotions. That is, your emotions tell you that you are experiencing a genuine cortical space response; and the strength of the emotion is also the strength of the response.

Without emotion as a guide you would never be able to orient yourself in space, even with an abundance of space cues. In order for space to seem real you must experience the emotional part of the space response. The emotional force seems to work rather like radar. It probes reality and validates the strictly visual side of space perception, which is mainly an intellectual phenomenon. Thus if you can *feel* space you can be fairly sure that you are actually perceiving it. It is possible to fool perception (e.g., in photography), partly because people like to be fooled. But in order for deceptions to be effective, they must work on both the intellectual and emotional levels.

In a sense, photography consists almost entirely of deception. In making real-looking photographs you are attempting to cause realistic space responses in the people who look at them. You want them to experience real *things*, not just spots of silver or dye on paper. You want them to *feel* that the things in your pictures are as real as

anything else. Well, people wish to go along with these ideas, but you have to play according to the rules of the game. That is, the viewers have to feel the reality in the pictures; they must feel objects in space. Intellectually seeing all the appropriate space cues is not enough.

## INCREASING YOUR SPACE RESPONSE TO PICTURES

We have seen that someone can react to a photograph by perceiving space but that such a response usually isn't very strong. It can be strengthened quite a bit if the picture is looked at under certain special conditions. The objective is to make both objects (filled space) and nothingness (empty space) seem more real. They should both look real and feel that way.

The trick is to isolate the photograph from everything else and to look at it with only one eye. The need for isolation stems from the fact that the things surrounding a picture tend to strongly contradict its three-dimensionality. By being obviously three-dimensional themselves they make it equally obvious that the image has only two dimensions. Though the feeling of space is still there, the contradiction saps its strength. However, when the pictures's surroundings are excluded from view the strength builds up again.

Using just one eye also helps considerably. I am not sure why that is true, but I have an idea. In binocular perception of the everyday world the brain gets information from two retinal images that are dissimilar in several very specific ways, and it uses the disparity to help form its space response. But when we look at a *picture* with both eyes, we get quite a different kind of image disparity, which indicates that everything seen is in the same plane, thus diminishing the feeling of space. That is, the brain doesn't get the kind of differential information that it expects from two eyes and real space. It doesn't have this expectation from a single eye and thus has no reason to partially block the space response.

It is easy to isolate an image from its surroundings, for example, by projecting a color or black-and-white slide in a darkened room. Shining a spotlight on a print will do nearly as well. Perhaps the easiest way with a print is to hold it rather close to your face and look at it with a peep sight that you make with your fingers. If you wish to get fancy, use a short tube made of black paper. The isolation is what matters most, not your method of bringing it about.

This method — isolation and one-eyed viewing — will strengthen your space responses enough for you to be certain that you are really experiencing them. It is even more important, however, for you to learn to use your imagination to feel the space in pictures without any help of this sort. Though the space in pictures is an illusion, of course, you nonetheless can get genuine space responses in the visual cortex.

Remember that all such responses originate with two-dimensional (retinal) images. Learning to feel responses is an important part of learning to see and becoming a fine photographer.

I will remind you once again that in a space response you perceive both objects (filled space) and nothingness (empty space). Thus if an object in a photograph seems to have volume or solidity you are experiencing space — or a thing that fills space, which basically means the same thing. Since this is an unusual way of thinking about space, I felt that the repetition was necessary.

In this chapter you have seen that a constant semiconscious preoccupation with space orientation is an integral part of human survival behavior and that it affects what we look for in pictures. Indeed, without space in pictures — filled and empty — there would be no art of photography. In the following chapters you will learn more about space and how it is manipulated in photography.

# 4 Nonphotographic Space Cues

I have pointed out that in order to see objects we have to have space cues. Without these cues (or clues) we wouldn't be able to orient ourselves in visual reality. Many of the cues that work for everyday seeing also work when we look at photographs, but some of the strongest won't, so it is a good idea to sort out which is which.

Understanding the cues is a very practical thing in photography. If you know which cues will work in pictures, then you can emphasize them. On the other hand, when you are perceiving the space in front of your camera you can tell if you are depending on the type that won't work. You can change things around (camera angle, composition, lighting, and so on) to make usable space cues effective, thus getting as much space as you need in your picture. Though this sounds difficult it is actually fairly easy and an everyday part of photography, as you will see in Part Two of this book.

## BINOCULAR VISION

Some of the strongest nonphotographic space cues are produced by binocular vision, which means looking at things with both eyes. The images in your two eyes are only slightly different when you are looking

at something five or six feet away, but the difference becomes considerable for close-up viewing. In a manner not yet understood, the brain computes this variable image difference into its space response — the greater the difference the stronger the response or feeling of space. At distances beyond ten feet binocular vision does little for space perception.

Remember that this space response is the brain's reaction to real space or space illusions (as in photographs). It forms mental models of the things we confront, and it is the models that we see, not the things themselves. One characteristic of such a model is that it may incorporate what we take to be space, both filled and empty. Information from two quite different retinal images is incorporated into a single model, but how that happens and how increasing the disparity adds to the feeling of space are not understood. We do know, however, that this space response can be very strong. Furthermore, we know that people may depend greatly on it for everyday survival behavior.

The brain uses the disparate retinal images to tell how far things are from us in the visual world. It can also use them to tell that certain things are in the same plane, which is true of objects in a photograph. Binocular vision doesn't help us see space in a photograph. Indeed, it seems to negate pictorial space somewhat, whereas closing one eye will bring it back again.

It has been surmised that the brain may also compute eye muscle strain into its model of three-dimensional space, with several sets of muscles involved. There are those muscles that change the shape of the lens for close-up focusing, a process that can cause a definite feeling of strain. Other muscles cross the eyes somewhat, also causing strain. It would appear that the greater the strain the greater the feeling that you are perceiving space.

Another factor in the brain's space computations may be alternating eye dominance. Surely you know that one of your eyes is dominant, but did you know that dominance can alternate back and forth from one eye to the other, sometimes rapidly, especially if you are looking at something close up? You can consciously control this shift (though you have to learn how), for example, if you want to look into someone's left eye with your left eye in order to avoid visual aggression in either party. But most people don't bother to learn the art. Thus the shifting back and forth is mainly unconscious, yet it seems to have a lot to do with space perception by means of binocular vision.

Apparently the alternation lays stress on the difference between retinal images, especially during close-up viewing. This would reinforce the difference that one feels even when dominance doesn't shift. Not only does shifting change the angle of view but there are other important changes too, though it is impossible to explain some of them. In brief, your eyes see two entirely different realities, though they seem to see just one.

In photography it is often useful to know how much binocular vision

is contributing to your perception of space, because you will have to do without it in your pictures and rely on other space and object (filled space) cues. Fortunately, there is an easy way to tell, though you have to practice it quite a bit in order to get used to it.

Stand stock still in front of your photographic subject making sure that your head doesn't move. Look at it wth one eye through a peep sight made with your fingers, the other eye being closed. Look with your dominant eye, which you will naturally do without even thinking about it. What you are trying to see is the amount of space you can perceive under these restrictions. If the space feeling is strong it will probably transfer to your pictures. If not, you will have to bring in some new space cues or emphasize those already there. In the next chapter I will start discussing the ones you can use.

This trick is a standard in photography and in use all over the world. At first it may take you five or ten minutes to size up a scene, setup, or event, but eventually you will manage to do it in seconds. Since you have probably never tried it before, the hard thing to do is assess the strength of the space you are feeling. Once you sort out what you are trying to do, the trick will become quite easy. Remember to hold your head stock still. You can use the same trick when you are trying to assess the importance of head movement in space perception.

## HEAD MOVEMENT

Head movement provides one of the most powerful space cues by making stationary things seem to move in relation to one another. For example, try looking at things at different distances from you. As you twist your head to the right, nearby objects seem to move to the left and more distant ones to the right. They seem to shift positions, but in different directions.

The eye is extremely sensitive to even the least bit of image movement on the retina. Thus the two-way shift is immediately spotted and interpreted in terms of space and objects in space. The remarkable speed of pickup (which happens to be an important survival characteristic) can be explained partly by the fact that the whole eye (not just the fovea) has an extraordinary ability to detect any movement whatever. Furthermore, the peripheral part of the retina, which is *especially* good at it, is dominated almost entirely by the unconscious mind, a fabulously sensitive instrument.

That is, the mind as a whole uses the eye as a whole in its computations, while the ego is mainly attached to (identified with) the images that fall on the fovea, which is an area about the size of a pinhead. With the ego safely out of the way, so to speak, the unconscious part of the mind can use the periphery of the retina to pick up movement with great speed and with equal speed interpret it in terms of space and objects in space.

**Figure 4.1.** When you move your head to the right, a nearby object seems to move to the left, and a more distant one seems simultaneously to move to the right. This apparent movement of objects in opposite directions is perhaps the main nonphotographic space cue.

I suspect that head movement, with the consequent two-way movement of objects on the retina, is the most important space cue. The term head movement applies to any movement that will shift the eyes from a fixed position in space and can be accomplished by moving your shoulders, twisting your head, walking, driving a car, and so on. We have a great dependency on it. Without the apparent two-way object shift you would be safe only in an iron lung, for it is impossible for a sighted person to navigate in visual space without it.

Awareness of head movement space cues is strongest when objects are partly overlapped or positioned close to your line of sight so that a two-way shift registers on the fovea or very close to it. Since the ego centers its attention on the fovea, it can easily make itself aware of the shift. Working through the periphery of the retina, the unconscious mind is even more aware of shifts, but it is next to impossible for the ego to tell how it uses this awareness. However, the unconscious does draw the ego's attention to movement.

## ZOOM AND UNZOOM VISION

Vision works much like the zoom lenses used for photographing football and baseball games for TV. Your awareness zooms out to things, then unzooms back again. Optically, your eyes do no such thing, but that is the way you perceive what happens.

It is traditional to describe this zoom-unzoom process as a simple change of focus in the lens of the eye. The muscular efforts required to change the shape of the lens are said to provide the safe cues for the brain. That is probably so, yet there is more to it than that.

Certainly, the ego knows when it wants to zoom or unzoom its attention, and the mind has no trouble in computing the zoom distances. Working through the brain, the mind forms the visual data into handy space gestalts or cues, which the ego can quickly recognize as such. The mind needs a brain to work through in order to make good contact with the ego, though it doesn't ordinarily need one. The great speed with which the ego recognizes space cues of this sort is a measure of the effectiveness of the contact.

When you look at pictures your eyes zoom and unzoom. That is, you project your attention forward and back. Though that is not the same as zooming and unzooming in the visual world, it does help provide a feeling of space, especially if you try to imagine space at the same time. If you want to see space, you very likely will. Oddly, wanting space is one of the very best ways of actually getting it into your pictures. Even so, zoom and unzoom vision doesn't work nearly as well with pictures as it does with visual reality.

## COMPUTERIZED SCANNING

It is well known that the brain in many ways functions like a complex computer, one of its jobs being to make constant space computations. As your eyes are scanning and fixing here and there, you may be sure that the raw space data are being fed to the brain, which handles the data methodically. There the mind forms them into space gestalts or cues for the benefit of the ego.

One of the reasons people are mostly unaware of this kind of activity is that it happens with such great speed. Another is that most of the mental action takes place on an unconscious or semiconscious level. In learning to see, however, we move many such activities up to the conscious level, where we can begin to understand them.

We have covered the main nonphotographic space cues. Though there are others, they are less important, especially in terms of what we are trying to accomplish with this book. Remember, the main reason for making yourself acutely aware of these particular clues is that they won't be working for you in your pictures. Thus you may have to compensate for their absence by reinforcing cues that *do* work.

# 5 Objects, Space, and Contrast

In this chapter we will consider what makes visual perception possible. Having covered visual perception in a general sort of way, we will now relate it more specifically to photography. Although looking at pictures isn't exactly the same as looking at visual reality, there are enough perceptual similarities to make it reasonable to talk about them at once. You will see that contrast, or tonal difference, is one of the main factors in both kinds of perception. In fact, visible difference of any kind has a bearing on what we perceive.

## SOLID OBJECTS

The reality that we know consists mainly of empty space, but there is no way to perceive empty space without the help of solid objects to use as reference points. On the other hand, we need space in order to see objects. Remember that objects and things are filled space. Thus we need filled space in order to see empty space, and vice versa. Without both kinds of space our reality would simply disappear. These ideas are

**44**

confusing, to be sure, but you can straighten yourself out by playing with photography. Consider it as a way of fiddling with space or objects (or illusions thereof) in order to find out what they can do.

For a while we will consider the question, "What makes objects look like objects?" It will help you understand how we manage to see anything at all and give you lots of things to look for in photography. With enough to look for you will develop an endless fascination with the medium.

The naive answer to the question is that objects look like objects simply because they *are* objects. This answer makes such splendid sense that few people have thought of looking beyond it. By looking beyond, however, you can open up a whole new visual world for yourself, learn to see better, and turn yourself into a fine photographer.

We can start our search for answers by noting that objects look like objects only part of the time. At other times they don't look like objects at all — in the dark, for example. In the half-dark they may look sort of like objects, but nothing more. You can test this notion by observing both visual reality and pictures, though you already know it is true. In photography you can get a lot of mileage out of using half-darkness (tones ranging from gray to black) to manipulate the apparent realness of objects and things. This controlled obscurity, ranging from blacked-out nothingness to considerable reality, is an important playground for photographers. You exert the control primarily in lighting and printing.

Having observed that objects may not look like objects without sufficient light, it is time to note that light itself is the primary factor in making things look the way they do. Without it they wouldn't look like anything at all. Though that seems obvious and therefore unimportant, there is much that you can learn by carefully investigating the obvious. Indeed, some of our greatest discoveries have come about in this way.

Light contributes to making objects look like objects in a wide variety of ways, so we will try to sort out a few of them at a time. It gives things solidity, which we consider an important attribute of objects. It can also take the solidity away again, making things look flat. It can turn objects into mere two-dimensional shapes in pictures. More surprising, it can turn two-dimensional shapes into solid objects.

If you place a white egg on a gray surface with a light source overhead, you will definitely perceive an object, and a photograph of it will also show one. In perceiving an object, your mind is computing certain space cues, which include: the egg's closed contour (a powerful cue), the tonal difference between the egg and the gray surface, the shadow under the egg, and a tonal gradation on the egg itself ranging from white on top to a fairly dark gray on the under side.

Together, these things account for your perception of an object, but they don't all contribute to its apparent solidity. If you remove the shadow underneath and the gradation from the tone of the egg, it will look flat. Though you still *know* that it is solid it simply won't *look* that

**Figure 5.1.** Contrast makes this egg look like an egg, solid and real. The contrast between the egg and the background establishes the egg's contour. The form shadow on the egg and the cast shadow under it give it form and solidity. How much difference such factors can make can be seen by eliminating them one or two at a time.

**Figure 5.2.** The apparent solidity of the egg was deliberately lessened by removing the form and cast shadows. Because of its well-defined contour it still looks like an egg, but it seems to be flat, lacking solidity or volume.

way; and in a photograph it will appear very flat indeed. To get this effect, you use a very flat lighting (see Part Two).

So you see that light can create solidity and also take it away again, but it can eliminate even more if you remove another of the space and object cues: contour. Then your very flat lighting will make the egg nearly disappear altogether right in front of your eyes. And in a photograph it will cease to exist. In this flat lighting it is easy enough to get rid of contour because your *perception* of contour is mainly dependent on the tonal difference (contrast) between the white egg and the gray surface. Replace the gray surface with a white one and the difference will disappear — and so will the contour and the egg itself. You will play with such magic in the lighting projects in Part Two.

**46**

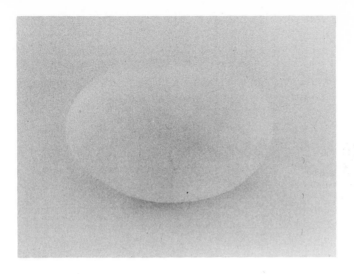

**Figure 5.3.** Now the egg is on a white paper and lit with a very flat frontal lighting, which nearly wiped out the contrast altogether. The little that was left was brought out with a no. 5 printing paper. By removing contrast, this picture demonstrates the great importance of contrast in creating a visual world.

A moment ago I said that light will also turn flat shapes into objects with apparent solidity. When you look at seemingly solid objects in drawings or paintings, you are seeing an example of this. What you are seeing is something that light is doing — pure and simple. Indeed, that is all there *is* to see. You can also create the effect with photographic lighting, though it is quite hard to do. For example, you can take an egg shape out from white paper and light it so that it looks fairly solid — just fake the space and object cues (tonal difference between egg and background, tonal gradation on egg, and the shadow, which you can draw in with a pencil).

Since light is the *only* thing that can make an object look like an object, there is still much to be said concerning how it does this. Rather than tackle an overall explanation at this point, however, it will be better to look at light later in different contexts. For the moment we will proceed with a general discussion of why objects and things are perceived as such.

Objects nearly always have clearly defined surfaces, so surface characteristics such as tone, color, texture, and pattern help us identify them as objects. Furthermore, we know from experience that certain specific kinds of objects are associated with particular types of surfaces. Thus when we see a surface, we are quickly predisposed to see the object that it goes with. For example, seeing a certain kind of hair prepares one to perceive a dog.

To a large degree, seeing is a memory process, and each of us has a very large visual memory bank filled with impressions of familiar objects. These impressions are in the form of well-remembered visual configurations of contour, color, texture, tone, size, and so on. Thus when we encounter such a configuration, we immediately identify it as an object — from memory. We can often make the identification even with most of the visual cues missing, because our minds fill in the rest.

For example, we can readily recognize things in obscuring fog or in very dim light.

As I promised, we are examining the obvious — but *is* it so obvious? How many times have you asked yourself, "What makes objects look like objects to me?" In the next section we will continue in the same vein.

## OBJECTS AND THEIR SURROUNDINGS:
## SIMILARITY AND DIFFERENCE

The relationship of an object to the things that surround it plays an important part in our ability to recognize what it is and even to see it at all. The significant factor is visible difference — in one or more ways (texture, tone, color, and the like) the object must look perceptibly different from the things around it. Otherwise, it will simply be lost among them, hidden by similarity.

There are numerous things in nature that illustrate how things can be lost in similarity — protective camouflage, for instance. Think of the zebra. With his bold stripes it is hard to imagine his being invisible, yet when he stands in tall grass he simply disappears. The shadow patterns made by the grass look just like his stripes. It is good for a photographer to remember this: in photographs, objects of many kinds can be lost in shadow patterns — if they look too much alike.

**Figure 5.4.** The zebra's high-contrast markings make him stand out, but in high grass, which has approximately the same pattern, he disappears. The rule is that similarity absorbs similarity, whereas difference (contrast) makes things stand out. Similarity squeezes things together; contrast pushes them apart.

For good visibility it is not necessary that an object and its surroundings be totally different. For example, a tonal difference is often perceived around the contour of an object, but the degree of difference between object and background can vary greatly from one section of the contour to another, and sometimes the difference can disappear entirely. Oddly, this variation along the contour can contribute considerably to the apparent solidity and realness of an object. In a photograph it can also make the object look as if it were actually surrounded by things. With too much difference (in tone, color, texture, or whatever) between an object and its surroundings you may get a feeling of artificiality, as if the object were something pasted onto your picture.

Thus you see that you need a good balance between similarity and difference, for both contribute to the apparent reality of objects and the space that you feel between them. With too much similarity you lose objects altogether, but too much difference can make things look as though they don't belong together. You can look at it this way: an object's difference from its environment enables you to identify it, but its similarity to the environment makes it look as though it belongs there.

## WHAT IS AN OBJECT?

We will take a brief detour in the interest of better understanding. I have been making considerable use of the word "object," though I use it with great reluctance. It is such a dull, dead, and clumsy word. Moreover, it has heavily negative connotations when employed in certain necessary ways. For example, my wife is an object according to the definition. That is, she is something that has solidity; she is filled space or something that fills it; and she is separate from empty space. Though she is surely an object is this sense, I call her one with great reluctance.

I use "object" mainly because I am fairly sure that nearly all my readers will associate it with something they can pick up, throw rocks at, or bump into. They can walk around it, touch it, and perhaps smell it. Moreover, they can see it and be sure that they have actually seen something. An object, whatever it may be, has definite existence.

## CONTRAST

Remember that things must differ from other things in order to be visible at all. In a sense, photography is the art of making things visible, so it must naturally deal with differences. Perhaps the most important is tonal difference or contrast.

To have contrast you must have two or more things that differ in

**Figure 5.5.** A manikin head in a darkened room lit by one light. As you can see, the lighting has created very high contrast on the head. The dark on the right side of the head consists of a large *form* shadow (as distinguished from *cast* shadow).

their degree of lightness or tone. High contrast describes a considerable difference — such as the relationship between black and white. Low contrast describes a small difference — such as the relationship between black and near-black, mid-gray and slightly lighter or darker gray, or white and near-white. In high contrast the tones are very different, in low contrast nearly alike. Medium contrast describes a lightness difference in between these two extremes.

Contrast of any kind whatever — high, medium, or low — is created entirely by light, but it works in two basically different ways. One way that light can create contrast is by permitting itself to be absorbed by surfaces to varying degrees. Thus we can have a highly absorbent surface (black) next to a highly nonabsorbent one (white) and end up with high contrast. The same amount of contrast (or any lesser amount desired) can be created in still another way — by the geometrical relationship between objects and one or more light sources. For example, you can take a solid object (say a plaster manikin head) into a darkened room and light it from one side with a spotlight. You will get the high contrast right on the face, one side being white and the other black, or nearly so.

The two different ways in which contrast is created work together nearly all the time. That is, we see contrast created by the differential light absorption of surfaces going along with contrast created by lighting geometries. These geometries are usually referred to simply as **50** "lightings." We will deal with the basic ones in Part Two of this book.

One of the big advantages of photography is that it makes certain things much clearer. For example, when you are printing, it is fairly easy to see what contrast is all about — to see what it does to the feeling of realness in images, to the visibility and apparent solidity of objects, and to the feeling of space. One can learn to see such things in the everyday world, but it is quite a bit harder to do. However, the things that make contrast work in prints are also operating to make visual reality look the way it does.

It is fortunate that people don't make good prints every time they try, because some things can be learned more readily from bad ones. In a successful print it may difficult or impossible to figure these things out. Consider a very flat (low contrast) print. For example. The very fact that you dislike it impels you to search for the reasons for your feeling. First of all, things don't look real enough. Objects don't have sufficient substance and solidity. The feeling of space is almost entirely absent. Moreover, the flatness may have a strong negative emotional effect on you as you look at it.

Contrast has a lot to do with making objects look like objects, which is what we have been mainly talking about for a while. In the flattest possible print, objects will disappear altogether. And so it is in everyday

**Figure 5.6.** The smoke in which the girl is standing has obliterated much of the contrast in this scene. As a consequence its solidity and feeling of space have been much diminished. Furthermore, the lack of contrast has given the picture a somewhat morbid or depressed feeling.

life — when contrast goes, objects also go, taking visible reality along with them. Fortunately, this absence of contrast occurs only at night or in blinding fog or snowstorms, but the very fact that it does helps us see how important contrast is in visual perception and human life.

If you print the same negative in a whole range of contrasts from normal to extremely flat, you can see the object-like quality of objects gradually disappearing. Progressively, they lose the feeling of solidity, getting more and more like two-dimensional shapes. They seem to fill less and less space and look gradually less real.

Even with all you have read and seen you may find it difficult to give contrast credit for all that it does. So consider this: a black-and-white photograph consists *entirely* of lightness or tonal differences, which is how we have defined contrast. Color pictures and visual reality as we perceive it mainly do too, though color differences are also a factor. Without contrast the perception of space is impossible. Indeed, the eyes function mainly as instruments for detecting tonal differences and the patterns that they make. These are *light* patterns, of course.

Since it is unlikely that you will accidentally make prints that are much too contrasty, you ought to do it on purpose just to see what you can learn from them. Use Kodalith negatives or Brovira no. 6 paper, or both. You will soon see that too much contrast destroys both solid form

**Figure 5.7.** The contrast of this picture is so high that it has lost much of its reality. Actually, the high contrast as such is not the problem—it's the lack of intermediate tones. The contrast here comes entirely from the lighting. The negative was printed on normal contrast paper.

and space nearly as readily as too little of it does. Actually, it isn't the contrast itself that does it but the absence of intermediate tones between black and white. In essence, these intermediate tones glue everything together in a harmonious way — both in visual reality and in pictures.

## TONAL RANGE

I have noted that a range of intermediate tones between the lightest and darkest tones seem to hold both visual reality and pictures together. That is usually the case, but not always. For example, a picture of a black cat on a snow bank wouldn't have these tones, yet it wouldn't matter. In most pictures it does, however.

We call this step-by-step dispersion of tones the tonal range. The tonal range in visual reality may be as much as 1 to 1,000. That is, the lightest thing before your eyes may be 1,000 times brighter than the darkest. However, it is more usual for the range to be around 1 to 400. When we make pictures we compress this range to about 1 to 30 or less, yet the pictures can still look very real despite the compression. The important thing is that there be intermediate tone steps, areas varying from light to dark.

In many pictures it is also important to have some pure blacks and

**Figure 5.8.** A picture with a long tonal range and medium contrast. There can be no doubt of the solidity and reality of this young woman. The portrait has a wraparound lighting, which makes the skin seem to be wrapped around something solid. The woman is very definitely filled space.

whites because having a tonal range that is quite long helps them to look more real. That is, it helps them look more like visual reality with its very extensive tonal range. But that is not a hard and fast rule; sometimes pictures look best with a black-to-gray range, a white-to-gray range, or a gray-to-gray one.

In photography, the tonal range is mainly an expression of contrast. A long range often goes with high contrast, a medium range with moderate contrast, and a low range with low contrast, or flatness. The problem is to get the range of a picture to resemble as much as possible the range of the thing photographed. This resemblance is possible, despite tonal compression, and has much to do with making pictures look real.

## CONTRAST PUSH, SIMILARITY SQUEEZE

Tonal contrast seems to push things apart — one could call it a space push or a push that creates space. For example, in either visual reality or photography an object will seemingly be pushed forward from its surroundings by contrast. At the same time the surroundings will be pushed back.

Now think of objects that partly overlap, some being in front of others. In everyday visual perception this overlap is a very strong space cue if you move your head while you are looking at it. In pictures it has much less strength and, if contrast is insufficient, can even destroy space instead of creating it. In order for overlap to create space in pictures you need a contrast push. You can do a lighting for the push; or you can create it in printing by dodging, burning in, or both.

One of the tricks in using the contrast push is to make it of uneven strength around the contour of the object you want pushed forward. If the amount of contrast is even all the way around the object, it may look like a cut paper figure pasted on your picture.

Creating the amount of contrast needed to push things apart in space is sometimes referred to as "getting good separation," which is a useful expression. You are simply using contrast to make things look separate. On the other hand, if there is insufficient separation in pictures, things will appear to be joined or squeezed together. Head movement won't help to restore the space that is lost this way.

We have seen that similarity can join things or squeeze them together in the same plane of a picture space. It can also make things that are similar go back in space, which is a good thing. By not standing out very much they are absorbed in the distance, so to speak. In comparison, a thing that gets a good contrast push will seem to come forward. In a picture, we almost always need both kinds — things to come forward and things to go back. Without both advance and retreat we won't get space. Objects won't look like objects.

# SURFACE CONTRAST OR CONTRAST WRAPAROUND

We can become aware of contrast in several ways that need to be examined in order for us to use it well in photography. We may notice contrast where the contour of an object seems to make contact with its surroundings. In this case it seems to be a local phenomenon. Once again, let us use the example of a white egg on a gray surface. We can see contrast as something happening around the egg's contour, perhaps just seeing one section of the egg at a time. We can also see contrast as an overall tonal difference between the egg as a whole and the background. There is still another important way to be aware of contrast: think of it as something happening right on the surface of the egg itself. For example, the egg will usually be much lighter on top than on its underside. This surface difference in tone is also contrast, even though the light and dark areas on the egg may blend together very subtly. This kind of contrast with smooth tonal gradation is characteristic of objects with curved surfaces that have been illuminated from an angle. One sees it all the time. Lighting from an angle can also produce surface contrast on objects with flat sides — a box, for instance — but it doesn't usually produce a graded tonality unless one deliberately goes for that effect.

I noted earlier that the fact that an object has a well-defined contour in a certain setting isn't enough to make it look like an object, that is,

**Figure 5.9.** An egg with a wraparound lighting and a three-way contrast push. The white side of the egg pushes away from the background, and so does the dark side. The form shadow on the egg—the wraparound—pushes the egg surface into three-dimensionality.

**Figure 5.10.** A woman with a wraparound lighting and a three-way contrast push. She is lighter than the background on one side, darker than the background on the other. The wraparound lighting on her face produces form shadows that make her skin seem definitely wrapped around something solid.

a thing that fills space and has volume or solidity. Though you know that it is solid it may simply not *look* that way. To look like a thing really filling space, an object needs surface contrast. That is what produces the feeling of solidity in photographs.

It is true that without contrast you can make very handsome pictures in which subjects are easily recognizable as solid objects (as in a very light or high-key portrait print) even though they don't look solid. Apparent solidity is one of the things we traditionally play with in photography, sometimes going for a little of it and at other times for a lot. By varying it, we control how real or unreal things look in pictures — but in this section we are still dealing with the basic question of what makes objects really look like objects, both in visual reality and in pictures.

Often when you photograph an object, you want its surface to look as if it were wrapped around it, as if the surface moved through space. This wraparound effect, which you get with surface contrast, makes the thing underneath the surface (the object) look three-dimensional or solid. You can get the effect (usually through lighting) when making a portrait; then the head will look solid and real.

**56**     Though you may not want things to look solid and real in certain

photographs, knowing how to get the effect is the best starting place. Knowing how to create reality gives you a foundation for manipulating it — you simply know which strings to pull — to create photographs that are as nonreal as you wish. One of my main reasons for telling you about photographic reality is to give you a foundation for playing around with it. That is an important part of the art of photography.

## THE THREE-WAY CONTRAST PUSH

There is one particular lighting and background situation that can make an object look especially solid and real. For want of a better name I call it the three-way contrast push. Let us again use the white egg. This time have it standing on one end, and instead of placing it on a white or black surface, use a gray background. The egg will look white on one side and black on the other (see Part Two) if you use a strong side lighting.

The contour of the egg will relate tonally to the background in two main ways: (1) it will be lighter than the background on one side (white against gray) and (2) it will be darker than the background on the other (black against gray). That gives us two parts of the three-way contrast push. The third consists of surface contrast, which ranges from black to white on the surface of the egg. These three pushes work together to make an object look really three-dimensional.

This system (a background of medium tone and the right lighting) is very popular with advertising photographers, so in magazine ads and TV commercials you see many models who were shot that way.

## CONTRAST VARIATION AND RELATIVE VISIBILITY

When you examine either visual reality or a picture section by section, you usually see tonal contrast happening in each of the parts, but the *amount* of contrast often varies considerably from part to part. Recognizing the contrast variation and learning how to control it is an important part of learning to be a photographer. For one thing, the variation determines which part of visual reality or a picture will be most visible in a strictly optical sense. In brief, areas with the most contrast will be most visible and those with the least contrast least visible. You can use this knowledge to make people see what you want them to in your pictures.

I have used the idea of optical visibility to describe a visual response that is mainly mechanical. Something that has this quality will affect the retina of the eye more strongly than something that does not. The strength of an object's optical visibility makes considerable difference in whether or not we will see it. However, it may have what might be

called psychological visibility. That is, people may see it mainly because it is the kind of thing they are interested in or are looking for. For example, a nude adult body in a picture will have good psychological visibility, even if its optical visibility is almost nil.

So optical visibility, which is to a large degree dependent on contrast, provides a means for guiding people's attention when they look at photographs. In some pictures (but not all) it can be controlled rather well by such means as selection of subject matter, choice of background, lighting, and dodging and burning in while printing. Where such control is possible it is generally advisable to set up a relative visibility scale, reserving the greatest visibility for the most important things in your pictures and less visibility for unimportant things.

The relative visibility scale will also help you create space in your pictures because the things most optically visible will seem to advance, those least optically visible to retreat. To a degree this same relationship will hold for psychological visibility, with interesting things advancing and dull things retreating. Later, you will see that colors can also advance or retreat.

Don't forget that we are still investigating why things look the way they do — real and unreal, solid and flat, and so on. Except for what color does, the relative visibility of things in the visual world or pictures is mainly determined by contrast, one of the most important space and object cues. In most cases there is a graded scale of visibility ranging subtly from a considerable amount of it to none at all. This scale itself is an important factor in making objects look like objects and creating space, real or illusional, around them. Beginners in photography often try to give things equal visibility, but they should know at the outset that this approach may entirely destroy the feeling of reality.

## CONTRAST AND FINE DETAIL

When you look at the visual world you find that it is made up mainly of things that are small — a beach is made of grains of sand, a tree of branches and leaves, a face of pores and eyelashes, and so on. In photography we call such things "fine detail" and use the very sharpest of lenses to record this detail in all its fineness. The reason is simple enough: fine detail helps make reality look like reality. Whether fine detail will even be visible in the visual world or pictures depends to a large degree on contrast.

You can't escape the need for contrast, even in the world of the ultraminute. If you were to play with electron microscopy, where a thing may be magnified ten thousand times, you would still find that contrast is important and that getting enough of it is a problem. Because you don't get color, contrast has to do the entire job. Without contrast there is no visibility at all.

# CONTRAST AND EMOTION

Though emotion is a very important part of visual perception, I have said relatively little about it. I have steered around the subject, usually just referring to the "feeling" of this or that — the feeling of space, for example. I can say one thing outright that you should remember, however: emotion validates sensory perception. Without emotion you could never have the certainty that anything actually exists in what you describe as reality.

Emotion or feeling also regulates how much attention you pay to the things around you, for you choose to be aware mostly of the things you like or find interesting, useful, or necessary. Without this emotional interest in things you would be aware of very little. We might say that emotion is a way of getting out of ourselves.

Contrast affects feeling rather strongly, though it usually is hard to translate this feeling into awareness, where you can examine it. The contrast in the visual world or in images has to be right, or we are somehow just not happy with it. You experience this state when you feel it necessary to adjust the contrast on your TV set. Though your feeling of unrest is vague, you nevertheless know what you want to do about it.

There are times, however, when the feelings aroused by certain degrees of contrast are inescapably powerful and, as such, are open to observation. Here I am thinking of situations, in visual reality or pictures, where the overall tone is quite dark and the contrast very low. Such a situation often causes strongly negative, very morbid emotions in the viewer. You have experienced such things, of course, and have perhaps been aware of how negative they made you feel. They demonstrate rather clearly that contrast does indeed affect emotion — you should always remember this.

I have given you a lot of material suggesting how contrast can be played around with for various purposes, but I haven't suggested a way to tell when it is just right for a particular purpose. Well, you tell by *feel* — when it *feels* right it *is* right. You feel it in your gut, your neck, or your head. Obviously, you must learn to observe your feelings. A very good starting place for learning this art is with a morbid, gray, muddy, low-contrast print. If you can't feel *that* you are indeed out of contact with your emotions.

In this chapter we have discussed why objects, in both visual reality and pictures, look like objects. We have dealt primarily with contrast, a major space cue. The subject of contrast is by no means exhausted, and it pops up again when we talk about color.

# 6 The Geometry of Space

It is time to remind you that this book is entirely about the behavior of light and how its energy is used to create the illusion of objects and space in the visual cortex. Though I often seem to be writing about other things instead, you should remember that you wouldn't even be aware of objects and space if it weren't for light and what it does to them.

This chapter will be entirely about geometric light patterns and how they help create the cortical illusion of objects and space. Holding a discussion within the confines of this linguistic framework could prove to be both unwieldy and hard to understand. Though reality as we see it consists entirely of geometric light patterns, it is hard to think in these terms and keep track of what you are doing. It is much easier just to speak of familiar patterns in the everyday world, leaving out the fact that we perceive them only as *light* patterns. For example, when I speak of a checkerboard, I can communicate well with you — you know precisely what I mean. However, should I say checkered light pattern or checkered *retinal* light pattern, it would start to confuse things. So I will talk mostly about the patterns (arrangements, compositions, or relationships) that things fit into in the visual world. In

other words, I will talk about the basic geometry of everyday reality
— how things are displayed before your eyes in relation to other things
— and how it affects perception. At the same time I will try to show
you how you can make use of geometry in photography.

## THE WORLD AS GEOMETRY

Though this chapter is about geometry, don't let the word frighten you
— there will be no mathematics whatever involved. We will simply
talk about shapes, everyday arrangements of shapes, and what they do
to perception. In brief, they create the visual world that you perceive.
Your visual world is largely dependent on geometry, but in order for
you to make use of this fact you must first be properly impressed by it.
Otherwise, you will hardly even notice the geometry, much less study
ways of putting it to use in photography.

We will start with formal geometry, then proceed to natural geometry
later in the chapter. Formal geometry is roughly what you would expect
it to be — a study of regular figures such as circles, spheres, rectangles,
cubes, straight lines, parallel lines, triangles, perpendicular lines. For
our purposes, the main thing you need to know about such figures is
what they look like from various angles. For example, you should know
that a circle viewed from a low angle looks like an ellipse. As you will
see in a moment, this knowledge can be put to use.

It is important for you to realize that the civilized world you live in
is mainly made up of these regular figures — they are literally all over
the place. For example, nearly anyone can walk around an average
apartment and count several hundred rectangles without half trying.
If the floor is tiled or parqueted, there are hundreds right there — and
don't forget the walls and ceilings! So you are inundated by geometrical
shapes from architects, interior decorators, carpenters, furniture de-
signers, picture framers, linoleum manufacturers, all of whom have
found that things are easier to build that way — everything can be
made to fit.

The thing about these regular shapes is that they are logical,
expectable, and predictable. In fact, that is why they are called regular.
Oddly, people have a very strong inward desire to see all shapes as
regular, even when they aren't. Perhaps this desire accounts for the
fact that the study of these shapes — squares, circles, cubes, stars,
spheres — has been an important part of metaphysics and the mystery
religions for millennia.

The appearance of a regular shape will change according to the
angle from which it is viewed, but people refuse to recognize the change.
They insist that a regular shape should be regular. For example, a
rectangle viewed from an angle will no longer make a rectangular
pattern on the retina, but people will still see it as a rectangle, even
when it is greatly skewed or distorted.

**Figure 6.1.** The civilized world is full of rectangles, all of which help us orient ourselves in space. Viewing them at an angle, we see most of them as skewed to some degree, and it is this skewing that is used in forming our perception of space. If you counted carefully, you could probably find one hundred rectangles in this picture. Since the skew here is relatively slight, it is hard to see; it is nonetheless present.

**Figure 6.2.** Outlines identify some of the rectangles.

This disproportion between what a thing actually looks like and how we perceive it is odd, of course, but it helps demonstrate the fact that space perception is mainly unconscious. Despite the fact that we refuse to consciously recognize skew in regular figures seen from an angle, the unconscious picks up on it immediately and uses the skew data to create space perception. To illustrate this point we will use the rectangle, the most common shape in the civilized world.

When you look at a rectangle from one end and at a fairly low angle it still looks like a rectangle. The pattern on the retina is strongly skewed or distorted, however. Though the front and back sides are still parallel, the left and right sides are strongly convergent. If these side lines were continued they would eventually come together at a point. Insisting that a regular figure continue to be regular, we don't notice the convergence. That is, our egos don't notice it and don't wish to. It would complicate life considerably to be aware that a regular shape — that paragon of dependability — never looks quite the same way twice. Fortunately, the unconscious is acutely aware of the fact and uses it for the creation of space perception.

For example, a single rectangle viewed as suggested above causes a skewed retinal shape that furnishes the visual cortex sufficient data to form a completed space illusion. In other words, looking at just one rectangle can give you the feeling of space. With such great simplicity, however, the illusion will be a bit ambiguous. That is, it will seem to change its spatial character while you are experiencing it and must be supported by additional space cues before it can become stable. Even so, it is a whole space perception.

We can make a rough breakdown of what this simple but whole space perception consists of, describing its makeup in terms of what it does.

1. It tells us the overall size of the rectangle.
2. It tells us the distance (space) from front to back.
3. It tells us from what angle we are viewing the rectangle.
4. It defines the plane on which the rectangle rests and our spatial relationship to this plane.
5. It tells us how close we are to the rectangle.
6. It tells us the proportion of the rectangle.

If you think about it, that is a large amount of information to get from a single regular shape and a skewed retinal record of it. Furthermore, we get such information almost instantaneously. The fact is, in the civilized world the mind has an enormous amount of experience in making spatial interpretations from regular figures.

In the last few paragraphs I have been explaining the obvious, but upon close examination the obvious turns out not to be so obvious after all. For example, I doubt if you were previously aware of the importance in space perception of skewed retinal impressions of regular shapes. You use them nearly constantly, but were you aware of doing so?

**Figure 6.3.** Girls at an English drama school, a picture with a considerable space feeling due largely to the ellipsis created by the figures. We interpret the ellipsis as circles and thus see the space that circles would occupy.

**Figure 6.4.** The main whole and partial ellipsis formed by the students and their teacher. They all help to give the picture its feeling of space.

# PERCEPTUAL HABITS

Photography consists almost entirely of the manipulation of objects and space to create illusions, but it takes knowledge to make the manipulations work. In this sphere it is important to know about common perceptual habits. By playing against them you can create almost any illusion you like. For example, you can use an understanding of regular figures to compress space, stretch it, tilt it, or even turn it upside down. This works especially well in photographs. We will see how it is done in a moment, after we have looked into the nature of visual habits.

Human perceptual habits can be compared roughly to a large number of buttons on a computer. Pushing one of the buttons results in a programmed response, sometimes called a conditional response. We might say that a computer is conditioned to respond in a certain set way when given buttons are pushed, and people are conditioned in much the same way and to a far greater degree than they suppose.

We all have vast numbers of perceptual habits, or set responses, to various kinds of visual stimuli. In walking across a crowded room a person may activate several hundred of those responses without being aware of having activated any. That is not an exaggeration. The fact that people are mainly unaware of such habitual responses makes them especially susceptible to cleverly created object and space illusions. Even the people who *are* aware can be taken in, because the habits still exist deep within them, and the programming in human beings is extremely hard to undo.

Never underestimate the strength of the programming (mostly done by yourself), for your very reality depends on it. Without it you would perceive realities entirely different from the ones you know. Thus people naturally cling to their habits, their programming, and this very fact makes possible the illusion-making process, which is essentially a manipulation of habits. It also explains why we see objects and space in photographs, when neither are actually there.

# REGULAR SHAPES: THE LAWS OF VISUAL HABIT

Remember that regular shapes viewed from an angle form skewed patterns on the retina and that all of us have experienced millions of these patterns and have responded millions of times by perceiving space. Thus we develop habitual space responses, which in a short time become veritable laws. Then when we experience certain retinal patterns we have to perceive space, whether we want to or not. These laws are constantly strengthened by the fact that the space perceived actually exists in visual reality. That is, the skewed retinal shapes tell us about regular shapes to which we are spatially oriented in exactly the way that we think we are. The cortical space perceived is an accurate model of space in visual reality.

The laws of habit are also strengthened by the fact that the shapes on which they are based are numerous and almost consistently regular. Thus long and often reinforced experience tells us that certain retinal patterns are caused by space in the real world and our position within it. Further reinforcement comes from the fact that the decisions we make on the basis of the resulting space responses are almost always correct. We don't even have to think about them. For example, we can easily perceive the space through which a flight of stairs rises and climb the steps without thought or difficulty. The fact that our perceived space almost always works for us makes us ever more obedient to our space perception habits or the so-called laws of habit.

As you will see in a moment, the regular shapes to which we are accustomed can be manipulated — preskewed, so to speak — and we will still follow the laws willy-nilly. The effect can be especially strong in photographs, which are analogous to retinal images, because contradicting space cues can be eliminated. That is, knowing the laws gives us a foundation for juggling the particular evidence on which they are based. This in turn permits us to create a variety of space illusions that work especially well in photography.

I will briefly state the main laws of habit that apply to regular shapes, qualify them, then go on to explain them at greater length. Remember that they have grown out of our long experience with the geometry of civilization and its billions of regular shapes.

1. *All quadrilaterals are rectangles.* Qualification: all quadrilaterals that cause the familiar skewed retinal shapes are rectangles.
2. *All ellipses are circles.* Qualification: if a figure causes an elliptical retinal shape it is a circle.
3. *All pairs of straight lines or edges are either parallel or at right angles to one another.* Qualification: the lines in a pair should be close enough together to be seen at one glance.
4. *All S curves are regular S curves.* Qualification: any retinal S shape, no matter how skewed, has to have a regular S curve as its cause.

*All quadrilaterals are rectangles.* A quadrilateral is a closed shape with four straight sides, which may or may not intersect at right angles. A rectangle is a quadrilateral with four right angles. The law says that we strongly tend to perceive quadrilaterals as rectangles, even if they don't have four right angles. That is because we generally perceive rectangles as skewed retinal shapes, sometimes with no right angles at all, and sometimes with no pair of parallel sides.

If you look at a nonrectangular quadrilateral you may initially persist in seeing it as a rectangle and simply twist your space perception around to make it fit what seem to be the facts. Soon, however, various contradictory space cues will make you see the truth — that you are actually looking at a nonrectangular shape. In photographs these contradictory cues can often be eliminated, so that the viewer is led to

**Figure 6.5.** Preskewed rectangular shapes give this little scene much more depth than it actually had. The skull and the figurine were only about eight inches apart.

**Figure 6.2.** These are the same elements as in the previous picture, but the preskewed rectangles are turned around other-end-to. The image will look more normal if you turn it upside down.

perceive space that differs considerably from what was present when the pictures were made. The original space may be twisted, compressed, extended, or even turned upside down without the viewer's having any idea that changes have taken place. The way to do this is to start out with preskewed rectangles, which aren't really rectangles at all, of course.

**Figure 6.7.** Here we have two illusional elements: the intersecting edges of the triangle and the ellipses, which are actually of different sizes. You assume that the edges are parallel and actually intersecting at a distance and that the ellipses are actually circles of the same size. Such assumptions make it appear normal to see a full cup of coffee hanging upside down.

*All ellipses are circles.* The ellipse is a shape that is seldom encountered. In contrast circular things are numerous. They are usually seen at an angle, however, and experienced as elliptical retinal patterns, leading to the law, based on an overwhelming amount of experience that all ellipses are actually circles being viewed at an angle. In photographs you can therefore use actual ellipses to twist space, tilt it, compress it, extend it, or even turn it upside down. Viewers would rather perceive such things as happening than alter their long-entrenched habit of thinking that there is no such thing as an ellipse. Their experience supports this view, of course, and the few actual ellipses they see won't alter it.

*All pairs of straight lines or edges are either parallel or at right angles to one another.* This law is the result of a visual culture in which nearly everything is constructed in regular shapes. Of course, pairs of lines don't *have* to be either parallel or at right angles, but we tend to see them that way.

Experience tells us that parallel lines viewed at an angle will always seem to be convergent. If they are long enough (like the edges of a long, straight road or the rails of a railway track) they will even seem to

come together at a point on the viewer's line of sight. Since we have all had a great deal of experience, we can use it with considerable accuracy in perceiving the space traversed by the parallel lines, even if they don't extend far enough to intersect. The convergence with very long lines isn't actual, of course, but it seems to be. Once again we end up with a skewed retinal pattern, and the skew is interpreted as space in the visual cortex. Remember that the cortex is where all of our visual perception takes place.

In making photographs you can preskew the lines that you wish to have interpreted as parallel lines seen at an angle and thus stretch the space that they seem to traverse. With a reverse skew you can compress it, turn it into two dimensions, or flip it upside down. Essentially, you use a V shape, either upright or inverted, and it provides the viewer with a powerful compulsion to perceive space in terms of lines that are actually parallel, not convergent.

An obliquely viewed pair of lines or edges that *seem* to be perpendicular to one another can also strongly modify the space they traverse if they aren't *actually* perpendicular. They also define (establish the position of) the plane on which they occur and will tilt it if they aren't really perpendiculars. They also appear to establish the viewer's (or the camera's) geometrical relationship to this plane. In fact, they can do about the same things to space as lines that falsely seem to be parallel, though they do them in different ways.

Lines or edges that are actually at right angles (90 degrees) to one another usually are viewed obliquely, which makes the angle seem to be either more or less than 90 degrees. Thus it doesn't take a 90-degree angle in a retinal image to make lines or edges seem to be at right angles. Depending on its surroundings (and other space cues), nearly any angle can be perceived as a right angle on the basis of a retinal image, which is usually skewed anyway. Whatever its actual degree, an angle interpreted as a right angle tells the viewer how he or she is geometrically positioned in relationship to the lines or edges that form the angle. The lines don't have to intersect, though intersection makes them stronger as a space cue.

*All S curves are regular S curves.* Though S curves aren't as frequently seen as rectangles, circles, and pairs of straight lines, they are nonetheless very familiar. Since they are almost always viewed at an angle the retinal images are usually skewed. That is, if an S curve is below eye level, the top will be smaller than the bottom, sometimes very much so. If it is above eye level, the top will be *larger* than the bottom. By preskewing S curves (or by using reverse skews) in photographs, you can falsify the actual space by tilting it, turning it into two dimensions, compressing it, extending it, or turning it upside down.

The S curve is an extremely powerful space cue and has long been used as such in photography, usually in the form of S curved roads meandering through bucolic landscapes. Country roads can have curves with reverse skew, however, in which case the desired feeling of space is usually wiped out.

# SPACE-COMPULSIVE SHAPES

The very common regular shapes not only help you see space but *compel* you to. More accurately, your space perception habits compel you, but it is convenient to say that the shapes themselves do it. Thus we can say that, viewed at an angle, rectangles, circles, pairs of straight lines, and S curves are all space-compulsive shapes. They make us see space whether we wish to or not.

When regular shapes are created with preskew or reverse preskew they are still compulsive, though they are actually no longer regular. As long as the preskew of a shape stays within the range of retinal skew for the regular shape that it is imitating, the ego will accept it as regular — until contradictory space cues show that it is not. Since regular shapes are skewed in many ways on the retina (depending on the viewer's position with respect to the shapes), we have a considerable amount of latitude for the manner and degree in which we can preskew such shapes for photographs without being detected. In other words, we have very considerable control over the apparent space in pictures.

Regular shapes, preskewed or not, can be made even more space compulsive when combined with other space cues covered in this book. Since nearly all space cues can be manipulated — changed around or preskewed — it is not too hard to make photographs that change space entirely in an undetectable way. The art of skewing regular shapes in order to make pictures is called "linear perspective," incidentally — I

**Figure 6.10.** A picture filled with contradictory space-compulsive cues. No matter which way you turn it, it won't look right. The glasses of milk act as "provers" to show you how the picture was acutally shot.

71

just thought you would like to know. I have given you the gist of it but have avoided the traditional approach and terminology so as not to confuse you.

## FOR YOUR AWARENESS

I have intentionally taken a rather mechanical approach in discussing the power of regular figures to cause space perceptions. I did this so that you yourself could follow my lead and make photographs that change space all around, even if you don't fully understand what I have been talking about. Just follow the recipes, and you will get the promised effects.

My reason for suggesting that you try such manipulation is not that I see any special virtue in trick photographs. They are all right in their place, of course, but they are not the be all and end all of photography. The real point in making them is not to end up with a collection of trick pictures but to awaken yourself to space as something that you must handle every time you make a photograph of any kind. Space, nonspace, reverse space, and so on, pop up in one place or another in nearly every picture, and you should learn how to treat them in order to make your pictures as successful as possible. The starting point is to become sharply aware of such things (which are going on all the time). Developing this awareness is thus the main point of doing the things suggested in this book. You could also call it "learning to see."

## PROVERS

In this and the previous chapters you have been given enough information to enable you to make photographs that do many strange things with space, and if you do them well your manipulations will not be detectable. Your pictures may look very much as viewers expect them to. Further more, people won't believe you when you tell them how you have twisted space around and turned it inside out. If you like private jokes, that is perfectly all right. However, it is more fun to put things in your pictures that prove to people that you have done exactly what you say. I call such things "provers." In the illustrations you can see that I have used them quite frequently.

When I tell you that space can be extended, compressed, turned into two dimensions, twisted, tilted, or turned upside down, I want you to believe me. So I made illustrations that do some of these things and put in provers to convince you that it actually happened. My favorite provers happened to be glasses or cups containing coffee or milk. When you see one of them upside down in a picture that otherwise looks

upright, you can be sure that something peculiar has been done to space.

Oddly, a good reason for you to use provers is to keep you from being taken in by your own pictorial deceptions. Sometimes space illusions can be so powerful that you can turn reality upside down and not be able to see that you have done it, no matter how hard you try. Turned upside down it looks just as normal as ever — if you turn the picture around. In this case a prover can convince you of what you have done.

## FALSE HORIZONS

In a picture, almost any horizontal line or edge can function as a horizon, especially if it is near the middle of the picture area and extends all the way across it. It works very well even if we don't think of it as a horizon. When we see a horizon, real or false, it tells us that we are confronting a considerable amount of space. In fact, horizons do much to create space illusions in the visual cortex. For this reason it is usually good to have a false horizon in a picture in which you are juggling around. It too can be juggled, which makes for a lot of fun.

Almost always, it is good to have a change of tone at the horizon. That is, the picture area above the horizon, real or false, should be of

**Figure 6.11.** Helped strongly by the two space-compulsive checkerboards, the false horizon makes the glass of milk seem to be floating in air above the top checkerboard, which is also floating. Actually, everything in the picture was sitting on the same surface.

a tone different from the area below. It is also good to have the horizon intersect one or more of the objects in a picture. To make an object seem to be flying, however, you can have all of it above the horizon. If all of it is below the horizon it may also seem to be far below the viewer. Thus you can see that the position of objects with respect to a horizon has a strong effect on the type of space illusion created.

## SIZE CONSTANCY

Life experience tells us that many things of basically the same nature differ little in size and that others differ not at all. This principle is called size constancy. That is, the sizes of certain things are rather constant or invariant. For example, the height of adult human beings, male and female, usually ranges from five to six feet, meaning that this range is constant.

We use this knowledge of constancy, which is based on a tremendous amount of experience, in perceiving space. For example, when you form a retinal image of two people in which one of them is three times as large as the other, you know immediately that it doesn't represent their actual size relationship. Instead, you quickly perceive that one is at a greater distance from you than the other. In other words, you use the knowledge of size constancy to create an accurate cerebral model of space.

The great retinal size difference of things known to be the same (or nearly the same) size is one of the strongest space cues and is used almost constantly in orienting oneself in the everyday world. As you will see in a moment, it can often be juggled to create forms of space that don't actually exist.

## SEEING TOO MUCH SIMILARITY OR CONSTANCY

In the previous chapter you saw that visual impressions are grouped or categorized in order to make them into easy to handle object and space cues. This ability to group or categorize (form gestalts) is very important for survival. Without it we would have to attend to all visual impressions individually, which would quickly overwhelm us. There are simply too many visual things going on for them to be handled one at a time. For example, in a crowded hall you are confronted with literally millions of separate sense impressions. If you couldn't conveniently group or categorize them you wouldn't be able to make any sense whatever out of what you were seeing, nor would you be able to walk across the hall. So you see that the gestalt-forming capability is very important in life.

Because grouping or categorization is vital to our survival, we tend

to overdo it. For example, we frequently put things in tight categories that only belong in loose ones. The basis for putting things in categories is similarity. If there is only a moderate amount of similarity we get a loose category, such as "living things" or "inanimate things." "Male Englishmen named Smythe who are six feet tall" would involve more similarity and make a much tighter category. Such tight groupings are more specific and easier to handle.

So the tendency is to form categories (groups or gestalts) and put things into them that don't really belong. There is a strange psychological law that we follow in this respect: Things that are alike in some ways are actually alike in all ways until it is proved otherwise. That leads us to such improbable ideas as, "Everything wet is water" and, "All things with two legs are human." That is stretching it a bit, but the law moves our thinking in this direction by encouraging us to stretch a little similarity into a great deal. And things with this much similarity must be identical or close to it. It is a strange law, of course, but it works in human beings.

The law can easily be used for space manipulation, especially when used with the information I have just given you about size constancy. Indeed, size constancy is a special case of the law itself. The notion that we make use of is that things that are alike in one or more respects must also be of the same size, and the size is constant of course. There are, however, a number of things that can look nearly identical except for size, which can vary considerably from one thing to the next. Examples are sea shells, balls, certain plants, rocks, statues. In a given group the size difference (which may be great), the law of similarity, and the assumption of size constancy can all work together to create strong space illusions in photographs.

The law of similarity is strongest with respect to things we ordinarily pay little attention to. In this case we see similar things as identical without even thinking about it, and this habit can be played against to create space illusions. Take round rocks. They can look identical yet vary greatly in size. Since people will assume they are the same size if you give them a little help, the rocks can be arranged in front of the camera in a size gradient — large to small — that will falsify the space by stretching it considerably. A reverse gradient will compress it. In both cases the space will seem real.

Though it is harder to pull off, you could do the same space tricks with a real person and a lifelike doll — like Barbie or Ken but more realistic. Using a lighting that obscures more than it reveals and eliminating contradictory space cues, you could lead people to think that these two things that are alike in many respects are also alike in size. Then, because of the assumption of size constancy, viewers would be led to perceive the person and the doll as standing a considerable distance apart. The people who do special effects for movies use this particular trick a lot.

**Figure 6.12.** Assuming that things that are alike in some respects are alike in all, you tend to think that these similar rocks are the same size—which they aren't. This is an assumption of size constancy that leads you to see more space than was actually there. The false horizon helps to deceive you in this matter.

**Figure 6.13.** When most of the contrast is eliminated with a flat frontal lighting, most of the feeling of space goes with it. Even a strong pattern gradient such as the rocks make won't work without sufficient contrast.

**Figure 6.14.** Here we have reversed the size gradient of the rocks. Since the assumption of size constancy, however unwarranted in this case, is still working, the space in this picture does peculiar things. Part of the effect is caused by having two horizons.

**Figure 6.15.** Showing how a preskewed or pregradated checkerboard is made. Draw it first in pencil, then blacken alternate squares with a nylon tip pen. Then trim it to size. You now have space-compulsive gradient that forces you to see altered space, whether you want to or not.

## SPACE GRADIENTS

A gradient is something that changes gradually. For example, a tone gradient is a tone that gradually changes from light to dark, or vice versa. A pattern gradient is a pattern in which the individual elements gradually get smaller or vice versa. In a texture gradient the small individual elements gradually get smaller or vice versa.

When you view a regular pattern from an angle, a pattern gradient is formed on the retina, and it contributes considerably to space perception. You have had a great deal of experience with such retinal gradients and long ago learned that you can depend on them for space interpretation. Your reaction to them is habitual and unconscious or semiconscious, which means that they can easily be manipulated for space effects without your becoming aware of it. For example, a photographer can put a pregradated pattern into a picture and give a false impression of the space that actually existed when he was photographing. With it, the space can be stretched, compressed, turned into two dimensions, tilted, twisted, or turned upside down.

You can do somewhat the same thing with a texture gradient, though the effect isn't as strong. The tiny shapes or lines in textures aren't usually visible enough to have much effect on us one way or the other. Even so, the effect is there, and it will influence how we perceive space, real or falsified.

Tonal gradients will also affect space perception, both in visual reality and in pictures. In the previous chapter we talked about them in terms of surface contrast and saw that they help make objects look solid. That is, they help the surfaces of objects move through space.

**77** Tonal gradients on *flat* surfaces also help give the feeling of space,

**Figure 6.16.** The graded tone in the background helps you see space in a picture that is otherwise totally flat. In photography, tonal gradients can be very important. They create much of the depth in pictures.

undoubtedly because many of the indoor spaces we have perceived have been associated with such gradients caused by uneven lighting. Remember that our space perception is based entirely on experience.

## CAST AND FORM SHADOWS

Though there are almost always shadows around, we very seldom pay any conscious attention to them. On the unconscious level it is another matter, however, because shadows play an important part in space perception. For example, a cast shadow can tell us that the object casting it is resting on a surface, that the surface is real and actually there, that the object itself is real, and that it fills a certain amount of space. One can test these assertions by faking or eliminating shadows, though that is usually the forte of painters. However, it is quite easy to fake or eliminate shadows when making photographs, partly because viewers don't really care what shadows look like. That is, it is unlikely that your mistakes will be held against you, provided that they are only moderate.

There are two basic types of cast shadows — those with sharp edges and those with soft ones, the latter being by far the most prevalent, especially indoors. It can be a bit difficult to fake convincing sharp-edged shadows, but soft-edged ones are dead easy — all you need is a soft smudge of dark that gradually fades away with increasing distance from the shadow-casting object. These soft-edged shadows don't seem like much, yet they do all the things listed above — without our even being aware of them.

**78**

In pictures, shadows help us tell up from down, which is more of a problem than it might seem to be. Indeed, knowing up from down is one of the most fundamental factors in space perception — we simply have to know. Our sense of gravity and the inner-ear mechanism generally provide the up-from-down information for us, but picture realities don't have gravity. To a considerable degree, therefore, shadows are gravity substitutes in photographs.

Shadows cast by one object onto another one can tell us about the objects' geometric relationship in space. For one thing, we see that they are not one object but two. Shadows can give the contrast push mentioned in the previous chapter, thus making the space between objects seem more substantial than it would otherwise.

A significant factor in space perception in an awareness of the lighting geometry — that is, the spatial relationship between the light source(s) and the things we are looking at. This geometry does much to create the perception of space and is at the same time a part of the space perceived. Shadows — how and where they fall — help us apprehend the geometry. For example, they tell us whether a light source is above or to one side of an object. Though people aren't generally aware of it, they find it necessary to keep constant unconscious track of the lighting geometry, and on occasions when it is hard to figure out can get quite uncomfortable. That happens sometimes in certain modern buildings in which light sources are very carefully hidden.

There is another kind of shadow, which I have previously described as surface contrast or a tonal gradient. We call it a form shadow. It is a darkening, often gradual, that occurs on the surface of an object as it turns away from the light source. As I said earlier, such a shadow has very much to do with making an object look like a solid thing instead of like a flat (two-dimensional) shape. Still earlier I said that in order to perceive space we must also perceive solid objects and vice versa. So you can see that shadows have much to do with the fact that we see three-dimensional reality at all.

It is odd that things so vital to object and space perception as cast and form shadows are so consistently ignored, but there are many strange things about human perception — I hope you have begun to see this. The fact that people pay so little attention to shadows makes it possible for us to play around with them in pictures — sometimes quite radically — without much risk of detection. You see, people have little idea of what shadows are supposed to look like, simply because they have never bothered to examine them. Indeed, there is no reason to, unless you wish to use shadows for some pictorial purpose. The pictorialist has to look at lots of things that others can safely ignore.

There are a few simple rules you should follow in faking shadows (which you might try simply in order to better understand how shadows work). You can easily make cast shadows on paper or cardboard with spray-can matte black or gray paint. Or you can use soft pencil or conte

crayon and rub it smooth with a cloth, removing unwanted areas of tone with an artist's kneaded rubber eraser. The first rule is that a cast shadow should be smooth. The next is that it should be darkest next to the shadow-casting object. The third is that the edge of a soft-edged shadow should be sharpest near the object. Finally, soft-edged shadows should have smooth tonal gradation and should generally disappear altogether after they have extended out a little way.

Form shadows can often be put on objects with spray paint. Put them on faces or bodies with dark makeup. With rounded objects the important thing is to have the gradation subtle and even. With rectilinear objects the fake shadow areas should be very even and flat.

In Part Two of the book you will be working with cast and form shadows nearly all of the time, so there is no need to say more about them here.

## THE STEPPING-STONE EFFECT

A favorite space-causing technique is to put visual stepping stones in your pictures. They are simply areas that stand out as being different and separated. They may be, for example, shapes, shadows, highlights, or patches of variant terrain.

**Figure 6.17.** The stairs are stepping stones into space, an effect intended by the play's producers.

**Figure 6.18.** The landscape surrounding the lamb seems quite deep and spacious, due partly to the texture gradient and partly to the rather subtle stepping stones into space.

**Figure 6.19.** Here the main stepping stones, including the lamb itself, have been outlined in black.

It is often said that the eye uses these shapes or spaces to jump back into the distance. Though the eyes don't actually work this way, you get the feeling of space anyway. It is not always possible to create visual stepping stones in pictures, yet you can do it more often than you might suppose — with lighting, dodging, burning in, and bleaching, for

example. Actually, the steps do not have to be strongly different from their immediate surroundings but can be so subtle that they are hardly visible at all. Even so, they can work very well. I use the trick nearly every time I print, so you see that it must be easy to use and adaptable. I also use it a lot in doing lightings.

## SPECIAL SPACE TRICKS FOR PHOTOGRAPHS

Thus far in the chapter I have talked about things that cause the visual-cortex space response when you are looking at either visual reality or pictures. In addition, there are some space-causing tricks that have evolved especially for pictures. Though they originate in everyday visual perception (remember that space perception is largely habit), it is not necessary to trace them all down to their origins. We will discuss these tricks mainly in terms of pictures and devote the rest of the chapter to them.

Lest you think that we are devoting too much time to space, remember that your visual reality depends almost entirely on your perceiving both empty space and filled space (objects). Without both you wouldn't even have a world. Remember too that on the semiconscious and unconscious levels you are almost constantly preoccupied with space orientation and that one of the purposes of this book is to help you bring this preoccupation into consciousness, where you can work with it. Finally, the very existence of photography depends on both empty and filled space.

## TONAL WEIGHT

A moment ago I said that gravity is one of the primary factors in our ability to perceive reality in the way that we do, Thus weight (your own in particular) is a help. Although pictures don't have weight as solid things do, they have something that substitutes for it adequately: tone. People seem to sense that tones have weight, for example that light tones are light in weight, dark tones heavy, and midtones intermediate. Whatever it is that people sense, it is a fact that pictures usually look better if the darker tones are at the bottom and the lighter ones at the top. That is, the feeling of space and realism is usually better, though that is by no means an absolute.

We orient the tonal weight of a lot of things in this way — rooms, for example. We have white ceilings, medium-tone walls, and darker floors. Clothing is often oriented this way, too. And when we make gray scales in photography we always put the darks at the bottoms. It just seems natural to put light things on top and dark things at the bottom, which probably has to do with our feeling that gravity and space perception

are related. Long experience with the light sky and the dark ground must have something to do with it.

## SPACE AND CAMERA LENSES

Wide-angle, normal, and telephoto lenses do quite different things to space. The normal lens is the only one that seems to "see" approximately the way we do, which is why it is called normal. Since it is so average and everyday in its effects, it is very hard to talk about, just as perception itself is. Discussing the normal lens is somewhat like trying to jump over your own knees. However, wide-angle and telephoto lenses can be talked about easily enough.

A wide-angle lens makes picture space look very wide and deep, though all the objects in the picture come out smaller than usual. Remember that rectangular things and parallel lines look skewed when viewed from an angle — wide-angle lenses strongly emphasize this skew, thus making the space more compulsive. That is, in looking at wide-angle pictures you feel compelled to perceive the space.

If you look at similar things that are at different distances, the one nearby will seem larger. In the way that they are generally used, wide angles often greatly increase the size differential, thus helping to create the feeling of great depth.

People often have the feeling that wide-angle lenses distort perspective, though they actually do not. However, they present us with an unexpected way of seeing things, which we interpret as distortion. It is somewhat like getting a retinal image in which foveal sharpness spreads out to cover the whole retina. Since that never actually happens, we have to guess what it would be like.

The wide angle is especially valuable because it brings space to your attention. As important as space is (both filled and empty) for seeing anything at all, we are ordinarily not very conscious of it. The problem of learning to see is to make yourself conscious of such matters, so the wide-angle lens is a big help. It helps both when looking through the viewfinder and when looking at pictures that have been made with it.

The zoom lens helps by drawing attention to the fact that our eyes, too, zoom and unzoom, so to speak. You might say that we zoom and unzoom our attention and not our eyes, but that is not the whole story. To a large degree perception is surely projective, and we do things that our eyes are not supposed to be able to do. Thus vision actually zooms out to things and unzooms back again. People who have messed with LSD, which I certainly don't recommend, have sometimes found that they could zoom and unzoom very far indeed. A friend told me about counting the eyelashes on a girl sitting all the way across a nightclub floor from him, and I trust the things this man tells me. At any rate, the main value of the zoom lens is that it draws attention to our eyes and how we use them.

**83**

**Figure 6.20.** A scene shot with a 19mm wide-angle lens. It compresses space laterally, so that more things are included in the picutre frame, but at the same time makes pictures seem much more spacious than usual. For example, the boats seem very far away, though they were not.

**Figure 6.21.** Like the 19mm lens, the 200mm also compresses space—front-to-back—but it seems to eliminate most of the space in the scene. A very long telephoto lens or a rather powerful telescope would almost eliminate it altogether.

The same thing is true of the telephoto lens, which is permanently zoomed out. It compresses space from front to back, the degree of compression being dependent on the focal length. That happens when we are projecting our vision outward, but we are usually unaware of it. The telephoto also emphasizes overlap when it is occurring, often using overlap to wipe out the feeling of depth. It makes distant and less distant objects seem to be more nearly the same size, which strongly counteracts the feeling of space. It also makes objects look flatter than they are. Working together, overlap and flatness often lead to pictures in which objects look like flat, cut-paper shapes. Projected foveal vision can also do this kind of thing, but we are not so aware of it.

**84**

You will probably find it useful to consider how your eyes work every time you use a telephoto, wide-angle, or zoom lens, especially if you have a single-lens reflex camera. The first camera lens was copied indirectly from the lens in the eye, so the camera is at least to that extent an analogue of the eye. And photography, from the beginning, has been an intentional analogue of visual perception. Naturally, there are many similarities between how you and photography see. Look into these similarities, because it is good for you. Just thinking about your eyes, in this context or any other, will lead you to observe what you do with them and eventually lead you to learn something about them. Despite their dependence on them, most people know surprisingly little about eyes.

## SELECTIVE FOCUS

Selective focus, which is a special way of playing with pictorial space, is usually done with a telephoto lens, though it sometimes works with a normal lens. Generally, the idea is to get a subject in sharp focus and the background way out of focus. Sometimes, however, we get the foreground or both the foreground and the background out of focus. These effects are obtained by photographing at a large aperture, so that there is little depth of field.

The most common reason for using selective focus is to smooth up a

**Figure 6.22.** In this photo, which was shot between the legs of a statue, selective focus makes it seem that the legs must have been a considerable distance from the hand, but that was not so. Though selective focus does things to space, in this case its contribution is to make a rather strange picture.

background by making it out of focus and at the same time get a good separation between subject and background, thus creating a feeling of space between them. However, the space in the background is usually totally destroyed, so that everything the background seems to be in the same plane. Thus we could say that selective focus creates and destroys space at the same time. We could even call it selective space creation.

It is most useful when a background is so graphically busy that it threatens to overwhelm and obscure the subject. Usually the busyness is caused by many strong and irregular shapes. When the shapes are all out of focus they blend together, sometimes entirely, and lose their strength. That gives the subject a better chance to be seen clearly.

## PHOTOGRAPHIC LIGHTING

Light sources can be manipulated to create a strong illusion of objects and space, to create a moderately strong illusion, or to wipe out the illusion entirely. How such things can be done is the subject of Part Two of this book.

**Figure 6.23.** A tunnel effect, often used in the theater, caused by darkening the edges of the scene. Though the stage is actually very small, the lighting forces you to see a lot of space in the center. It is almost as if a wide-angle lens had been used for this purpose, yet a 50mm was actually used.

## THE TUNNEL EFFECT

Though it works in relatively few pictures, the tunnel effect has long been a favorite with people who like a strong feeling of space in pictures. It is usually created by lighting or by burning in. The idea is to make your pictures look somewhat like a dark tunnel that the eye must travel through in order to see the image. That is, the sides of the picture are quite a bit darker than the center. The notion is that the eye is thereby forced to see deep space. Though the eyes don't actually work this way — they generally hop around all over the place — you do get much more than the usual amount of space feeling.

A few people are so intrigued by the tunnel effect that they only shoot the kinds of picture in which it will work. However, I would call that unduly limiting oneself. As this book should convince you, there are enough space-creation techniques to cover almost any kind of an image — so it doesn't make much sense to concentrate on just one of them.

## BLACK SPACE

Quite a few people are now making pictures in which the blacks and near-blacks function as deep space. Considering that extraterrestrial space *is* black, that shouldn't be surprising. In pictures, however, blacks and near-blacks don't always look like space. In fact, such tones are more likely to look like a dark curtain, fairly close to the viewer, that has been drawn across part of the picture. The truth is that dark tones can either create deep space or severely lessen it.

If you *think* space into your blacks you may get it. This suggestion implies that a photograph is essentially a thought form projected into material reality. At present it is impossible to prove it, but the fact remains that some photographers, who *think* deep black space, seem to get it.

A photographer friend of mine who happens to be a very powerful psychic does this deep space projection thing better than anyone I know of. The subjects in his pictures are so three-dimensional that you always half expect them to step out of the picture area and walk across the room. And his blacks and near-blacks, of which he uses a good many, seem to extend back to infinity. He gets solid-looking objects and deep space because he is constantly thinking of them. Moreover, he has taught some of his students to get as much deep dark space as he does.

There may be other ways to create black space than by thinking about it, but I know of only one — for black-and-white printing. Dodge your highlights and burn in your blacks. It is about that simple. You don't usually do much dodging, but you should *really* burn in the blacks,

**87**

so that *all* the silver is exposed. Then develop for two minutes or slightly more. This trick works very well, but it is no substitute for thinking black space.

**Figure 6.24.** There was a great deal of black space in the original print, but most of it disappeared in the reproduction. However, the picture does make the point that there can be space in blackness.

## CONTRAST PUSH

In the previous chapter I discussed how contrast can be used to push things apart in space. Experienced picture makers often create a contrast push between their prints and the cardboards (usually white) they are to be mounted on. The idea is to make a picture area seem like a window you are looking through. You generally get the effect by burning in both top corners somewhat, then burning in the bottom of the picture. That builds up the edge contrast between the print and the mount board, thus seeming to push the image behind the mount. If you overdo it, however, you may merely attract attention to the print borders and lessen the amount of attention that the image will attract. For most images the technique works quite well, though you shouldn't let it become a habit. In learning to see, you are trying to overcome visual habits, not fall victim to new ones.

## FRAME EFFECTS

One of the main functions of a picture frame is to impart dimension to the image that it surrounds. The frame itself has three-dimensionality, which seems to carry over to the picture. However, if the dimensionality

**Figure 6.25.** The black line around the picture is a frame that adds to the space within it. The window is a frame within a frame that also adds to space.

of a frame is too strong — as it often is in frames designed for paintings — it may have the reverse effect and make a photograph look very flat. Thus it is best to stick to the simple black or aluminum frames that have become traditional for photographs. They are widely available in department and artists' supplies stores.

You can get the effect of frames by printing your pictures with narrow black lines around their image areas or by drawing step-off lines on the mounts around the images. You can also use submounts — usually black, dark gray, or a very toned-down color. In a way they all look like frames and are used for the same pictorial purposes.

# 7 Awaken Your Color Vision

No discussion of the visual cortex and how it creates a visual world would be complete without at least a brief look at the subject of color. Color relates more to your emotions, however, than to the fact that you can perceive objects and space. Indeed, for the perception of visual reality you can get along without chromatic color and rely entirely on black, the grays, and white. You simply don't need the yellows, reds, blues, greens. Your ability to see images clearly in black-and-white photography is clear proof of that. Without chromatic color you can still readily see objects and space in pictures.

Even so, everyone wants to know about color, and it does influence vision, mainly because the the world that we see is colorful. Moreover, color influences space perception, sometimes to a considerable degree. And it gives objects some of the qualities that help us identify them as objects of particular kinds. For example, we know an orange when we see it chiefly because it is orange in color.

There is a serious problem in writing about color, which is that most people see it poorly. The reason is that their eyes are partly asleep, a phenomenon usually called gray adaption. However, the eyes can be

awakened, at least to color. Since it is necessary for you to see color well in order to understand what I wish to tell you about it, I will give you some wake-up exercises that have been used for centuries in the arts. They will fit in nicely with the projects in Part Two, which are also drills (with light) for awakening your eyes.

## A SHORT COLOR VOCABULARY

In order to think about color or discuss it coherently, it is necessary to use some words that we have gotten along without thus far. These words — *value, chroma,* and *hue* — have been used for hundreds of years in all the visual arts. These terms happen to *work,* which explains why they have prevailed. Saying *why* they work would get us into the field of semantics, which is not what we are up to in this book.

*Value*  The value of a color (chromatic or achromatic) is its degree of lightness or darkness, often referred to as its tone (as in "light tone" or "dark tone"). We speak of light colors as having high values, dark colors as having low values. Unfortunately, "tone" is sometimes used to describe hue (as in "a tone of green or blue"), so we must stick with "value" in order to think or communicate clearly.

*Chroma*  The vividness or relative brilliance of a color is its chroma. When used to describe a dye, chroma refers to the degree of saturation with dye particles. The words "chroma" and "chromaticity" are interchangeable. Pink is a low-chroma bluish red. In comparison, the red on the American flag has high chroma.

*Hue*  The name of a color refers to its hue. Thus the hue of a red color is red, the hue of a green color green. All hues can be derived (by pigment or light mixtures) from certain basic hues, which are yellow, red, magenta (bluish red), blue, cyan (greenish blue), and green.

By using these three terms you can describe any color you can name, though the so-called fluorescents can give us a problem by being so terrifically vivid — they run off the scale, so to speak. We will see how the terms work together, starting with black, gray, and white. You must understand that these achromatic tones are just as much colors as are blue, green, and red. Black is a low-value, no-hue color, gray an intermediate-value, no-hue color, and white a high-value, no-hue color.

Still using these terms, the red on our flag might be described as a medium-value, high-chroma red. A pink could be described as a high-value, low-chroma bluish red (or magenta). A bluish gray might be described as a medium-value, low-chroma blue. As you see, the terminology can accurately describe a color in terms of its three main visible characteristics — value, chroma, and hue.

You can get even more accurate color description by fitting the three basic terms into a color-codifying system based on numerical values for the three attributes. Using such a system (there are several available) you could telephone to Bagdad to get a rug of a certain unusual color and be sure of getting exactly what you asked for.

To construct such a system you fit all the possible values (tones) on a 1 to 10, low-to-high value-rating scale, doing the same thing with different chromas and hues. Thus we might find the color of your rug described as 3 value, 9 chroma, 4 magenta, 2 blue, which would make it a dark, rich purple or fuschia. It might burst the rug merchant's eyeballs, but he will deliver the right color.

Color-codifying systems (the Ostwald and the Munsell are two of the best known) are used mainly in the graphic arts and the paint industry, where highly accurate color descriptions are necessary. It is quite unlikely that you will ever need such precision. If you can keep track of the meaning of the three basic attributes of color — value, chroma, and hue — you will be doing quite well enough.

## A UNIVERSAL COLOR WHEEL

Though the three-term color vocabulary will help you a lot, it doesn't go far enough. It doesn't help you keep track of how the various hues relate to one another, and it is hard to relate them in your head. Visualizing low and high value, or low and high chroma, is easy enough, but we need something for the hues in the form of a color wheel, the classic way of handling the problem. You first used one when you were in grade school, but were hardly aware that it has long been a visualizing tool for some of our best artistic and scientific minds.

The universal color wheel (page 93) helps us deal with both colors of light and pigment colors. All of the basic hues are on it, and all other hues can be mixed from them, with either colored lights or pigments. The solid-line triangle joins together the hues of light that can be used for mixing all the other hues. For example, a red spotlight overlapping a green one will produce yellow (truly it will!), and a red spotlight overlapping a blue one will produce magenta. Red, green, and blue are called the *light primaries*. Mixing any two of them will produce the color between them on the color wheel.

The dotted-line triangle connects the three *pigment primaries,* the hues that you can use with paints or dyes to get all the other possible hues. A mixture of any two of these primaries will produce the hue between them on the wheel.

Hues opposite one another on the wheel are called complements or complementaries. Mixing together any pair of opposites will produce a no-hue, no-chroma color such as white, gray, or black. That applies both to pigments and to mixtures of colored light. Hues of light increase in

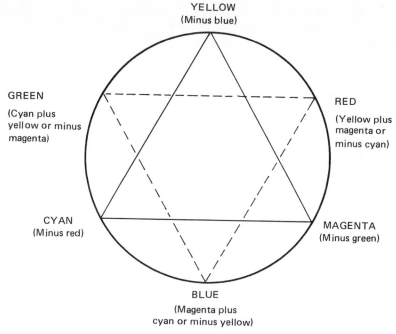

Solid-line triangle: subtractive primaries
Broken-line triangle: additive primaries

**Figure 7.1.** This is called a universal color wheel because it shows both the additive (light) and subtractive (pigment) primaries.

value (get lighter) when they are mixed, whereas hues of paint or dye decrease in value (get darker) — except for the combination of blue and yellow, which produces an intermediate value.

In grade school you were taught that yellow plus blue would produce green but it doesn't. Yellow plus *cyan* (greenish blue) will, however. You and your teachers just didn't know the difference between blue and cyan, which looks blue but is only partly blue.

So now you have the basic color wheel used in both the arts and sciences. Later I will show slight modifications of it and tell you how to use them.

## GRAY ADAPTION: SLEEPING EYES

The main problem in learning to see is to awaken your eyes. It is made immensely more difficult than it should be because you are certain beyond a shadow of a doubt that they *already are* awake.

The technical term for the phenomenon of sleeping eyes is *gray*

*adaption.* Scientists describe it as the habit of seeing a given gray thing as gray, no matter what color the light source used for viewing it — refusing to let it have a hue, persisting in seeing it as gray even when it is reflecting light with color in it.

Gray adaption also refers to the habit of seeing hues, especially grayed ones, as more gray or achromatic than they actually are. That is, our brains "dechromatize" hues, pushing them toward neutral. Science has no explanation of why most people use gray adaption or of how it works. I suspect that the basic problem is that color that has not been mentally grayed in this manner is simply too glorious for average people to cope with — it is too tempting a distraction. In order to get the work of the world done, we find it necessary to put our color awareness partly to sleep. But since you are in this state of sleep, you are in no condition to become aware of what you already know, which is practically everything. The task of recall is doubly difficult because among the sleepers are your eyes, ears, and brains. And ruling so-called consciousness is the ego, which is also profoundly asleep.

Why should your organs be asleep and how did they get that way? They were all put to sleep by your unconscious mind in order to protect your ego. The average ego is a very fragile instrument that is unable to tolerate very much genuine awareness. Too much of it would simply blow the ego's circuits, perhaps permanently. So a kind of daylight sleep (the state of being awake) is the main available protection.

You may think that your eyes are fully awake because you can easily distinguish bright reds, greens, yellows, blues, and so on, but that doesn't mean a thing. These are simply vivid hues for sleepwalkers, recognition signs that will penetrate the deepest sleep. Any sighted person who isn't color blind can recognize them if he has even the sensitivity of a jar of olives. Thus, being able to recognize the bright colors is a skill of no consequence whatever.

People differ very considerably in the degree to which their eyes are awake to color. The majority have eyes that are barely awake at all. However, there is a modest number whose eyes are approximately halfway awake to color, which makes them geniuses compared with everyone else. Your great artists fall in this category. Such people see chromatic color literally *everywhere* — not just in yellow stop signs and red flags for bulls. They see hues even in colors that are assumed to have no hues, that is, in the blacks, grays, and whites.

And they readily see that a given dark brown color may actually be a low-value, yellow, orange, red, or magenta. They see that the color of daylight changes from day to day and is never the same hue twice. And they see all hues as *lively.* In short, they see literally *everything* as having *subtly vibrating chromatic color* — even a white barn, which they may see as yellow, pink, or blue. To them there is really no achromatic (hueless) color.

Some of you will find that your color awareness reaches the halfway point and above, which means that you already have superb talents

compared with the average. But some of you will find that your awareness is sadly lacking. Oddly, the people in both groups will probably reject the findings of the test. You see, it is as enormously difficult to convince some people that they are awake as to convince others that they are sleep. Will the peculiar wonders of human nature ever change?

## COLOR AWARENESS TEST

*Neutrals.* If they want to, people whose eyes are awake can easily see hues in all the colors assumed to be nonchromatic — the blacks, grays, and whites.

1. Can you see hues (chromatic colors) in these neutrals?
2. Can you see the hue differences when viewing them under tungsten light, fluorescent light, skylight, sunlight?
3. Can you see these hues as being quite lively sometimes?

*Dreams.* People who are relatively aware of color usually dream in color and remember the colors they have dreamed.

1. Do you dream in color?
2. Do you often remember the dream colors?

*Stars.* People whose eyes are at least halfway awake often see stars, and color in stars, when others cannot.

1. On a very clear, sunny day can you see stars in the sky?
2. On a very clear night can you see that stars are colored, not merely white?

*Light Streaks.* The awakened eye often sees myriad light streaks, somewhat like sparks from a welder's torch, but faster and in straight lines.

1. Can you see these light streaks almost any time you set your mind to?

*Color Memory.* Memory is largely a function of internal time, and those who have an abundance of this time usually see colors well and remember them easily. Try this simple experiment: gather four or five color samples (bits of fabric, paint samples, pieces cut from magazine reproductions) that are not pure hues but are grayed somewhat. Without looking at the samples once you have collected them, match each of them with a mixture of acrylic color (see the projects that follow). Or go into a big department store and find colors that match,

again not looking at your samples until you have made the matches. In other words, match colors as you remember them to be.

  1. Can you match your samples exactly?

*Color Slides.* Many people assume that the color from projected color slides is too chromatic to be true to nature, but that just isn't so. People with partly awakened color vision see reality this way most or all of the time.

  1. Is your visual reality generally as vivid as a color slide?
  2. Have you suspected that people who can't really see color tend to make pictures that are so vivid that they hurt your eyes? (They do this to attract their own attention.)

*Shimmering.* For people with awakened eyes, color in the environment is often experienced as a kind of subtle vibration or shimmering.

  1. Does color tend to vibrate for you?

*Color TV.* With almost all color TV sets that are in good condition the color can be tuned so that it is either beautiful or ugly.

  1. Have you noticed that most people like to tune their sets ugly?

*Skin Colors.* White skin is actually good for something — use it for tests. It is actually gray (unless it is tanned), as the blacks have been saying all along — gray with a little bit of color in it.

  1. Can you readily identify these very common "white" skin colors: pink gray, violet gray, green gray, bluish pink gray, yellow gray, orange gray, reddish gray?

*Color Reflection.* Tape a sheet of bright red 22" × 28" cardboard to a wall and hold a sheet of white typing paper parallel to it at a distance of four or five inches. You should see that the side nearest the cardboard is a brilliant red. Keeping an eye on that side, slowly back away from the cardboard until you reach a distance of about five feet:

  1. At that distance can you still see the paper as rather obviously tinted with red?

Although the preceding test is simple, it is revealing. If your answers are mostly yeses, it is probable that your eyes are relatively awake to color. If they are all noes, your color awareness is sound asleep and in need of a little prodding which the following projects will give them. You don't need turned-up color awareness for everyday visual perception, but your pictures will be much prettier if you have it, and you can't be a real artist without it.

# PROJECT ONE: COLOR NAMES

Learning to see is to a large degree a language problem, as surprising as that may seem. Words help us decide what things to look for, help us recognize them, and help us focus our attention on them while we decide on their qualities. This first color awareness exercise is a word exercise.

In trying to talk or think *accurately* about color, it is wise to stick with your three-word color vocabulary (value, chroma, and hue) and the six basic hues on the color wheel — yellow, red, magenta, blue, cyan, and green. All possible colors can be described accurately with these terms.

Accurate thinking is highly necessary, and obviously good in its place, but you also need *imaginative* thinking in which accuracy may not be the main point. Most of the color names that we hear in everyday communication show a good deal of imagination — dusty rose, amber, passion pink, mauve, brown, beige, peach, apricot, apple green, and so on — and each color name has certain associations with things in real life that help us remember what it looks like. For example, the color "apricot" looks like the skin of a ripe apricot, and "avocado" looks like the flesh of an avocado — very simple and neat, you see. And also accurate.

The project consists simply of making a large collection of these imaginative color names (everything that is not on your color wheel) and drilling yourself to remember what the things they refer to look like — green apples, for example. You can find the names in the dictionary, in magazines, on cosmetics labels, with paint samples, as descriptions of fabric colors, and so on. Some of the names will be old familiars like mauve and dusty rose, while others will be recent inventions like mango, torture pink, or grandma blue. It doesn't matter: collect them all, and you will be surprised how much this project will do to awaken your color awareness.

*Color Mixing Drills.* In order to truly awaken your eyes you have to confront them with hundreds of colors, which is difficult to do in everyday experience. There just aren't that many colors around when you start looking for them. And when you do find the colors, there is often no way of bringing them home so that you can work with them. These problems can be solved. The thing to do is to mix your own colors with acrylic pigments, which can be bought in tubes from an artists' supplies store. With them you can mix literally thousands of colors, each of them different from all the others. That is precisely what you need for the awakening process.

The idea is not to paint *pictures* with the colors — indeed, you should stoutly refrain from even trying it. Since you are not a painter, you would only be discouraged. The idea is to make a large variety of color

samples, going about it in different ways, and then look at them

carefully. No matter how clumsy you are with artists' tools, you will be able to use them well in the projects.

Though the color drills are a kind of glorified dabbling, somewhat like making mud pies, it would be wise to take them seriously just the same. Painters have been using them for centuries to keep their eyes alert. Since painters have gone far beyond photographers in the color realm, it would make sense to follow their lead. Some of the better color photographers have used such drills, so you see that the idea is not foreign to the photographic art.

Though all of the artists' acrylics on the market are of good quality, I chose Liquitex colors, made by Permanent Pigments, Inc. — mainly because some of their hues fit so well on our color wheel. That is, we can make a good wheel with them. However, if you can't find this brand locally, others (such as Grumbacher) will do quite well. You don't have to buy all the Liquitex colors, because some of them are very much alike. In the list below, Liquitex names are given first, followed by the correct scientific name in parentheses. For example, Liquitex's Acra Violet is generically known as magenta. Purchase only the following:

Cadmium Yellow Light (greenish yellow)
Cadmium Yellow Medium (reddish yellow)
Naphthol Crimson (red)
Acra Violet (magenta)
Ultramarine Blue (blue)
Pthalocyanine Blue (cyan)
Permanent Green (green)
Mars Black (black)
Titanium White (white)
Burnt Umber (a yellow so deep that it looks dark brown)

In order to play with pigments in the fastest and most efficient manner you need adequate working tools:

One long, thin palette knife
One ⅜″ (no. 18) boar-bristle oil painting brush
One ⅜″ (no. 18) sable-hair oil painting brush
Disposable palette (made of oiled paper)
Pad of heavy drawing paper
Black china marker pencil
Paper towels
Large lemonade pitcher for rinse water
500-watt photoflood bulb

The palette knife, which looks like a small and delicate spatula is for mixing colors by smooshing them together on the disposable palette. When throughly mixed, the resulting new color is spread out smoothly on the palette (or on drawing paper) like cake frosting. It looks great!

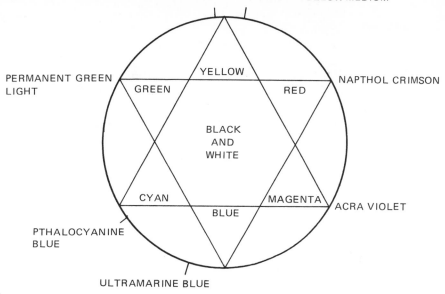

**Figure 7.2.** How the Liquitex colors by Permanent Pigments, Inc., fit on the color wheel. With some colors the fit is only approximate. For example, the Ultramarine Blue has too much cyan in it, and the Cadmium Yellow Light is a little green. Note that the Liquitex hue names don't correspond very well to the scientific names.

Any color at all does! You can also mix colors with a brush, but you have to use much larger quantities (with a palette knife you can use quarter-inch dabs). You also have to wash the brush in water thoroughly before each new mixture, then wash it again immediately after you have applied the paint. If it dries in the brush you won't be able to get it out. You can clean a palette knife, however, by simply wiping it with a dry paper towel.

To see what you are doing with color, you need to work under a proper light source, which is why the photoflood is recommended. Fluorescent light or a low-wattage tungsten bulb would be very bad. Skylight is pretty good, except for the fact that the light color changes from day to day to day. So stick with the 500-watt bulb.

A disposable palette is a pad of about fifty sheets of white waterproof paper. You can do most of your projects right on this pad, where the palette knife works best. When you fill a sheet (not too full!), draw lines with a china marker between the hues that you used to get your various effects. Otherwise, you may not remember because some of your mixtures will be very deceptive in appearance. Then tear off the sheet, saving it for future reference, and start working on a fresh one.

The brushes are for painting patches and squares on the white drawing paper. The boar-bristle one (stiff) is for working with colors

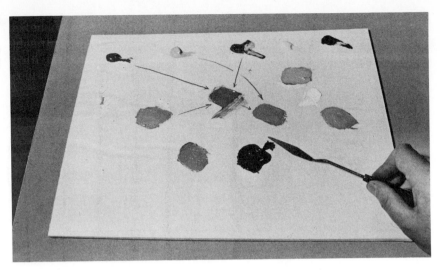

**Figure 7.3.** When you make paint samples on your disposable palette you should use a china marker to indicate which colors were mixed together. Otherwise, you might not remember.

right out of their tubes, when they are rather thick. I recommend that you use them this way nearly all the time. You can paint with your palette knife instead, if you would rather. The sable brush (pliant and soft) is for working with acrylics diluted with water, which then look like good quality watercolors.

When you first see the burnt umber (yellow so deep that it looks like dark brown), it just won't seem to fit in anywhere with the other hues, which are very chromatic. However, it happens to be the purest available low-value yellow, and it is good to accustom yourself to what such a yellow looks like. Burnt umber is also excellent for mixing with other dark hues to reduce their chromas and darken their values. When white is added to such a mixture you can get beautiful low-chroma tints — much like the colors you see on charts of paint samples. You can also get them without burnt umber, but it takes a lot more messing around.

## PROJECT TWO: QUICK PIGMENT CHECK-OUT

When you first get your acrylics it is good to check each one quickly to see what it looks like in value ranging from the pure color all the way up to the most delicate tints. The fastest way is to progressively add more water to a puddle of the pure color, painting a little patch of it on your drawing pad at each step. The idea is to paint a sample for each dilution. Work with your sable brush. If one of the patches gets too sloppy-wet, squeeze out your brush and use it to pick up the excess.

## PROJECT THREE: QUICK MIXTURE CHECK-OUT

For this project use only Cadmium Yellow Light (greenish yellow), Acra Violet (magenta), and Pthalocyanine Blue (cyan). Find out what pairs of these colors will do when mixed together. For example, start out with a small quantity of undiluted magenta and make a series of puddles that contain progressively more undiluted yellow, until the last puddle is undiluted color — pure yellow. Then run a water-dilution check-out (as in Project Two) on each separate puddle. Follow the same procedure with the other two pairs — yellow and cyan and cyan and magenta.

## PROJECT FOUR: COLOR WHEELS

Working with undiluted yellow, magenta, and cyan pigments, make a six-hue color wheel. You will have to use your pigments to mix the missing colors — red, blue, and green.

When you are finished with your first wheel, make another with colors coming straight from the tubes. That is, use pure yellow, red, magenta, blue, cyan, and green pigments. This second wheel should be almost identical to the first one, except that the red, green, and blue will be more chromatic (pure). For example, the blue that you mix won't be as lively as the UltraMarine Blue (blue) from the tube.

## PROJECT FIVE: VALUE SCALES

For this project you will use all of your colors, but don't dilute them. You will be making two-inch color samples on drawing paper, which you can later incorporate in your library of color samples (Project Twelve). Make a square cardboard template to trace around with a pencil to get your squares. When you are painting a square, overlap the pencil lines because the color goes on smoothest this way. When it is dry, use the template to trace the square again, then cut it out with scissors.

To get a paint sample with a very smooth surface, apply the pigment to your paper with a palette knife (your brushes will make a texture, which you may not want). Until you figure out what you are trying to do, you can make small preliminary samples on your palette, again using the knife. You will need a fair amount of pigment to cover a two-inch square, but don't use any more than you have to. You should learn right away to be miserly with your pigments.

Now, working with one hue at a time, make a value scale for each hue. Get the light values by mixing white pigment with a hue, the dark values by mixing black with it. For example, you can make three

or four samples of lightened green by adding white to it, and an equal

number of darkened samples by adding black to the pure hue. With hues that are very dark to begin with, you may have trouble getting more than two darkened samples that look distinctly different from the colors from the tubes — and you won't get many lightened yellow samples, either. When you have finished a value scale for a given hue, the samples should show a gradual change from almost white to black.

The darkened yellow samples will look greenish, but don't let that bother you. The lightened burnt umber samples will give you some very pretty browns. Incidentally, you can speed up the drying of a sample by holding a lit match under it or by holding it close to your 500-watt light bulb, which is very hot.

## PROJECT SIX: TEN-STEP BLACK-AND-WHITE VALUE SCALE

With mixtures of black-and-white acrylic, paint two-inch samples to make a ten-step gray scale ranging from black to white. Although you should be able to make a twenty-step scale, you will probably find that making a ten-step one is a challenge difficult enough for anyone.

## PROJECT SEVEN: COLOR-COMPLEMENTS CHROMA SCALES

Remember that complements (or complementaries) are hues directly across from one another on the color wheel. You can reduce the chroma (or vividness) of a hue by adding some of its complement to it. At the same time, you can also make a chroma scale between two hues, with a neutral color as the middle step. For example, you can have a scale going from magenta to green, with the magenta steps getting progressively less chromatic until you reach gray or black. Then you come to low-chroma green, which gets progressively more chromatic until you come to pure green. Make such a chroma scale for magenta and green and another for red and cyan. You can do that right on your palette if you like — or make two-inch paint samples.

These first two color-complements chroma scales will be so dark that you won't see what is happening very well, so make an additional pair. Start out this time by mixing each of the hues fifty-fifty with white acrylic, then start mixing the complements. You will easily be able to see what you are doing. Furthermore, you will find the colors quite pretty.

In both sets of chroma scales, the dark pair and the light pair, get the grays in the middle as neutral as you can by mixing only complements. That is, use only two hues to get a gray, not three or more. Use the gray samples from Project Six to help tell you how neutral you have gotten the grays made with complements. Frankly, you will find

it hard to mix neutrals, especially with pigments that haven't been lightened with white. However, the difficulty of the task helps awaken your eyes, which makes attempting to mix neutrals especially good for you.

## PROJECT EIGHT: CHROMA SCALE FOR YELLOW AND BLUE

Make a chroma scale similar to the ones for Project Seven. For this scale, start by lightening the blue with white, but use the yellow (Cadmium Yellow Medium) uncut. You should have three or four chroma steps on each side of the gray, which should be as neutral as possible. You will probably find, however, that no matter how hard you try you can't get it neutral enough. After you have exhausted all the possibilities of two hues, try getting it even grayer by adding another hue — either red or green. Don't give up until you have exactly matched the neutrality of a paint sample from your black-and-white gray scale.

By this time you will have decided that there is a good deal more to mixing colors than you had previously supposed. Earlier in the chapter I said some things about being able to see chromatic color in gray; you should now be able to understand that better.

## WHERE YOU ARE

Having come this far with the projects, you are now able to understand some things you previously weren't ready for. For example, you are ready to see that all possible hues can actually be mixed from the six basic hues (the addition of black, gray, or white changes value but not hue). Indeed, you can come pretty close with just three colors — yellow, magenta, and cyan. With colored lights, which you haven't worked with, you can do the whole job with only red, green, and blue.

Surely you have been having a good time with color, just making patches and daubs, and you must have seen how pretty color can be in all of its mixtures. If color weren't so all-fired pretty I wouldn't have given you these projects, because you wouldn't be able to force yourself to do them. As it is, they are lots of fun, though thoroughly exasperating at times.

By now you should also know what it means to see color in tones that most people take to be neutral. Trying to mix neutrals from complements should have helped. In the case of the yellow and blue chroma scale, you should have seen why these Liquitex colors weren't placed exactly across from one another on the color wheel. They aren't quite complements, for complements are hues that can produce a neutral when mixed together. Cadmium Yellow Medium and Ultramarine Blue just won't do that.

Finally, you should now realize that there are virtually countless colors and that all of them can be mixed with the six basic hues plus black, gray, or white.

## PROJECT NINE: COLLECTING COLOR SAMPLES

A part of learning to see is discovering the variety of color samples — paint chips, magazine ads, fabrics, and so on — available in your everyday world. The best learning tool is collecting these color samples. Cut the larger samples into two-inch squares and mount the smaller ones on squares of heavy paper. This project should continue for six months or more — by that time you should have covered the ground very thoroughly.

## PROJECT TEN: MATCHING COLOR SAMPLES

As you are collecting color samples, you should try matching each one with your acrylics. That is particularly important for sample colors that aren't very chromatic — the browns, off-whites, off-grays, and off-blacks. In matching them, you will learn which basic hues they contain (which is often hard to tell) as well as how much white, gray, or black. While you are collecting samples you should also be adding to your dictionary of color names (Project One).

## PROJECT ELEVEN: A LIBRARY OF COLOR SAMPLES

While you are doing these projects you should be making two-inch paint samples of every color that strikes you as being in the least bit different from colors you already have. In other words, start creating a library of color samples, which includes your collection from Project Ten. Shoot for around 400, which is really not all that many when we consider the fact that most people can discriminate about 3,500 colors. It has been said that someone with perfect color vision can discriminate as many as 370,000 though I have never met or heard of such a person.

You will find that constantly adding to this library will do much to awaken your color vision and keep it alert (it can go back to sleep), though the project is essentially mechanical. All of the projects are, in fact, which is one of the reasons why they actually work. They ask you to systematically do things that nearly anyone can do; and the desired increase of color awareness is simply a natural by-product of going through the steps. On the other hand, if I were merely to ask you to awaken your color sensitivity, you wouldn't have the vaguest idea what to do.

# PROJECT TWELVE: CHOOSING COLOR COMBINATIONS

One of the main reasons for assembling an extensive library of color samples is to give yourself lots of color to play with later on. Now that you have them, pick out samples (three or four at a time) that look either good or bad together — the best and the worst combinations. If you have enough samples you can do this for a few minutes every day for months.

Use three colors of paper (white, gray, and black) as temporary backgrounds for your samples, trying each combination out on all three of them. You will find that the background makes a considerable difference in how a given selection looks. For example, one group may look good on white, fair on gray, and excellent on black. Or you might find that a selection looks good on one background and bad on the others. Remember that you are going for both the best and the worst so that you will learn to recognize them.

With each of the background papers, make an arrangement of overlapping samples and see how you like it. Then separate them so that the paper shows between them and see if you like this effect any better. Sometimes you will, sometimes you won't.

In the projects in which you were matching samples, painting chroma scales, and so on, you should have discovered that any color whatever is handsome by itself. You should now learn that colors can look really ugly in certain groupings and that it takes a bit of effort to get a handsome grouping.

The secret to getting good combinations is to avoid sticking to highly chromatic colors. In terms of their basic attributes — value, chroma, and hue — your colors should vary considerably. You need dull colors to go with vivid ones, light values to go with dark, hues that look warm to go with cold hues, and so on.

After a little practice you will be able to make successful combinations of six or more colors — successfully beautiful or successfully ugly, depending on what you are going for. In a fairly short time you will develop a knack for knowing what colors will go with what. Or you may find that you already had the knack.

# PROJECT THIRTEEN: AFTERIMAGES

In the unlikely event that you don't know what an afterimage is, I will tell you. If you stare at a patch of vivid color for quite a while, then look at a white surface, you will see an image that seems to float in front of your eyes. This image will usually (but not always) be the hue complementary to the color you stared at. For example, staring at magenta (Acra Violet) will generally give you green. Oddly, this green afterimage will usually look fairly chromatic, in spite of being lighter

than the white paper — which doesn't seem to make sense, for what color could be lighter than white?

You can get a much darker green afterimage by having the magenta color sample on a black background while you are staring, then looking over at a white surface. For an even darker green, look afterwards at black instead of white. The magenta works best if it is lightened somewhat with white, which will make it look more vivid. Actually, you can get an afterimage with any color whatever, including white, gray, and black, but you have to stare quite a bit longer at neutrals and dull shades or tints.

While you are staring at a vivid sample you will see a bright color fringe around it — the complementary hue. At the same time you can detect what looks like a thin overlay of the complement on top of the sample; it will seem to gray the sample somewhat. This effect shows that you see the original color and its afterimage at the same time, though it is usually thought that one follows after the other, which is also true. Start out with somewhat lightened magenta, because it works best, then try some greens and blues — which you will have to stare at quite a bit longer.

There are several excellent reasons for studying afterimages at considerable length. For one, it gives you an idea of some of the hidden potentials of your eyes. It will also tell you what vibrant color (mentioned in the Color Awareness Test) looks like, in case you don't know.

The best way to see afterimages is to adopt a passive attitude of patient waiting, trying to to think of anything but the images. If you let your mind wander it will simply blind you; it will wipe out your world, so to speak. In learning to see, patience is the chief virtue. Be patient with yourself, and the world will come into your eyes. On the other hand, you may project a world that reflects back to your eyes. Same thing, only different.

The main trouble with afterimages formed by staring at a color sample — whether they are light, dark, or darker — is that they last only two or three seconds. You might try one or more of the following procedures for getting afterimages that last as long as four or five minutes each.

If you have an electronic flash unit, hold it up to your face and flash it in your eyes, then look at a piece of paper, light or dark, and wait patiently for the afterimages. If your surroundings distract your attention so much that you don't notice any images, hold your hand over your eyes so that everything is black. You will see two brilliant hues, sometimes together (with one a fringe around the other), sometimes in sequence. You can do the same thing with flashcubes or bulbs, though you will get different colors. In this case, *be sure to cover the flash with heavy, transparent plastic sheeting (about ⅓ inch) in case the light explodes.*

The afterimage you get with electronic flash is initially a brilliant white, which lasts for a second or two, then turns into a vivid color. It

will be in the form of an image of the flash head itself, which helps you keep track of it in your eyes (it will move around). To change the hues you can put colored filters over the light. However, you may get images of the same color as the filters, which is not what one would expect. In such a case, look at white paper and begin blinking rapidly. With each blink you will get an afterimage that is the hue complementary to the filter.

If you don't have any electronic flash unit there is another way of getting chromatic and enduring afterimages. You cut a one-inch hole in a piece of cardboard and hold it up to a lit photoflood lamp. A few seconds of staring will give you very good images. You can also put color filters over the hole. A cute trick is to use several different cardboards with holes of different shapes — circle, star, triangle, snowflake — with a different color filter taped over each one. Then you can stare at several of them in fairly rapid sequence (about fifteen seconds per stare) and get some fancy overlapped and multicolored images in your head.

I have another trick for you to try: right after flashing into your eyes, cover them with your fingers and press hard until the whole visual field turns light (probably yellow). At this point you will see an afterimage that is coal black. Another trick: as you are watching an afterimage come and go, let your mind wander. You will then find that the image changes color, depending on what you are thinking about.

# 8 Color, Objects, and Space

As I said earlier, color has little to do with our ability to perceive objects and space, and we could get along very well without it. Now I will tell you all that really needs to be said about color in terms of our ability to perceive reality, which will be relatively little.

## THE PROBLEM OF PRETTINESS AND UGLINESS

Color does more to deceive vision than to aid it, chiefly because it can be either very pretty or very ugly. Prettiness and ugliness describe the ability to evoke positive or negative emotional responses, and emotions are notoriously deceiving. They can make us see things that don't even exist and prevent our seeing things that are obvious. Though emotion is an important part of seeing, it is very hard to deal with, mainly because we know so little about what it really is. Emotions aroused by color are hard to think about objectively.

(Before proceeding I wish to remind you that any color seen by itself is pretty, especially on the appropriate neutral background. There can be ugly *combinations* of colors, however, which is another thing. For example, a dull orange and a dull red of about the same value make such a combination. So do a dull medium-value orange and black. Some combinations can be very ugly indeed — and evoke negative emotional responses.)

The problem of being led astray by color is most obvious when you are trying to think coherently about color prints or slides. All you can think of is whether the color is pretty, average, or ugly and whether you like it or not. All of the hundreds of other things you can think about pictures are rather well blocked out of your mind. Color as such tends to dominate all thought, pushing the button that turns off your brain.

In some of the lighting projects in Part Two we get around the problem by photographing neutral-colored subjects with black-and-white films, but you can't always take that way out. Often you have to confront color, but you should never forget how deceptive it is — because of its emotional effect. Color is truly wonderful, no doubt about that, but it is also tricky, especially in color prints and slides.

## COLOR CODING

Color does a few things for perception, and descriptive coding is one of them. Colors help us to identify a lot of things. For example, the five human races are all color coded. So are all foods and all animals and plants. In fact, every natural thing is coded, and we depend on its color to some degree to decide what it is and what condition it is in.

Human artifacts are also coded to a considerable degree: most fire engines and hydrants are red; traditionally, babies have either pink (for girls) or blue (for boys) clothing; artificial raspberry syrup is red; undertakers' limousines are black; and so on. Such coding is done partly for emotional effect, but it can also help us identify things.

## AGGRESSIVE AND PASSIVE COLORS

In terms of their ability to attract and hold attention, some colors are aggressive, others passive. Red and the hues closest to it on the color wheel are aggressive, blue and its neighbors passive. Hues that look highly chromatic are more aggressive than those that appear to have low chroma. In a moment you will see what difference aggressiveness and passivity make.

## WARM AND COLD COLORS

It is traditional to describe some colors as warm and certain others as cold. There are also neutral-temperature colors, which are neither warm nor cold. Red and the adjacent colors are warm, while blue and its neighbors are cold. A room painted a reddish hue will feel warmer than one painted bluish. Yellow, violet, black, gray, and white are neutral-temperature colors. A hue can be warmed by putting red into it, cooled down with blue, or made more neutral with yellow, violet, black, gray, or white.

## ADVANCING AND RECEDING COLORS

Some colors seem to advance, others to recede, and the remainder seem to hold no particular position in space. Because of their aggressiveness in terms of human emotional response, red and reddish colors seem to

**Figure 8.1.** Colors that are red or reddish (magenta and orange) tend to advance; the purer the red, the greater the advance. Colors that are blue or bluish (green and blue violet) tend to recede; the purer the blue, the greater the recession.

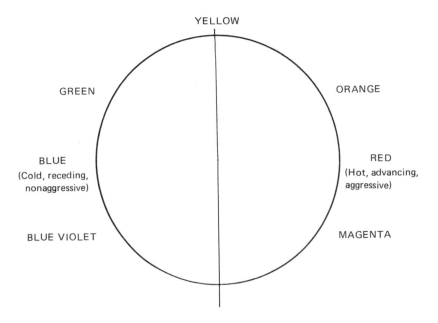

YELLOW

GREEN

ORANGE

BLUE
(Cold, receding,
nonaggressive)

RED
(Hot, advancing,
aggressive)

BLUE VIOLET

MAGENTA

INDIGO (Neutral temperature, neutral aggressiveness axis. The colors on it neither advance nor recede in relationship to other colors of equal chromaticity.)

advance. The passive colors (blue and adjacent hues) seem to recede. Yellow, violet, black, gray, and white aren't locked into any special position in our perceptions of space.

Blue seems distant not only because of its passivity but also because there is a habit factor involved. Atmospheric haze has accustomed us to seeing distant things as bluish, and we become habituated to this situation. Thus seeing blue can push a conditional response button and make us see deeper space than we are actually confronting.

In paintings, completely neutral gray tones won't occupy the space that the painter has in mind for them and form "little spots of anywhere or nowhere" in his pictures. They just won't stay put, so to speak, but float in a space of their own. They are never a problem in photography, however, because in prints and slides all grays have a color cast in them.

In general, colors that seem to have high chroma will advance more than those that appear to be low in chroma. Thus a high-chroma blue can be made to advance, though blue characteristically recedes.

By using *simultaneous contrast* you can make colors either advance or recede more than they ordinarily would. It is like the contrast push mentioned in Chapter 6.

## SIMULTANEOUS CONTRAST

I'm not sure where the name came from, but the term simultaneous contrast is in general use. It refers to the effect that complementary (opposite) hues seem to have on each other. This effect is actually in the eyes of the viewer, of course. We will use magenta and green in an attempt to explain it. If you make a mixture of the two on paper in very small dots (like pepper) you will get a vibrant gray, which is called an "eye mixture." That is, the eye seems to mix the colors thoroughly, even though they are still separate as small dots. In a pigment mixture they are thoroughly blended into one substance, and here, too, the result is gray. The difference is that an eye mixture is vibrant, not usually true of gray.

If you mix dime-sized spots of magenta and green (which you really ought to try for yourself) you get quite a different effect. The hues will seem to be fighting for dominance and may even appear to be moving on the paper. We call this a color clash, and you will see why, once you experience the turmoil. It is especially strong in very chromatic complementary colors that are of the same value. In terms of advancing and receding, both colors appear to be trying to advance at the same time. That is quite obvious with magenta and green, red and cyan, and even blue and yellow. With the latter pair, however, you have to dilute the blue with white to bring it close to yellow in value. Although diluting also reduces the chroma, the effect is still fairly strong.

Oddly, complements can be made to go together better than any

other pairs of colors. The thing to do is get them well separated in value. For example, use a darkened green with a lightened magenta, and if the value contrast is great enough they will go together extremely well. Also the magenta, which is already an advancing color, will advance quite a bit more than it ordinarily would. There is a regular contrast push (see Chapter 6) plus a simultaneous contrast push, the two types of contrast (or difference) working together.

This double contrast push is often used in portrait studios to make figures stand out from backgrounds and to make flesh tones look lively and pretty. Ordinary contrast is sufficient for the first purpose but not for the second. White skin is usually an off-gray, which is easily overwhelmed in a color picture made against a neutral background. But if the background is a soft grayish-blue you get simultaneous contrast, which livens up the warm off-gray of white skins. It also makes skins of a lively brown even more lively. Using a more chromatic blue background would be a bad risk, because it might overwhelm white skin and clash with brown. If you do the projects suggested in the previous chapter you will have ample opportunity to see how simultaneous contrast works in such matters.

Simultaneous contrast is actually an afterimage effect. In the case above, your eye forms a pinkish yellow afterimage from the blue and overlays it on the flesh of the person in the picture, thus making it more vibrant. If the blue is too chromatic the overlay may turn out to be blue, which would kill the skin color of either white or black people, though black skin color is hard to ruin.

Your best opportunity to observe how much color can affect your space perception is to experiment with simultaneous contrast. Colors that are supposed to recede are usually made fairly dark and low in chroma — and it helps if they are receding colors to begin with. Colors that are·supposed to advance are made more chromatic where possible and considerably different in value from the receding complementary colors.

Professional color photographers have over the years made considerable use of the information in this section, although it is quite condensed here.

## ABOUT LIGHT

Though it sometimes doesn't seem to be, this book is entirely about learning to see what light does to things and what things do to light. In talking about color, for example, I have been talking indirectly about light. You see, color *is* light; or we could say more accurately that all color perception is *caused by* light. Furthermore, the only color attributable to an object comes from light reflecting from it, passing through it, or emitted by it.

Let us think of a red apple for a moment. Actually, this apple has no color whatever, nor does any other object. However, the apple absorbs

green and blue wavelengths of light energy and reflects red wavelengths. Some of these red wavelengths enter the eye and fall upon the retina, where they are changed into electrical impulses. The latter are then transmitted to the visual cortex. In the cortex the impulses are used to form the perception of redness, which is an illusion. We assume that this illusion corresponds closely with reality and that there is actually an apple there. However, the apple isn't red; it merely reflects energies that *cause* the perception of redness. Being something is not quite the same thing as being the cause of it.

Because we project our cortical illusions of the apple, however, we are certain that the apple itself has the built-in attribute of redness. Though the apple we see is in our heads, we see it and its presumed redness as outside of ourselves. Because of projection we don't sense the cortical illusions as being illusions. And we sense color as being an attribute of things, which it is not. The perception of color is something that is caused entirely by light. Color is an attribute of light and of nothing else.

## EXPANDING AND SHRINKING COLORS

If you have two identical objects displayed against a neutral background and paint one red and the other blue, the red object will seem somewhat larger — assuming that the two hues are of the same value and chromaticity. It works this way because aggressive or advancing colors have a stronger effect on the eye and seem expansive, whereas passive or receding colors seem to shrink or contract.

Contrast, regular or simultaneous, can also make a colored area seem to expand. For example, a black background will make a bright yellow area seem larger than it is. A very dark magenta will do the same thing for a light and very chromatic green, though green isn't normally expansive.

There is probably little practical reason for knowing about expanding and shrinking colors, but it does no harm to know that color can mislead us concerning the size of things. As I said earlier, color can mislead us in many ways, mainly because combinations of color can be pretty, ugly, or somewhere in between. Thus we can be misled by our emotional responses to color. If you don't believe this, try eating some mashed potatoes that have been dyed purple.

## COLOR-BASED JUDGMENTS

We judge many things according to their color. For example, color can tell us whether a banana is ripe. Skin color can tell us how healthy a white person is. Color can tell us when a white person has spent too

much time in the sun. The color of clothing people wear can tell us whether they see color well. It can also tell us something about their personalities.

We look for certain colors in food and meat, and when they are wrong we are highly suspicious of them. People are very particular about the colors they use in their homes. Every day you probably make one or more judgments based on color, so you see that it has a considerable influence in human affairs.

## COLOR CONSTANCY

Because the color we see in things comes entirely from the light source(s), these things naturally change in color with color changes in the light source. We resist seeing the color changes in objects, however, and this resistance is called color constancy. We tend to see the color of an object as a constant, no matter how the light source changes, although there are limits to our ability to maintain a constancy. For example, in a very chromatic yellow light a blue object will look black, but we will still try to see it as blue if we know that it actually is blue.

People who have learned to see color can overcome color constancy rather easily. They realize that the color of all things is dependent on the colors in the light source. When buying clothing under fluorescent light, for instance, they will look at it under daylight before paying for it. And women can tell whether lights in restaurants and night clubs will be flattering to them. That is, they know that the color of their skins will be changed (no constancy there) and that the change may or may not be good. Such people aren't victims of color constancy, which is simply a habit.

# Photographic Lighting

# A Love Affair with Light

Our finest photographers agree that photography has to be a love affair with light — it has always been that way and always will be. To be a topnotch photographer you must fall in love with that divine substance or wave form that makes photography possible: light. But one doesn't fall in love with something by merely saying presto change-o — there is more to it than that. To be truly in love with light (or anything else) you have to know something about it.

One of the aims of this book is to promote your love affair with light by adding to your information about it. In a general way I have talked about what light does in terms of visual perception, which is entirely a matter of responding in various ways to light patterns. Without light there is no seeing at all — you have read this before, remember? It is such an obvious fact, yet so terribly easy to forget.

Now it is time for you to do lightings, in order to start adding to your knowledge of light, mainly in terms of what it does to the appearance of things. What does light do to things, and what do they do to light? Answering these questions is your big problem, and you can solve it only by making pictures that embody the answers. Any experienced photographer will tell you that it is the hardest part of learning the art.

**117**

## RESPECT FOR LIGHT

A part of loving light is to learn to respect it deeply. Since your life is dependent on light, that wouldn't seem to be a problem — yet it most certainly is. Except for the visual artists and a relatively few others with acute visual sensitivity, practically no one respects light — people just don't think about it at all.

Light is almost always there when you want it. In the daytime it costs absolutely nothing and at night very little. Though it raises hundreds of questions for the astute viewer, most people see no questions at all. Light seems to ask nothing and say nothing. It does everything you want it to do without complaint, and you don't even have to figure out what it is that you want from it. If the thought never crosses your mind, light will still fill your needs.

## RESPECT YOUR OWN EYES

Your direct contact with light comes mainly through your own eyes, of course. If you could fully respect what they can do, it would greatly help you in learning to respect and love light. One of the purposes of this book is to help you fill in the knowledge gap, but it is surely only a start. Other books are available, and you should read them, too.

I suggest two books you might start with, both of them comprehensive, highly readable, and well illustrated. For a general discussion of light, the eye, and visual perception, and to learn how marvelously complex your own vision is, read *Light and Vision* by Conrad G. Mueller, Mae Rudolph, et al. (New York: Time-Life Books, 1972). For a discussion of how to apply a knowledge of vision to photography, read *Eye, Film, and Camera in Color Photography* by Ralph M. Evans (New York: John Wiley and Sons, 1959). You will be astonished at all the ways in which eyes, cameras, and photographic materials relate in their dependency on light. There is also an abundance of material on vision and photography.

In addition to reading, a good way to gather knowledge about the eyes is self-observation. Intentionally set out to make yourself aware nearly all the time of what your eyes are doing. Constantly ask yourself, "What am I doing with my eyes right now?" It will make you self-conscious at first, but you will get over it. Being constantly aware of your eyes when you are with other people is distracting, but you will get used to that, too.

One of the best ways to focus your attention on what your own eyes are doing is to do photographic lightings. The ones covered in this book are excellent for this purpose. However, once you get the idea of how to do them, you should make yourself aware of lightings wherever you

118  happen to be, indoors or out. As you will recall, a <u>lighting</u> is the

geometric relationship between objects and one or more light sources. The objective is to see what effect this relationship has on the way objects and their environment look. In that attempt, your attention is focussed on how you are seeing. To observe the eyes is to keep what you are using them for and how you are doing it. In time develop a healthy respect for the marvels of your own eyes.

## TY OF LIGHT

n for people's indifference to light is that it is so readily in such great abundance. All day long the sun floods the with it as far as eye can see, and at night homes are brightly rtificial light. This abundance breeds indifference. The cave-t have this problem — you may be sure that he adored the ht given off by his small fire, thinking that from sunset to ade the difference between existence and oblivion. And when at his fire he knew for a certainty that he was looking at real bona fide thing.

mend that you imitate the caveman and explore the poverty at was available to him. After dark, turn out all other lights riment with candles, fires, and flashlights. As you will see in ects, they make excellent photographic light sources.

is an old saying in the arts that dark makes light. That means ght tone surrounded by a dark area will look quite a bit than it would if the area were a lighter tone. For example, a e against a medium gray won't look very bright, but against

The enchanting poverty of candlelight converts torso into a magical landscape.

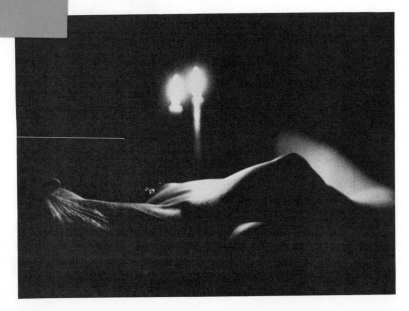

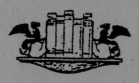

**Figure 9.2.** A single candle makes an architectural detail in a kitchen very handsome and romantic.

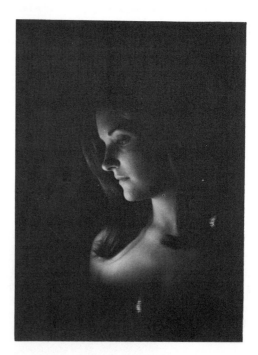

**Figure 9.3.** As anyone can tell you, candlelight is very flattering to a face. The woman is holding a birthday candle in a cup, the rim of which you can barely see.

pitch black it will look very bright indeed. More important, a very light tone against black will tend to look like the ethereal substance that we call LIGHT! In the same way, the light from the caveman's fire was emphasized by the surrounding dark. Light as a tangible thing thus became an important part of his existence.

I suggest that you live part of the time with small light sources such as candles and try to rekindle the awareness of light that was an

120

integral part of the lives of your early forebears. It will help you develop your love affair with light and should be no great burden on you — candles are cheap and a lot of fun.

Remember that becoming aware of light *as* light is a problem that you should solve if you wish to become a good photographer. Ordinarily, you see only *things,* but that is not enough. You should try to develop your awareness to the point where you constantly realize what is actually happening. Your only visual contact with things is the light that they reflect, emit, or transmit. Otherwise, they have no visual existence for you. Seeing a thing means to see light — unless the thing is black. And if it is black, you see it by contrast with its illuminated surroundings. There is always light involved in seeing, however; try to make yourself aware of that. Experimenting with a poverty of light will help you form this awareness. Since candles, flashlights, and fires are excellent photographic light sources you should also use them for making pictures.

## RESPONSIBILITY FOR LIGHT

It is hard to fall in love with light if you feel no responsibility whatever for what it does. If it is just something that is available all the time you won't even think about it, much less see it and feel responsible for what you see. Fortunately, assuming control over light is an easy matter and is best done when you are photographing in a darkened room with a single light source. When you turn this one light on and position it in relationship to a photographic subject, you can be sure that you are responsible for what the light is' doing. You yourself deserve any praise or blame for the appearance of your subject.

Two factors are important: there is only one light source in the room, and you can position it anywhere you like. This total control and the resulting responsibility are precisely what you need in order to learn to really see light. This in turn means that you can learn to see, because seeing and seeing light are the same thing.

When you first take control of your light, you will have an upsetting experience — the quality of your pictures will drop dramatically. I am assuming here that you have been making pictures all along by available light, which is the kind of light that just happens to be there when you are photographing. For photographic purposes, available light is more often good than not. Without even thinking about what it does to your subjects, you can make good pictures. Controlled light is another story — it is usually bad until you make it good. Though that would seem like a good reason for never using controlled light, it is actually a very desirable situation.

Though your own bad pictures are distressing, you can learn a great deal from them. A lighting may be so terrible that you can actually see for yourself what makes it that way, though your seeing as a whole

may not be very good. (Bad lighting is ordinarily hard to see, anyway). Furthermore, you need to know what bad lightings are in order to recognize good ones.

With controlled light you will begin to zero in on what light actually does, helped by having a mixture of well and badly lit pictures to analyze. The bad lightings will help you see the good ones, and vice versa. This part of learning to see takes place mainly when you are printing or making contacts. What you see in a print or contact helps you see better the next time you shoot.

The controlled light experience will help you analyze your available light pictures for the first time and to appreciate what light was doing for you. However, you don't have to yearn for the beauties of available light as if they were friends forever lost — you can always go back to them whenever you like. More important, you can use controlled light to create all the available light effects that you wish. The thing to do is to stick with controlled light until your pictures are even better than they were with available light. Then you will really be getting somewhere.

By this time you should find yourself really falling in love with light, seeing that it can be used for making either wonderful or terrible pictures. The important thing is that you should see many of the things it *does,* both good and bad. And the goodness is always there for you to use as soon as you learn to recognize it for what it is. Seeing what light does gives you a proper basis for caring for it — and caring for it gives you the motivation needed for turning yourself into a good photographer.

## SIMPLICITY AND ECONOMY

In a sense, light is extremely simple — it's just a steady flow of something that falls upon the world as we know it. We could say that it is *visually* simple. The thing that it falls upon, however, can make it extremely complicated by the time it is reflected to our eyes. That is, we may perceive very complex retinal light patterns. In learning to see, you should try to account for these patterns, area by area, in terms of what light does to things and things do to light.

In such a complex situation, the traditional learning method is to simplify things as much as possible and deal with the basics one by one. In photography, the approach is to deal with simple objects at first, then pass on to more complex ones. In looking ahead to the projects, you can see that I have done this simplifying for you. More accurately, the teachers of photography for the last seventy-five years have done it. You see, most of these projects are classics, and many thousands of students have learned from them. From your point of view the important thing is that they really work and will cut as much as a year (or even two) from the time it takes you to learn to see. Furthermore, you will

learn some things from them that you would otherwise never learn at all.

Along with the intentional great simplicity of these projects we have economy. Though it would be easy to spend twenty-five thousand dollars on photographic lighting equipment, you can get along for less than fifty dollars. Furthermore, with your inexpensive outfit you can learn most of what you need to know about seeing light. Having expensive gear won't help you in this respect. In fact, it might slow down the learning process considerably, for there is such a thing as getting lost in your equipment.

I would like to tell you about Eugene Atget and Edward Weston, two of the greatest photographers who ever lived. Both used very simple and cheap equipment. You could outfit either man completely for less than half the cost of a Nikon or Leica. Though they used equipment that most amateurs would sneer at today, they were among the great artists of the ages. Their techniques were also simple, yet very, very effective.

You won't underestimate the complexity of visual perception and the resultant need for simplification in the projects if you read the two excellent books that I told you about earlier in the chapter. In reading them, you will see also that Part One of this book has been greatly simplified — for your benefit, I hope.

## THE PROBLEM OF LAZY EYES

Because they are on automatic most of the time the eyes get very lazy when it comes to performing disciplined tasks in seeing what light is doing. For your love affair with light, this laziness must be overcome because you must learn to see what light is up to. How can you care for something if you don't know what it does?

The eyes like to jump around all the time, seldom holding still for more than a second or two. For ordinary seeing that is perfectly all right, but not for seeing light. Here you must discipline your eyes to hold still long enough to see what light is doing to something that you are looking at. At the same time, ask yourself questions about such things as contrast, separation, the feeling of depth, and the apparent solidity of objects. Since it is hard for a beginner to see these things, and holding the eyes still can be equally hard, the effort can be exhausting. Indeed, it can make you feel as though you have just played a game of professional football. You can learn to put up with the fatigue, however — it is something that all good photographers go through in the beginning.

Such eye fatigue (which is actually ego fatigue) is entirely harmless, but it sometimes frightens people into thinking they are injuring their eyes. We are all very sensitive about possible eye injury, of course.

Though there is no justification for equating fatigue with possible injury, it often leads people to unconsciously avoid the necessity of disciplining their eyes to obey, to make them work instead of constantly playing. When you force your eyes to hold still while you answer questions about what you are looking at, they may suffer some strain, of course, but they can take a great deal of it without suffering even temporary harm. Even if you push yourself into getting painful headaches (which isn't really necessary) you won't get into trouble. It is more a problem with your ego than with your eyes, anyway. So eye discipline is actually ego discipline.

## SHOOTING AND PRINTING

It would be nice if you could simply light a subject and at that point know exactly what you were looking at, but it usually doesn't work out that way. No matter how hard you try to see, there are things that you miss. You can pick them up, however, when you are printing, either from an enlargement or a contact sheet. Though it is best to do your analysis on an enlargement, you can look at a contact with a magnifier and do pretty well.

The things that you learn from prints or contacts carry over into your shooting, so that you tend to repeat successes and avoid repeating mistakes. When a subject is translated into a print, it is simplified considerably, mainly because there are fewer surrounding distractions to lead the eye astray. The print represents just a piece of the whole situation that you confront when you are shooting. Furthermore, it consists entirely of tones caused by light patterns on the subject. With this simplification it is easier to see what light was doing — and easier to get excited about light itself.

It is probably not necessary to tell you that shooting and printing are a part of the same visual process and that experience with either one of them helps you do better with the other. Shooting helps you print — printing helps you shoot. You may go for slides instead of prints, of course, but they can be analyzed in more or less the same way.

I have said that you should have a love affair with light, and it is really not all that hard to do. In fact, it usually comes naturally for people who get involved with photography. When you look at a subject you are seeing light and nothing else, and the same thing is true when you look at a print or slide. If you like pictures you will probably find yourself liking light, too. In an important sense, pictures *are* light.

# 10 Things to Look For: Ways of Looking

When you are making a picture, there are certain questions you should ask yourself concerning the composition and lighting of your subject. These questions can help you decide what you are looking for and in this sense are aids to seeing. For a given subject, you can ask all of them or just a few. After a while you will find yourself asking and answering them automatically, without even thinking about what you are doing.

*Composition.* Are things arranged in an interesting and sensible way? Does the composition hold together, or does it tend to fall apart? Is everything in the scene necessary for what the picture is supposed to say? Is the arrangement graphically coherent? That is, does it "read" right? Is it easy to look at? Does the composition communicate a sense of order?

*Separation or merger.* Do overlapping things seem to separate, or do they merge? What is that doing to the feeling of space in the picture? Is there too much separating or too much merging?

125

*Solidity or flatness.*  Do the objects before the camera look solid or flat (two-dimensional)? What is lighting contributing to either solidity or flatness? Which of these two qualities does this picture seem to call for? Would a compromise between the two be best? How could I modify the lighting to affect this compromise?

*Space.*  Does this arrangement have a feeling of space? Or does it seem two-dimensional? What is light doing to create either space or nonspace? How is composition affecting either space or nonspace? That is, is the geometry of my subject better for creating space or for limiting it? Have I identified all the space illusions (there are usually several)? Is space being warped, reversed, tilted, or falsified in any way? Is there a feeling of "air space" around objects? Does this picture call for a lot of space, no space at all, or something in between?

*Visibility gradient.*  Have I managed matters so that the most important things in my picture will be the most visible? What is composition doing in this respect? What is lighting doing? Have I used selective obscurity (in lighting, composition, cropping, selective focus) to tone down unimportant things so that the important things will show up well? If not, can I obscure certain things while printing (e.g., by burning in)?

*Simplicity or complexity.*  Will my picture have just a few shapes, edges, tones, and textures (simplicity) or a lot of them (complexity)? What is lighting doing to contribute to either simplicity or complexity? Will the picture be simple enough to be boring? Complex enough to be confusing? Or will it be something in between? Which quality would help the picture make its point?

*Graphic clarity.*  When people look at my picture will they see immediately what it is all about? What are subject matter, composition, and lighting contributing to this graphic clarity? Should the point of my picture be somewhat obscure rather than clear? That is, should the picture function at least partly as a puzzle to be studied and solved?

*Beauty or ugliness.*  Will my picture be beautiful, ugly, or something in between? Have I identified all the factors (subject matter, lighting, composition) that might make for beauty? Have I seen where the very same factors are also making for ugliness? Which quality does my picture actually call for? Which specific parts of my image could come out ugly? Which parts beautiful?

*Tonal range.*  Will this picture have a long, medium, or short tonal range? Is this due mainly to lighting or to some other factor? In terms of what I want the picture to do, what kind of tonal range would be best?

*Dynamic or static.* Will my picture be graphically dynamic, static, or something in between? Is that due to subject matter, composition, lighting, or some other factor? Have I identified the dynamic and static areas in this particular picture? What are the factors that make them one way or the other? In terms of what the picture is all about, which quality would be best for it?

*Time, season, and era.* Does this picture have the feeling of a certain time of day and season of the year? Is it in accord with what I am trying to say with the image? What factors are contributing to the feeling of time and season? Is there also a feeling of a certain era (the 1890s, or the 1920s for instance)? What causes this feeling?

*Apparent size.* When my picture is completed, will its subject matter look larger than it actually is, the same size, or smaller? What factors tend to contribute scale or the feeling of size? If I wished to change the scale, how would I go about it (with selection of subject matter, composition, lighting)? Will the scale in the finished picture be appropriate in terms of what I want the image to do?

*Mood.* What mood will this picture have? That is, how will it affect the viewer emotionally? Will he or she tend to be elated, sad, nostalgic, or what? Will the mood be appropriate for what I am trying to accomplish? What particular factors (subject matter, composition, lighting) are contributing to the mood? Will I be able to add to their effect when I am printing the image?

*Lighting contrast.* Is the contrast due specifically to high, medium, or low lighting contrast? What things could I do to make it even higher or lower? Is a contrast change advisable? How does lighting contrast affect the feeling of space in my subject? How does it affect mood? Does it affect how dynamic the picture will be?

*Realness.* Will the finished picture look real, semireal, or unreal? What factors are contributing to that look? On the relative realness scale, will my picture fit where I want it to?

*Light balance.* Is the light on both sides of my subject in balance so that the same tone will be even in the final picture? Do I actually want the sides to balance? Could light imbalance contribute to my awareness of light in my picture?

*Sharp-edge shadows.* What space illusions are they causing? (They nearly always cause some.) Do they seem to be mutilating my subject matter? (They often do.) Is the pattern made by the shadows both interesting and appropriate? Does this pattern contribute to or subtract from my subject? How much do the sharp shadows add to the complexity

of my picture by creating extra shapes? How dark are the shadows? Should they be darker yet or lighter?

*Highlights.*   Do the highlights form a pattern? Is it interesting and appropriate? Is it handsome or ugly? Is there good contrast in the highlights? Are they in the right places? Do they help emphasize the important things in my picture? How much do they contribute to the solidity of objects and the feeling of space?

I remind you that these are questions to ask yourself while you are photographing. At first they won't make much sense to you, but just keep on asking the questions while you are working, and their meaning will gradually seep through to you. If you already knew the answers, there would be no reason for me to give you the questions. Without questions, however, you would not know what to look for.

## TRICKS FOR SEEING BETTER

Seeing a photographic subject well can be a complicated problem, depending mainly on the complexity of the subject itself and the nature of the visual distractions in the environment in which you are working. There is not much you can do about a complex subject except to take extra time in examining it. However, the visual distractions can be blocked out so that they don't confuse your judgment.

*The peep sight trick.*   With one eye closed and your head held stock still, examine your subject through a peep sight made with your fingers. Or you can make a short tube of black paper and use that as the peep sight. This trick blots out environmental distractions and helps you concentrate on your subject and nothing else. While you are using it you can ask yourself any of the questions suggested in this chapter.

*The frame trick.*   Make yourself a little frame of black paper with an opening about 2″ x 3″. With one eye closed look at your subject through it. The frame does about the same thing as the peep sight, so you can ask yourself any of the questions while you are looking through it. It also makes your subject look more like a picture, which helps. Looking through the view finder of your camera will do about the same thing, but the paper frame is somewhat faster to use. One way to use it is in selecting a camera position if your camera is on a tripod, thus saving a lot of time on making tripod adjustments. You can check out a dozen tripod positions with the frame in a matter of seconds.

*The swinging-light trick.*   After you have positioned a light in what seems to be the right position, you can check what it is doing to your subject by swinging it back and forth at a moderate rate. That will

make the shadows move and change size, helping you to concentrate on what they are doing. It is much easier to hold your eyes still when they see movement than when they don't. The swinging also gives you a choice of lightings that are fairly close to being the same. When there are choices, it is much easier to decide on the best lighting. In comparison, give yourself no alternative, and your choice may be the wrong one. When you are swinging a light, your head should be right next to your camera so that you can see what your camera is "seeing."

*The squinting trick.* Squint your eyes so that you are looking through your eyelashes, thus diffusing and blurring things somewhat. Distracting details in your subject will be slightly obscured so that you can see the overall composition and the light and shade pattern better. The trick is also good for seeing light balance and for determining which areas are dominant and which subordinate. Many experienced photographers do a great deal of squinting when they are photographing. While doing it they ask themselves the kinds of questions suggested in this chapter.

*The viewing-filter trick.* Look at your subject through a dark amber or neutral density filter. It will obscure all minor detail so that you can see how the picture as a whole (the composition and lighting pattern) shapes up. This is roughly equivalent to the squinting trick and can help you answer the same questions. Quite a few photographers would never think of shooting without a viewing filter. Some use blue filters, which used to be the favorites.

*The on-and-off trick.* When you are using more than one light on a subject, use this trick every time you add a new light. Turn the additional light on and off a number of times so that you can see how it is changing the light already falling on your subject. This will create a kind of shadow movement on which the eye can easily concentrate. Without this trick it is hard to tell what an additional light does to a subject.

*The one-at-a-time trick.* Check your photographic subject one area at a time when using any of the preceding tricks. That is, mentally break it up into zones and check them individually, for each of them asking the questions I have listed. It will take a while to learn which questions are most appropriate for a given subject, but you will master the art of selection in time. Only experts can check a subject all at once, and even they will often revert to the area trick. While you are still a beginner you should be working on trying to see your subjects as a whole, but back up your seeing each time with an area count.

*The feel-around trick.* Holding your head near the camera position, extend your hand toward your subject as if you were going to feel

around behind it, but do the feeling in your mind. You are trying to see if your subject has a feeling of space in it. Though the space cues are visual, you can feel them in your hand if you learn to exercise your imagination. That is, your sense of sight and your sense of touch can be made to work together. Ask yourself, "With both my eye and my hand do I feel any space here?" Though both seeing with your hand and the space itself are illusional, this trick works very well — if you use your imagination.

*The bag of tricks.*    Ordinarily, you use a mixture of these tricks for a given subject. For example, you may squint when using the peep sight or frame. When using the on-and-off trick you may be either squinting or using a frame. With the feel-around trick you may be squinting. And so on. It will take you a while to get everything sorted out and developed into a modus operandi suitable for your particular personality. However, that will come in time.

At first you will find that the tricks aren't helping you much because you haven't yet learned which questions to ask yourself when you are using them. That is, you still don't know what to look for. One answer is to look for anything that happens to pop into your mind and see if you can see it in your subjects. This is at least a starting point. Another answer is to study this and similar books and gradually figure out what the authors are telling you to do. That is not especially easy, but good photography isn't very easy to learn, either.

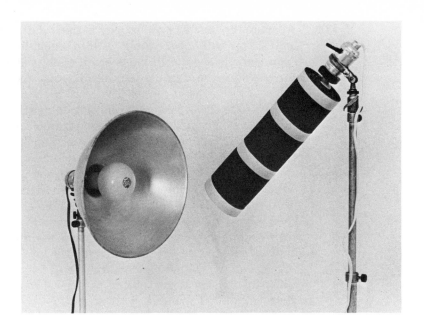

# 11 Basic Equipment

I said earlier that you should use very simple and economical equipment in learning to see light and that seeing light is the most important thing you have to do in becoming a good photographer. However, you can go just so far toward simplicity and economy before you find yourself without adequate tools for doing your work. Fortunately, the photography books and magazines are wrong when they suggest, often indirectly, that you need expensive lighting equipment. It is true that an adequate camera, tripod, and exposure meter are quite expensive, but other things don't have to cost so much. As I said, your total outlay for lighting equipment can be fifty dollars or less. If you are in a school situation where equipment is furnished your personal outlay can be minimal.

## THE WORK PHILOSOPHY

Equipment for lighting projects of any kind should be simple and serviceable. Photographic subjects should also be simple — how this can be managed will be covered in the projects themselves.

131

Part of the teaching philosophy is that what you learn about seeing small things will apply equally well to seeing large ones. For example, if you learn to see a well-made small-scale model of a house, you will also be able to see a real house well. The size doesn't matter that much — appearance is what counts. Therefore we are able to miniaturize our projects, so to speak. You will photograph mostly little things, making for both economy and convenience. For example, it is cheaper and easier to photograph a small white pill bottle than to search for days for a building or other large structure that is its large visual equivalent. And you can learn the same things about seeing from both.

For some of your projects you will be asked to paint your subjects entirely white before photographing them on a white background. When color and tonal differences are eliminated with paint, things are greatly simplified. For such projects your main tools are small, cheap, simple objects, white paper, and a can of white spray paint — nothing complicated. These simple materials will help you learn how light creates the illusion of solid objects and space, among the most important things for you to learn.

Many of things I will ask you to get have uses that extend far beyond the projects in this book. In fact, you might call them basic parts of the photographer's working kit — equipment you will use nearly all of the time.

## THE OMISSION OF ELECTRONIC FLASH

In looking through the basic equipment lists you will see that electronic flash is missing. Though some beginners might see this as a shocking omission, it is actually nothing of the sort. This book is primarily about learning to see light, and electronic flash is extremely bad for this purpose. In fact, you couldn't make a worse start in photography than by making electronic flash your initial lighting equipment. The reason is simple: the flashes are just too brief for you to see what light is doing *while it is doing it.*

Thus you don't see an electronic-flash lighting until your slides come back from the lab or until you make your prints. By then it is entirely too late to correct faulty lightings. In comparison, in working with tungsten lightings you can fiddle with them endlessly before shooting — and in this way you learn to see light. If you are to learn to see light, the light must have considerable duration, and electronic flash simply does not.

## BASIC SHOOTING EQUIPMENT

| | | |
|---|---|---|
| Camera | Tripod | Cartons |
| Close-up lenses | Cable release | |
| Separate exposure meter | Work table | |

*Camera.* Use either a roll-film or a view camera. A roll-film camera should be of the single lens reflex (SLR) type. It can be a 35mm (or 126) size or 120. It should have the following shutter-speed settings (among others): "B" (bulb), 1, 1/2, 1/4, 1/8, and 1/15 seconds. It should have a tripod screw or a provision for attaching one. A built-in meter is generally useful but not nearly as good for the projects as the separate type. The camera should have a cable release socket. A normal lens (about 50mm for a 35mm camera) is desirable. It should be at least as fast as f/4. These requirements add up to quite an expensive camera, so stand warned.

Just about any available view camera will work fine for the projects. Use a normal lens with a speed of at least f/6.3. The shutter should have both "B" and "T" settings and all the slow speeds listed above.

*Close-up lenses.* They enable you to get sharp images of things close to your camera, thus making it possible to photograph small things with an ordinary normal lens. A set of three is recommended — a +1, a +3, and a +5. They can be used separately or combined. Thus the recommended lenses will give you the following magnifications: +1, +3, +4, +5, +6, +8, and +9 (diopters). This will give you a considerable range of distances at which you can work, starting with +9, which will bring you very close to your subject. When using these lenses you don't have to adjust the exposure, and that is very convenient.

Using a macro lens is even better than using close-up lenses but can be rather expensive. Another good bet is a macro-zoom, which is also expensive.

*Separate exposure meter.* Ideally it should be of the super-sensitive type such as the cadmium cell Gossen Luna-Pro, though a less sensitive selenium-cell meter will also work. It should have provision for both incident and reflected light readings.

Built-in meters usually won't work for dim-light readings. Furthermore, they are extremely awkward to use for projects of the type given here. And they don't offer the advantage of meter dials, which are very handy for calculating exposure options for shutter speed and aperture combinations.

*Tripod.* Every serious photographer should have a tripod for indoor work, for dim-light photography in general, and for still lifes such as those in the projects. For a roll-film camera a lightweight tripod will do quite well, though a heavier one would be less subject to vibration. A view camera calls for quite a sturdy tripod.

*Cable release.* A device for releasing the shutter without jiggling the camera. It should be used for all pictures in which a tripod is employed (except for shots in which a self-timer is used). You should get the type of release that has a lock for holding the camera shutter open at the "B" setting.

*Gray card.* A Kodak Gray Card is used for making simple and accurate exposure readings. It is an 8″ × 10″ piece of cardboard that is 18 percent reflectance gray on one side and 90 percent reflectance white on the other. Both sides are used for readings.

*Work table.* A card table or kitchen table is a good size and height, but you can get along with kitchen counter tops, bureau tops, ironing boards, and the like. You make your setups on your work surface.

*Cartons.* It is often handy to make your smaller setups on cardboard boxes sitting on your work table. This raises the height so you don't have to bend over so much when you are choosing a camera angle, cropping, and focusing.

## BASIC LIGHTING EQUIPMENT

Two photoflood bulbs in round reflectors
Two light stands, possibly homemade
One spotlight, homemade
Light cords

Candles
Two flashlights
Light box, homemade

*Photoflood bulbs in round reflectors.* Though rectangular reflectors (often with barndoors) are available, round reflectors without barndoors are better. The cheap clamp-on type is perfectly fine. A ten-inch reflector is about the right size, though a somewhat larger or smaller one would also be all right. Use 500-watt photoflood bulbs, though the 250-watt size is also good. The average household circuit will readily handle three 500-watt bulbs, but you will use a maximum of two for the projects.

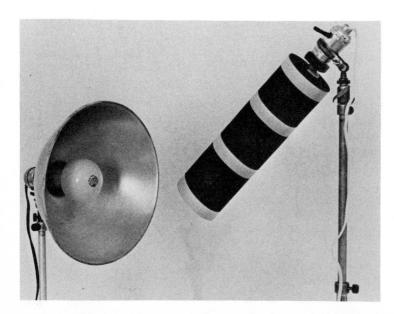

**Figure 11.1.** Two basic pieces of lighting equipment: an inexpensive photoflood reflector and a homemade spotlight made of heavy paper taped around a light bulb, both on lightweight portable stands. The photoflood is used nearly all the time, the spotlight occasionally.

*Light stands.* Lightweight folding portable stands are very nice if you can afford them. However, you can make stands for less money. All you need is a long stick for a standard and some kind of base to hold it securely. Then you can attach a clamp-on light to the stick at any position you like. This is not the best kind of rig, but it works reasonably well. The easiest base to use is probably a Christmas-tree stand.

*Spotlight.* Though a spotlight is nice to have, you will find you don't use it very much. Since they are quite expensive, there is no point in buying one. You can make one by taping a long cylinder of heavy black paper around an ordinary light bulb, say 60 watts. To make a reflector for a hotter light bulb, use a tall juice can — or solder two together. Though it will burn pretty hot, you can use a 500-watt bulb in it.

*Light cords.* For the projects you can use ordinary household light cords. If you intend to shoot color eventually with your lights, you should use a heavy-gauge wire because a lighter gauge will drop the color temperature of your bulbs. Ask at the hardware store what gauge you should use for a 500-watt bulb. For black-and-white projects a drop in color temperature simply doesn't matter.

*Candles.* Buy a half dozen ordinary candles and three or four boxes of the kind you put on birthday cakes.

*Flashlights.* Buy one that takes either two or three D batteries and a penlight that takes two AA cells. Instructions will be given later for converting them into miniature spotlights.

*Light box.* You can make a small one by setting an 8″ x 10″ piece of opal or milk glass in the top of a cardboard carton, then putting a light bulb inside. A larger wooden box can be used for fluorescent tubes. Use a heavy sheet of opalescent plastic.
    Though a light box does nice things for illuminating small objects, it is a piece of lighting equipment that you can usually get along without.

## OTHER BASIC SUPPLIES

| | |
|---|---|
| Background papers or cardboards | White and black spray-can paint |
| Light reflectors, white cardboard | Masking tape |
| Light absorbers, black cardboard | Two plastic photocubes |
| Fine sand | Miscellaneous small items to paint |
| Cheap flour sifter | and photograph |

*Background papers or cardboards.* You can buy these at an art supplies store. Get the largest sheets available in white, gray and

black. These sheets are for putting under or behind your photographic subjects.

*Light reflectors.* 16″ x 20″ white mount boards make very good reflectors. They are used for reducing lighting contrast and for illuminating poorly lit areas of a subject.

*Light absorbers.* Black 16″ x 20″ mount boards are very good for this. They are used to absorb light that you don't want reflected into a subject.

*Sand.* Though you can get along without it, sand is extremely handy for making still-life setups. Buy a carton of it from a sand and gravel company.

*Flour sifter.* Used for cleaning bits of foreign matter out of your sand.

*White and black spray-can paint.* Used for preparing the subjects for some of the projects. It should be matte rather than glossy.

*Masking tape.* Very useful stuff when you are making setups.

*Plastic cubes.* For our purposes, the best kind contains a plastic sponge and has an open bottom. In the other type, the seams show too badly after painting.

As you can see, the lists of basic equipment and supplies are not very extensive. Even so, it will take you a while to assemble everything, because you have to go different places to get the individual items. The shooting and lighting things should be a part of your basic equipment if you want to be a photographer. Though you can get by in the medium with nothing but a camera, you restrict yourself unduly this way.

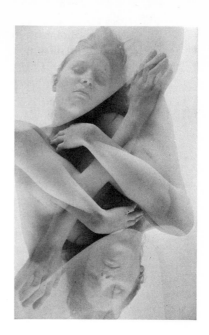

# 12 Exposure Determination

Since this text is designed primarily for intermediate students of photography, I have assumed that you already have a pretty good idea of what photography is all about. You could probably profit from a review on exposure, however, so I will provide one.

## EXPOSURE

A photographic image is created by exposing a light-sensitive material to light, causing a subtle change in some of the silver halide crystals in the material's emulsion. This process forms a latent image, which is capable of becoming visible when the material is given normal development.

Any combination of light and time will give you an exposure, but the *correct* exposure is another matter. It is the particular amount of light (light intensity × time) that will produce an image of the desired density (degree of lightness or darkness). Thus for a given type of image, there is only one correct exposure. Everything else is either **137** underexposure or overexposure. Though a slight variation is permissi-

ble, photographers always try to hit the correct exposure right on the nose. The amount of exposure required by a material depends on its light sensitivity or speed.

## FILM SPEED

For a given photographic subject, various types of film require different amounts of exposure, depending on their speed. For example, an exposure that is right for Tri-K film (high speed) would be entirely inadequate for Panatomic-X (slow speed).

Film speeds are standardized according to the so-called ASA system, with numerical differences accurately describing speed or sensitivity differences. Thus an ASA 400 film is twice as fast as an ASA 200 film and four times as fast as an ASA 100 one.

## EXPOSURE METERS

An exposure meter is a device for measuring light intensity. It also incorporates a minicomputer so that you can set film speed on it and find the correct exposure for a particular film at the measured intensity. The higher the film speed the less the required amount of exposure and vice versa.

Separate meters can usually be used for reading either reflected or incident light. In a reflected reading you point your meter at your subject and read the light reflected from it. For an incident reading you point the meter at the light source and read its intensity. Built-in meters are all of the reflectance type.

## THE AVERAGE TONE

Most photographic subjects have a tonal range from light to dark, often with a tone in between the extremes that represents the average. Long experience has shown that this average tone usually comes from something that reflects 18 percent of the light falling upon it. For convenience it is referred to as an 18 percent reflectance gray, though in most subjects it is actually a chromatic color. The important thing to understand is that, colored or not, it reflects an average amount of light and is thus in the middle as far as tones go.

For a reflectance reading, you try to find this average tone in a subject and take your reading from it. That will give you the correct exposure. If this tone is missing, you can supply it yourself in the form of a Kodak Gray Card, which reflects 18 percent of the light that falls upon it. Then you read your gray card instead of your subject.

In an incident reading, the 18 percent idea is programmed into the meter. Thus by reading the light source from a position near your subject, you get the correct exposure based on a part of it that is reflecting 18 percent of the light. Even if this tone is missing in your subject, you get a reading for it. Furthermore, you generally get the correct exposure.

## REFLECTANCE READINGS: BRIGHTNESS-RANGE METHOD

The important thing in a reflectance reading is to read only your subject and not the background, though you can read both if they are of the same tone. If you include a dark background in your reading you will overexpose your subject. Including a light background will lead to underexposure. These problems can be avoided if you hold the meter — either separate or built-in — close enough to your subject to shut out the background.

Outdoors, the important thing is not to include the sky in your readings. If it is bright, it will lead you to underexpose. Either point your meter at the ground or bring it close to your subject. Indoors, avoid including light sources in your readings; read only the subject itself.

We have seen that you should take your readings from an average tone. Outdoors, grass is about the right tone, so you can usually take your reading from it. However, there may be no average tone, and you may have to determine it indirectly, which you can do with the brightness-range method. For this method, examine your subject and read both the darkest important tone and the lightest, then average them. The average represents the missing 18 percent gray closely enough for practical purposes. Use the exposure figure you get for this average tone.

The darkest important tone is the darkest area in which you want your picture to have shadow detail. Similarly, the lightest important tone is the lighest area in which you want highlight detail. There is no point in metering extremely dark shadows or extremely bright highlights because in both cases the details will be lost anyway.

Other kinds of reflectance readings will be discussed below under separate headings.

## GRAY-CARD READINGS

We have seen that a gray card can be substituted for the average tone of a subject and used for making exposure readings. This is one of the most dependable methods for exposure determination. There are a couple of tricks to know, however. For example, the intensity of the light falling upon the card must be exactly the same as that falling

upon the subject. In a still-life setup you can handle this by putting the card right in the scene for the reading. Then use the reading for making your exposure.

The way the card is angled and tilted radically affects the amount of light that it reflects. If the light is coming from directly behind your camera, face the card directly toward it — which will also have it facing the light source. If the light is striking your subject at an angle, which is usually the case, face the card so that it is aimed halfway between the light source and the camera. This almost always works just fine.

If your subject is dramatically lighted and has large and strong dark areas, go about the tilting and angling in another way. Close one eye and sight over the card as if it were a rifle sight, lining it up with your subject. Then tilt and/or angle it until its degree of grayness seems to be the average of the tones that you see in the subject itself. Then take your reading from it. As you will see, tilting and angling will change the tone of the card considerably — you can make it look light, dark, or just average.

In either gray-card method the tilting and angling are very important, and failing to do them correctly can lead to serious over- or underexposure. It is easy enough to get them right, however, and the methods are very dependable.

## HAND READINGS

The skin of the average palm reflects 36 percent of the light falling upon it. Knowing this, you can use your palm as if it were a gray card, holding it in front of a subject and taking a reading from it. Double the amount of exposure that your reading gives you.

You can also tilt your palm until it matches the average tone of your subject (it will get quite dark if you face it downward; then read it. In this case don't double the exposure but use the reading directly.

## SUBSTITUTE READINGS

In some cases it is inconvenient or impossible to take direct reflectance readings from subjects. For example, they may be too far away or too small. The solution is to read a substitute that has the same average tone as your subject. Sight over your substitute — which may be a piece of paper, your hand, or some other object — and line it up with your subject. Tilt it and/or angle it until there is a tonal match with the average subject tone; then take your reading. We have already discussed this method in terms of sighting over a gray card or your palm. It is all right if there are entirely different lightings on the subject and the

substitute, or if they are naturally different in tone. All that matters is the tonal match when you line them up. If the tones match, the same exposure will be right for both subject and substitute, even if they are a hundred yards apart or the subject is too small to read directly.

## WHITE-CARD READINGS

If your meter is not very sensitive or the light is too dim, your reflectance readings — gray card or some other kind — may be too low. That is, the meter needle may hardly move, thus giving a reading that is not dependable. In this case you can read the white side of your Kodak Gray Card, which will often give the needle quite a boost.

Because white reflects five times as much light as the average gray, using the white side could lead to serious underexposure of everything darker than white. You take this into consideration, however, before you set the film speed on the meter. Simply divide the speed by five to get a special white-card speed and set that on your meter. Then use the white card just as if it were a gray card, using the indicated exposures directly.

## BUILT-IN METERS

All the foregoing reflectance-reading techniques will work with meters that are built into cameras. Indeed, you can remove your camera from the tripod and use it as if it were an exposure meter, though it is quite inconvenient to do so. Separate meters are much more convenient for still-life work, but you can get along without one if you have to.

## INCIDENT-LIGHT READINGS

If you can't quite make up your mind what you are doing when you try to determine the correct exposure, an incident reading is your best bet. For reasons we needn't go into, it is the most dependable method. Since the meter's operation is based on the average gray tone you don't have to go looking for an average tone to take a reading from. In fact, you read the light source instead, which is a very easy thing to do.

If the light source is directly behind the camera, point the incident-light sphere right at it. If the light hits your subject at an angle, point the meter halfway between the light source and your camera. As you can see, the aiming procedures are the same as with a gray card. Usually, gray-card and incident readings will be identical because both the meter and the card use the 18 percent reflectance-gray idea.

The only trick to using an incident meter is to make sure that the light striking the meter is of the same intensity as that striking your subject. There can be two different light sources — one for the subject and the other for your meter — as long as their intensities are the same.

With very even lighting, such as daylight, your meter doesn't even have to be close to your subject — you can safely assume that both are receiving the same amount of light. With indoor lightings, which are more likely to be uneven, it is best to hold the meter right in front of the subject and point it halfway between the camera and the light source. When doing a still life, you can often hold the meter in the middle of the setup.

Using the average-gray idea with an incident meter usually works very well, but not always. Sometimes you get a subject that is colored much darker or much lighter than the average gray, which throws off the exposure. For example, an incident reading for a lump of coal would lead to considerable underexposure. Likewise, a snow bank would be overexposed. When subjects are quite a bit too light or too dark to be called average, it is best to use a reflectance reading. Bracketing the exposure from an incident reading works well, too.

## EXPOSURE BRACKETING

Even with the number of metering methods just described, all of which are excellent, it is sometimes hard to figure out what the exposure ought to be. That is expecially true if the lighting on your subject is very tricky or offbeat. In such a case it is best to bracket your exposures if your subject will give you time to do it. Since a still-life subject is going nowhere and doing nothing, you have all the time in the world.

To bracket means to make a series of exposures around the one you think is most likely to be correct, which is usually called the normal exposure. For example, you might shoot two overexposures, a normal exposure, and two overexposures. Shoot them one stop apart. That is, starting with the greatest underexposure, the exposures should progressively double.

The idea of bracketing is that if the so-called normal exposure turns out to be wrong, one of the other exposures is highly likely to be correct. It is the most sure-fire way of getting the correct exposure and is frequently used by professionals, who can't afford to miss. Therefore, I suggest that you do it on all or most of your still-life projects.

You may think that bracketing is wasteful of film — and it is, of course. However, you should make a practice of thinking of film as very expendable and cheap, especially if you intend to be a professional. In contrast, being stingy with film is a fairly sure way of getting yourself into trouble.

# EXPOSURE CORRECTIONS FOR THE RECIPROCITY EFFECT

The speed of film may drop radically if the exposure times are one second or longer. Knowing this, you can compensate by adding extra time. Making this adjustment is called compensating for the reciprocity effect, which needn't be explained here. The only thing that you really need to know is how much the film is slowed down during long exposure times. This slowdown can be described in terms of necessary exposure time increases.

The film-speed drop varies according to the type of film, some films slowing down more than others. The correction figures in Chart 12.1 apply to regular Kodak films such as Tri-X Pan, Plus-X Pan, Verichrome Pan, Panatomic-X, Royal-X Pan, and 2475 Recording Film. For other types of film you would need different figures.

Indicated exposure times are those you get from your meter after taking readings. That is, the meter indicates the exposure you can use, but it doesn't take the reciprocity effect into consideration. Adjusted times are the ones you actually use in making your pictures, of course. Though some of them seem very long (e.g., 40 seconds) you will not overexpose your film when you use them. Indeed, if you fail to use them, you will underexpose quite badly.

Chart 12.1
Compensations for the reciprocity effect

| Indicated exposure times | 1 2 3 4 5 6 7 8 9 10 sec |
|---|---|
| Adjusted exposure times | 2 5 8 10 13 18 20 25 32 40 sec |

## TRI-X PAN

For the projects in this book I recommend that you use Kodak Tri-X Pan, a fast (ASA 400) fine-grain film with relatively low contrast and considerable exposure latitude. Though fast films often have coarse grain, Tri-X does not. Some films have finer grain (e.g., Panatomic-X) but much less exposure latitude, and the latter is very useful to have for the projects.

Exposure latitude, usually expressed in stops, refers to how far you can miss the exposure without a significant drop in image quality. The permissible latitude for Tri-X is about two stops. That means, roughly, that you can be either over- or underexposed by about one stop, though it is safer to be overexposed. This is quite a long latitude. If a moderate

**143**  drop in image quality is acceptable, the latitude is somewhat longer.

Exposure latitude such as that of Tri-X makes it possible to get acceptable pictures even if your exposures aren't right on the button. It also means that in high-contrast subjects you can get detail in the shadows and still have printable highlights. An additional aid in this respect is the fact that normally developed Tri-X is a relatively low-contrast film. That is, it compresses considerably the tones of the subject when it records them — Tri-X goes further than most films in this respect. Thus the tones of a relatively high-contrast subject can be compressed sufficiently for all of them to be printable. With a high-contrast film, you would either lose the shadow detail or block up the highlights.

Though this chapter on exposure has been brief, it should provide an adequate review of the subject. With most of your projects you can do exposure bracketing, which will almost guarantee success. Remember that the professional attitude toward film is that it is very cheap.

# 13 A Glossary of Lighting Terms

In order to think about something, you need words or terms to hang your thoughts on. I am now asking you to think about lightings and herewith offer you the words most often used to talk about them. They will give you some ideas concerning light sources and lightings and what people do with them. They will also help you understand things you read or hear about lighting.

*Available light.*   Common term denoting light from sources not furnished by the photographer. The light that happens to be there when you decide to photograph. A relatively low level of light is usually implied. In recent years available light has been found to be very good for photography. Indeed, it is often better than light fully under the photographer's control.

*Baby.*   A small spotlight, often used in portraiture for making the hair lighter or in still life photography for lightening a small area of a setup.

*Background.*   The area behind a photographic subject. Compared with the subject it is usually subdued and static and is often empty (as

in the case of a background paper or wall). The background is nearly always used as a foil for the subject; its purpose is to make the subject look good.

*Background light.* A small lamp used in portraiture to lighten the background immediately behind the subject's shoulders. It gives a feeling of air space in the picture.

**Figure 13.1.** The *background light* behind this woman's shoulder adds a little three-dimensionality to the picture. The picture is a little grotesque, but don't let that throw you.

*Background projector.* A device used to project an image onto a translucent screen so that objects photographed in front of the screen appear to be on location. This procedure is called rear projection.

*Back lighting.* (1) Lighting that originates from behind the subject or opposite the camera position. (2) The illumination of translucent or transparent objects from behind. Also called transillumination.

*Balanced lighting.* (1) Implying that the lighting contrast of a scene or setup is such that satisfactory detail can be retained in both the shadow and highlight areas of the photograph. (2) In color photography the matching of different light sources as to color temperature.

*Bank light.* A cluster of lights arranged in a shallow box to function as a single larger unit. The front of the box is covered with a translucent material to diffuse the lights. The bank light approximates skylight and is popular with advertising photographers.

*Bare bulb.* Refers to the technique of using a flash bulb (or tungsten light, etc.) without a reflector, thus producing a mixture of direct light and bounce light. The subject will have distinct but not dark shadows.

*Barndoor.* An adjustable blinder for a studio light, used to cut down

**Figure 13.2** Makeshift *barndoor* taped to a photoflood reflector—handy device in photographic lighting.

the area of the light pattern. With two barndoors on each light the pattern can be limited to a narrow band if desired.

*Boom.* An adjustable horizontal rod, often counterweighted, attached to the top of a light stand and generally used as the support area for a small spotlight. A boom is very useful when it is necessary to have maximum flexibility in placing a light source.

*Bounce light.* Diffuse illumination produced by aiming a light source at a reflecting surface rather than at the subject. Commonly used with flash, electronic flash, and photofloods to produce the illusion of natural (available, existing) light. Walls and ceilings are commonly used as reflectors, though smaller surfaces will also work.

*Brightness.* The relative lightness or darkness of something, usually a surface.

*Brightness range.* (1) The visually perceived relationship between the lightest and darkest areas of a scene or subject. (2) A method of using a reflectance-type exposure meter in which the lightest and darkest areas of interest are read and the calculator indicator set midway between the two readings.

*Broad light.* (1) A light source that spreads diffuse light over a relatively large angle, for example, a photoflood bulb in a relatively large reflector. (2) A lighting unit that contains two or more incandescent lamps in one large reflector, used to produce relatively intense diffuse illumination.

*Broad lighting.* A type of portrait lighting in which the pose is three-quarter front. The main light is positioned to illuminate the side of the face nearest the camera (the broad side), thereby projecting the nose shadow onto the far side. Used for lighting very thin faces, because it makes them appear fuller.

*Broad source.* (1) A light source that spreads light over a relatively large angle, as does a broad light. (2) A source that is itself broad, such as the open sky on an overcast day or a wall that becomes a source

when used for bounce lighting. A broad source typically casts shadows that are very soft, sometimes hardly even discernible.

*Butterfly lighting.*  A type of portrait lighting in which the main light is positioned right in front of and somewhat above the subject's head, thereby projecting a nose shadow onto the upper lip. This shadow is shaped somewhat like a butterfly. Also called high front lighting.

*Butterfly shadows.*  An effect obtained when an object is lit by lights of nearly equal intensity from opposite sides of the camera, so that symmetrical shadows are formed on the background. The shadows can be perceived as wings that are attached to the object. Similarly, two nose shadows can be created on a face, though that is usually considered undesirable.

*Chiaroscuro.*  The not always obvious pattern of light and shade in a picture. If the pattern is strongly defined, the picture is said to have heavy chiaroscuro, which often contributes to a three-dimensional appearance.

*Clamp.*  A mechanical gripping device typically used for supporting a light source or camera.

*Clamp-on.*  An inexpensive photographic light source that has a grippling device or clamp built into it so that it can be attached to a door, chair, stick, pipe, or such, thus eliminating the need for a light stand. Often called a clamp-on photoflood.

*Contrast.*  (1) Difference. (2) The tonal or value difference between things, usually described as high contrast (large difference), medium contrast (moderate difference), or low contrast (little tonal difference). Applies to photographic subjects, lightings, films, papers, developers, and the like. In any of these areas contrast can be manipulated.

*Contrasty.*  Applies to a scene or image in which contrast is greater than normal. Also applies to factors producing such an effect, e.g., lighting, film development, paper grade.

**Figure 13.3.**  A very *contrasty* picture made by photographing the scene on Kodalith film, which has very high contrast.

*Cookaloris.* A piece of opaque or translucent material used in front of a light source for the purpose of creating a design of light and shade on the background or some other surface. For example, one might duplicate the shadow pattern cast by sunlit leaves. Syn: cukaloris, cookie.

*Cross lighting.* Illuminating a subject from one side as distinct from front lighting and back lighting. You can also illuminate it from both sides and call this double cross lighting if you wish. Cross lighting tends to give more of a feeling of object solidity and space than other lightings do.

*Dark.* (1) Without light. (2) The perceived quality of a material of high light absorptance, e.g., a black object or an excessively dense photographic image. (3) The quality of deep shadows. (4) A quality of tone in which visibility is poor or nonexistent.

*Diffuse.* Applied to light that is reflected from a nonspecular surface (not mirrorlike) or transmitted by a translucent material. Such light is scattered rather than collimated.

*Dodger.* An opaque object, usually a round piece of cardboard on a wire, that can be used for holding light back from an area of a print while it is being exposed. A similar device can be used when lighting a scene or setup, where it is then called a head screen or gobo.

*Dulling spray.* A transparent liquid that dries quickly with a matte finish when applied to an object with an atomizer. Usually applied to polished metal objects to reduce glare and reflections. Often used when it is not convenient to make a tent, which is another way of solving the glare and reflections problem.

*Edge light.* (1) The light projected by the edge of a light source. (2) To light something by aiming the light source in front of or behind it, so that only the edge of the light pattern falls upon it. Typically used for controlling lighting contrast and for better rendition of tones. In tungsten-light portraiture it also lessens the amount of heat and glare affecting the subject.

*Electronic flash.* A light source in which a high-intensity, short-duration flash is induced by passing an electrical current through an inert gas such as xenon. The flash tube can be used for many flashes. Mainly needed for freezing movement in subjects and for canceling the effect of camera movement. The high intensity makes possible the use of relatively small aperture settings. Electronic flash is not recommended for beginners in photography, even though they commonly use it.

**150**  *Existing light.*   See Available light.

*Feather.*   To edge a light source, i.e., light a subject with only the edge of the light pattern.

*Fill light.*   A light source or reflector used to lighten the shadows created by the main light, thereby reducing the lighting contrast. The fill light opens up the shadows, so to speak, making them more visible.

*Flat:*   (1) Having contrast that is lower than normal; variously applied to subjects, lightings, negatives, prints, etc. (2) A vertical panel, usually moveable, used in studios as a background, wall, or reflector.

*Floodlight:*   A light fixture designed to hold an incandescent lamp, electronic flash tube, or other source of light and to reflect the light diffusely over a relatively large angle. Additional diffuseness is obtained by using an opaque deflector or a translucent diffuser in front of the lamp.

*Form shadow:*   A darkening on the surface of an object as it turns away from the light source. Though not a darkening in the usual sense of being a cast shadow, it is nonetheless a shadow. Like cast shadows its tone may be anything from fairly light to extremely dark. Sharp-edge form shadows are created by small light sources, soft-edge ones by large sources.

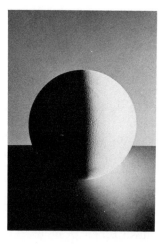

**Figure 13.4.**  The dark tone on the ball is a *form* shadow (as distinguished from a *cast* shadow).

*Front lighting:*   Subject illumination that originates from the general direction of the camera, as opposed to side lighting and back lighting. In portraiture, the light is pointed squarely at the frontal part of the

subject's face, while the subject faces the camera. If the light is high on its standard it is called high front lighting — if low on the standard, low front lighting.

*Front projection:*   Projecting an image from the camera position onto a screen behind a photographic subject, as distinct from rear projection, where the projector is behind the screen. A partially transmitting mirror is positioned at a 45 degree angle in front of the camera lens and the image projected onto it so that the shadows cast by the subject and the projector light are concealed by the subject and thus not visible from the camera position. The subject is lighted separately, and the relatively low-intensity projected image is not noticable on it.

*Glare.*   (1) Intense light. (2) Identifies a specular (mirrorlike) reflection as distinct from a diffuse reflection. A small, intense light source will produce flare on smooth glass or polished metal, and sometimes larger ones will, too. Glare may cause lens flare.

*Gobo.*   A small panel of cardboard, heavy cloth, or wood mounted on a boom-type light stand and used to shade selected areas of a subject to darken them. Also used to shade a camera lens from light that would cause glare or fog. It is the studio equivalent of the dodger used in printing. Also called *Flag, Cutter, Headscreen*.

*Gray card.*   A neutral-color cardboard of 18 percent reflectance, used as a standard average tone for exposure-meter readings. The card represents the medium tone of the subject, whether it actually has such a tone or not. The card is read instead of the subject.

*Guide number.*   A number used to obtain the correct exposure when using flash or electronic flash. The number is divided by the distance in feet from the light source to the subject to find the correct *f*-number, which is then set on the camera. The guide number is matched with a given flash unit and film of a given ASA speed. For other units and ASA speeds there are different numbers.

*Hair light.*   A small light source, typically a baby spot on a boom, used to lighten the hair in portraiture. Often used for blond hair, which sometimes photographs too dark. The type of hair light that comes with an adjustable aperture (for controlling light intensity) is especially useful.

*Halogen lamp.*   A light source with a tungsten filament surrounded by an active halogen gas. The gas prolongs lamplife and permits higher operating filament temperatures (thus higher color temperatures). The bulb or envelope used is actually fused silica rather than quartz. The color temperature of a halogen lamp, which is good for exposing color

films, remains constant throughout the life of the filament. Also called quartz-halogen (quartz-iodine, quartz-bromine, etc.) lamp.

*Head screen.*   See *Gobo.*

*High contrast.*   (1) Great tonal difference. (2) Applied to a lighting, film, developer, printing paper, and soon, used to increase differentiation of tones beyond the normal, either to achieve a desired contrasty effect or to compensate for low-contrast influences elsewhere in the process.

*High front lighting.*   A portrait lighting in which the main light source is somewhat above and directly in front of the subject's head. The result is to cast a nose shadow on the upper lip. The eye sockets also cast shadows, making the eyes look larger. In the 1930s and 1940s this was a very popular "glamour" lighting among Hollywood portrait photographers. Also called *Butterfly lighting.*

*High key.*   (1) Refers to a subject or image in which nearly all the tones are very light. (2) Applied to a lighting that is very flat (low contrast). It may be very diffuse light from behind the camera, or the subject may be in a tent.

**Figure 13.5.**   A *high-key* print.

*Highlight.*   (1) Refers to subject areas illuminated by the main light source (or key light) or to corresponding areas in images. A strong reflection from a shiny surface is called a "specular" highlight. (2) Loosely applied to any light tones in a subject or positive image, or to corresponding dark areas in a negative.

*Highlight pattern.*   The design or composition formed by the light tones in a subject or image. This pattern is especially visible if the subject contrast is fairly high and tends to disappear in diffuse low-contrast lightings. It is desirable to have the pattern well and handsomely organized.

*Hot spot.*   An area appreciably lighter than its surroundings, possibly caused by a poorly designed reflector. Hot spots in copying are caused by having the lights too close to the original. Hot spots in copy negatives make printing extremely difficult.

*Inky (inkie).*   Slang for incandescent light source.

*Junior.*   Slang for medium spotlight.

*Keg.*   A large focusing spotlight.

*Key.*   (1) The light source that provides the main lighting on a scene or setup. (2) The prevailing tone of a photograph. A high-key picture consists mainly of light tones; a low-key picture is mostly dark tones.

*Lens flare.*   Light bouncing around within the lens before reaching the film causes a loss of image contrast due to excessive exposure in the dark areas. Lens flare is usually caused by bright light striking the lens — from a light source, a specular highlight, or an excessively bright background area. Shading the lens with a gobo will often solve the problem.

*Light absorber.*   A dark surface that absorbs most of the light falling upon it. Used on the shadow side of a setup to increase the lighting contrast by lessening the amount of light that will reach the shadow areas.

*Lighting ratio.*   The amount of light reaching the shadow areas in a subject as compared to the amount reaching the highlights. For example, in a 1:4 ratio, the highlights are four times as bright as the shadows.

*Light reflector.*   (1) A surface that reflects most of the light falling upon it. (2) The reflective housing of a light source. (3) A panel or flat, in a light color, usually white, used to reflect light into the shadow areas of a scene or setup, thereby reducing the lighting contrast.

*Light table or box.*   A box holding a translucent surface illuminated from below. Used for retouching, viewing negatives and transparencies, and photographing small objects. In photographs this surface comes out white.

*Low contrast.*   Flat. Applied to a scene, lighting, or image in which the tonal difference is small. A low-contrast print that is also overexposed will often look muddy. High-key pictures are intentionally made with low contrast.

*Low front lighting.* In portraiture a model in a full-front pose is frontally lit with a light source that is low on its standard.

*Low key.* Applied to a subject or positive image in which most of the tones are dark.

**Figure 13.6.** A moderately *low-key* print—one in which most of the tones are dark.

*Main light.* The key light. The light source that makes the major contribution to the lighting of a scene or setup. The one that establishes the highlight pattern.

*Narrow lighting.* Lighting used in portraiture when the subject is posed three-quarters turned toward the camera. The main light is positioned to light the front of the face, which is the narrowest part of it from the camera position, hence the term narrow lighting. This lighting is often used with people with full or fat faces to make them appear more slender. In a very narrow lighting, often called a Rembrandt lighting, only a small triangle of light appears on the side of the face nearest the camera.

*Natural light.* Available or existing light. Light not furnished or manipulated by the photographer.

*Neutral test card.* A gray card, usually with 18 percent reflectance on one side and 90 percent on the other, used in making exposure readings with a reflectance-type meter.

*Obscuring light.* A lighting in which more is obscured than revealed. Typically, large parts of the subject are hidden in shadow. Knowing when to obscure something is an important part of the photographic art.

*Open shade.* Refers to the light in the shade on a clear, sunlit day when a large section of the sky is visible. The sky alone (not the direct sun) illuminates the subject. Skylight is very soft, diffuse, and generally flattering to portrait subjects. A large bank light will approximately duplicate open shade.

*Painting with light.* Moving light over a subject or scene while the camera shutter is open. The movements of the light source may be similar to those made with a paint brush or spray. In the image, the light may look very diffuse, and it may appear as if many light sources had been used. A method of lighting a large area — say the interior of a cathedral — with just one light source. Painting with light can also be done with small light sources such as flashlights.

*Photoflash lamp.* A flash bulb, either separate or incorporated in a flashcube or flash bar. A bulb containing oxygen and a highly combustible wire or foil, which is ignited by an electrical current. It produces just one flash. Distinguished from electronic flash, which involves a high-voltage discharge through an inert gas and which may produce several thousand flashes.

*Photoflood lamp.* A tungsten-filament bulb that operates at a temperature of about 3450 K, which is near the melting point of tungsten. The light is more intense than with conventional lamps, but the operating life is short — about four or five hours. Some color films are balanced for this light source. Distinguish from a 3200 K lamp, for which other color films are balanced.

*Point source.* Theoretically, an infinitely small light source; practically, a very small one, for example, the sun or a baby spot with a *snoot*. Such a small source causes very sharp-edge cast and form shadows, which may be desired. However, in portraiture such shadows are generally considered unflattering.

*Polish.* A surface characteristic that causes light to be reflected in a specular rather than a diffuse manner, as in polished metal, smooth glass, and mirrors. The specular reflection may cause flare on film, so it is often made more diffuse by use of dulling spray or a lighting tent.

*Profile.* (1) A lighting in which the subject is positioned against a dark background. The light, from behind, draws a line around the edge of it. (2) In portraiture, a side view.

*Prop.* Short for property. A secondary object supplied to a setting or scene to help explain where and what it is, clarify the meaning of the action, establish the role of a person, contribute to a mood, and so on.

Though it has the same general function as scenery, a prop is on a smaller scale.

*Quartz-halogen (quartz-iodine, etc.) lamp.* Halogen lamp, also tungsten-halogen.

*Realistic.* Applied to photographs intended to portray "truthfully" the appearance of the subjects photographed. A lighting may be realistic, as opposed to strange, offbeat, obscuring, distorting.

*Rear projection.* Use of a translucent (rather than reflecting) screen behind a subject. An image is projected from the rear onto the screen, and the subject is lighted separately in front of it, with pains being taken to keep the light from hitting the screen. In motion pictures, a way of combining live action with filmed scenes. In still photography, a way of combining a subject with a scene that is accessible only in the form of a slide.

*Reflector flood.* A tungsten lamp with a built-in mirror, designed to illuminate a relatively wide area.

*Reflector spot.* A tungsten lamp with a built-in mirror, designed to illuminate a relatively narrow field.

*Rembrandt lighting.* A lighting derived from studies of portraits painted by Rembrandt. The subject faces three-quarters to the camera, the main light on the face side and slightly behind the subject. On the side of the face near the camera, the light forms a triangle bounded by the nose shadow, the cheek line, and the eye. For dramatic effects, little or no fill light is used, but a lighting ratio of about 1:4 is used in most portraiture. This means that the main highlight on the face is about four times as bright as the main shadow area. With this much fill light, the film records ample detail for the shadow area.

*Revealing light.* A lighting that makes clearly visible all or most of a subject, thus leaving no doubt as to its nature. As opposed to a lighting that obscures much more than it reveals. Good photography often involves a fine balance between revealing and obscuring.

*Rim lighting.* A type of backlighting in which, from the camera viewpoint, the subject appears to be outlined with light.

*Scrim.* A sheet of gauze or cheesecloth, often on a light, wooden frame, used to diffuse light. Scrim is often used to soften the lighting in outdoor setting lit by bright sunlight. It can also be used to diffuse the light from floods or spotlights. It is sometimes used as a background, too.

**Figure 13.7.** The figure on the right is illuminated by *rim light*.

*Seamless.*   A roll of plain background paper, usually nine feet wide, which can be attached high on a wall, then rolled out on the floor in a smooth curve without a break. Comes in a variety of colors, including black, white and gray. Used because it greatly simplifies photographic scenes and setups and frees them from any suggestion of a specific environment. That is, a seamless seems to represent no particular place, which is very convenient for many purposes.

*Separation.*   In a subject or photograph, the distinguishability of the various parts, usually due to tonal difference or contrast. If two things separate well from one another, it means that they stand out so that they can be clearly seen as not being part of the same thing. Lighting is one of the main tools for guaranteeing adequate separation. The opposite of separation is merger, which is also desirable at times.

*Setup.*   An arrangement of things brought together by the photographer, including main subject(s), props, scenery, backgrounds, and so on. Equivalent to a stage set with the actors in it, though it may be on a much smaller scale. Also any contrivance that the photographer has assembled in order to photograph it, including the setting and the arrangement of the light source(s).

*Shadow.*   An area shielded from the light source. (2) A dark area in a subject or picture, as opposed to highlight. It may not actually be a shadow but may be called that anyway simply because it is dark. This usage is seen particularly in the expression "detail in the shadows," which applies generally to the thin portions of a negative in which dark subject areas (not necessarily shadows) are recorded.

*Shadow pattern.*   If the lighting contrast on a subject is moderate to high, the shadows will probably make a definite composition or design — a shadow pattern. The problem is to get this pattern so that it looks

just right. With soft-edge shadows from broad light sources, the solution is easy, with sharp-edge shadows from small sources harder.

*Sharp-edge shadow.*   A distinct shadow with a contour sharply defined all the way around, generally cast by a small light source, which may also cause sharply defined form shadows. Such a shadow gives the feeling of crispness or hardness to a subject, but it may also introduce apparent distortions. A sharp-edge shadow on an object may look like a slash or cut.

*Sheen.*   Glossiness, as of a photographic paper or a polished or semi-polished surface of any kind. Such a surface tends to produce specular (mirrorlike) reflections.

*Silhouette.*   An image in which the subject appears as a flat, dark shape against a bright background. One can easily make a silhouette by lighting a background (or finding one already well lit) and keeping all light off the subject. The picture is exposed for the background, not the subject.

**Figure 13.8.**   A *silhouette.*

*Side lighting.*   Cross lighting. The light strikes the subject from one side, the path of light being approximately perpendicular to the lens axis. Side lighting usually makes objects look solid and pictures look three-dimensional, as opposed to low front lightings, which usually make objects and pictures look flat. There is also double side lighting in which the light comes in from both sides of the subject. Rembrandt lighting is a side lighting.

*Skylight.*   (1) Light from the sky which with direct sunlight makes up daylight. Skylight without sunlight provides a favorite lighting for

photographers, e.g., in hazy or overcast sky or open shade. (2) A window, usually large and facing upward and northward, used as a source of light in some photographers' and artists' studios.

*Snoot (snout).*   A cylinder or cone fitted to a spotlight to produce a small circle of light on a subject or background.

*Soft-edge shadow.*   A cast or form shadow made by a broad, diffuse light source. In a cast shadow the edge may be so diffuse that the shadow is noticeable as a shadow only in the area close to the object that causes it. Either form or cast shadows with very soft edges are not particularly noticeable as shadows, yet they do much to give space to pictures and to make objects look solid. Because of their softness, they seldom cause any compositional problems, as opposed to hard-edge shadows, which often do.

*Specular.*   (1) Mirrorlike reflection, as in specular highlights on smooth glass or polished metal, even on damp or oily skin. (2) Unscattered, collimated, like the light from a condenser enlarger or a spotlight — as in specular illumination.

*Speedlight.*   Electronic flash unit. A reusable light source involving a high-speed discharge of electricity through a tube filled with an inert gas.

*Spot.*   Short for spotlight, a light source in which the emitted light is confined to a small area. Usually has a fresnel lens to help make the light rays parallel rather than diffuse.

*Still life.*   An assemblage of inanimate objects, usually on a tabletop, or a photograph of such a scene. The photographer's usual intention is to make his still life look "artistic."

*Tabletop.*   (1) Refers to a photograph of one or more objects on a table. (2) A still life. (3) Refers to a kind of photography in which miniatures, often set upon tables, are used to simulate reality. A typical example would be a battle scene done with toy soldiers.

*Teaser.*   A small gobo or headscreen placed in front of the camera to protect the lens from extraneous light that might cause flare.

*Tent.*   A structure of paper, matte plastic sheeting, wood, or cardboard placed over polished metal objects in order to diffuse the light falling upon them and eliminate strong specular reflections. With translucent materials such as paper or matte plastic, the light may be beamed through the tent from outside. With opaque white cardboards or wooden flats, a larger tent may be required so that the light source(s) can be

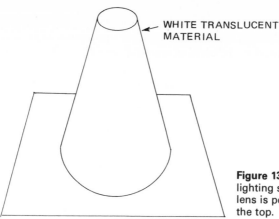

← WHITE TRANSLUCENT
MATERIAL

**Figure 13.9.** A drawing of a *tent* for lighting small objects. The camera lens is positioned in the aperture at the top.

put inside it with the light beamed at the inner surface of the tent. A tent may be rigged with such things as sticks, string, wire, staples, and masking tape — often supported by flats. It is usually flimsy and can be of almost any shape, depending on how reflections of it are formed on the objects being photographed, the usual goal being to cut obvious reflections to a minimum. Polished metal of any kind photographed in a tent always tends to look like pewter.

*Three-quarter view.*   In portraiture, a pose halfway between a profile and full front or full face. Most formal portrait poses are three-quarter.

*Tone.*   (1) The relative lightness or darkness of something. (2) Value. (3) Luminance or brightness. A light tone has relatively high luminance, a dark tone, low luminance. (4) The color of a print, as cold- or warm-toned. (5) The general lightness or darkness of a print, as light-toned or dark-toned. (6) To change a black-and-white print to a chromatic color, such as blue or brown, by means of chemical treatment (toning).

*Tone separation.*   Separation. (1) The extent to which areas in a subject or photograph are distinguishable. (2) Value difference. (3) Contrast. (4) Tone separation can be increased or decreased by changing the lighting geometry, manipulating the lighting contrast, changing films, modifying the film-developing time, and through choice of printing paper contrast.

*Top light.*   Light that strikes a subject from a light source positioned above it, or from overhead bounce flash or bounce flood. In portraiture, such light often creates unflattering shadow patterns. Many subjects, however, look good when illuminated by top light.

*Transillumination.*   Lighting a transparent or translucent object by letting the light come through it from behind. Thus the object is

between the source of light and the camera. Glassware is most frequently lit this way, the light coming from a sheet of brightly lit paper or a flat. Transillumination of small things is often done on a light box.

*Umbrella.*    A special umbrella used as a light reflector, usually with electronic flash. The inner surface is aluminized or painted to aid in light reflection and diffusion. The photographic effect is about the same as one would get with a floodlight of the same diameter. Though there is no special magic to an umbrella, it is nonetheless very popular at the moment.

*Underlighting.*    (1) Using too little light to provide a good exposure. (2) Lighting from underneath; transillumination.

*Value.*    Tone. A term describing the relative lightness or darkness of something, e.g., white is a high value, gray a medium value, and black a low value. The term is most often used by artists, photographers preferring to use "tone."

*Viewing filter.*    A dark filter used for viewing a scene to judge its lighting or to attempt to anticipate how its tones will translate into a black-and-white print. Formerly, dark blue filters were used, but now filters of deep amber or neutral density are favored.

*Wraparound.*    A kind of lighting in which an object is given considerable three-dimensionality. The object's surface seems to wrap around it. The tone on the surface changes subtly from side to side, ranging from a highlight on one side to a relatively dark form shadow on the other. This gradation from light to dark creates the wraparound effect.

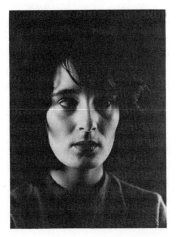

**Figure 13.10.**  A *wraparound* lighting (bounce light from both sides), which makes it appear that the woman's skin is wrapped around solid tissue and bone.

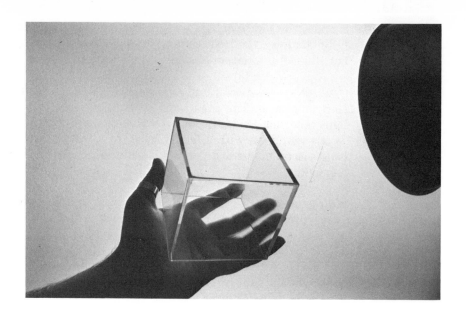

# 14 Lighting Projects

## PROJECT 1: CUBES

This project, which involves shooting first a white cube, then a black one, is based on a classic project in American photography. The original version was popularized by the famous landscape photographer Ansel Adams, who described it in one of his books, and also by the Rochester Institute of Technology, where it was for many years taught as a basic in learning lighting technique. Literally thousands of photographers have done it while learning to see light. The original version involved shooting a white cube, and we have added a second step in which a black cube is also shot.

The project calls for photographing a series of lightings on a white cube, then trying to get approximately the same effects by photographing a black one. In all cases the negatives should be *very* carefully printed in the effort to get handsome *pictures,* not just crude records of cubes. Making something handsome from a mere cube is an important part of the challenge.

**162**

*How Light Affects a Solid Form.* Notice that in some of the illustrations the cubes don't look particularly cubical or solid, though in others they look very solid indeed. This shows you that while light can give you solid form, it can also take it away again, which is an important part of what you are supposed to learn from this project. In two cases, the form of the cube is partly destroyed. In two other cases, lightings make the cubes practically disappear. If I had made them disappear entirely, which I could have done, you would never believe that I had done it without cheating somehow. Thus I was obliged to show enough of the cubes to convince you that they were actually there. You don't have to convince anybody, however, so I suggest that when you do the project, you make your cubes disappear totally. You will find it an interesting challenge. Please take my word that it can be done — I've watched hundreds of students do it.

If nothing else, this project should convince you that light can both create and destroy objects and space, and that will validate and underscore much of what you read in Part One. In a sense, all of the projects will serve as illustrations for what I have already told you.

*Learning Through Imitation.* For thousands of years imitation has been one of the main teaching methods in the crafts. The student simply imitates things that the teacher has done and thereby learns certain things that he or she is supposed to know. In this project you will imitate exactly the cube pictures in this book. However, your pictures should be much handsomer, because photographic prints are much prettier than reproductions of them. This handsomeness is very important, because it can help motivate you to do a good job on something as intrinsically uninteresting as a cube.

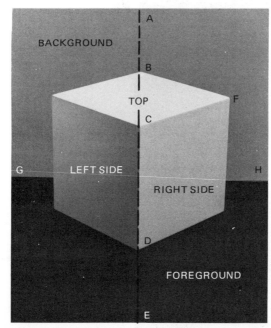

Full-frame 35mm-format photograph of the basic cube. Note positioning of cube in frame. Distance from A to B is equal to D to E. Cube is perfectly centered on all sides.

Purchase two plastic cubes, the kind that come with sponge foam inside and are intended for displaying snapshots. See text for painting instructions.

In my opinion, the best way to make light-meter readings for this project is to follow exposure information given in the captions for each cube. However, an acceptable technique for incident meter is to place meter in cube position with sphere pointing halfway between light and camera.

Another acceptable meter-reading technique is to make reflected-light reading off a neutral gray card positioned as shown, in front of the cube, facing halfway between camera and light. Make reading from height of cube.

Though photography is a wonderfully self-expressive medium, there are times when self-expression is simply not the point — and this is one of those times. The point in this case is to see, in the easiest and quickest way possible, certain things that light does, and that way is by making imitative pictures of cubes, a white one and a black one.

Merely looking at the pictures in this book is not enough to teach you what you have to know, because at this point in your career you don't know how to really see. You think you do, but you don't. Even though the cube reproductions are greatly simplified, you don't really see what is happening in them. Therefore — make no mistake of this — you actually have to do the project — and do it well — in order to learn what it has to teach you. It is designed to counteract everyday visual complexity with the most rigorous and austere simplicity. The purpose is to help you see certain important things very, very clearly and to save you many months of hard and mainly fruitless work in learning to see.

*The Problem of Caring.*   It can be very hard to care about something as simple as a cube, but if you don't care about something, it is impossible to do it justice photographically, which is what you are being asked to do. Caring about something that you find basically dull has to be an act of the imagination — you imagine it to have value and beauty. Considering what cubes can do for you, which is quite a lot, you at least have a starting point for building up an imaginative interest in them.

Imaginative caring about basically uninteresting things happens to be a very professional skill, so don't underestimate its value. Frankly, it can earn a good living for you. For example, I have a friend in advertising photography who does some very exciting things, yet he has many times paid his high studio rent by shooting pictures of refrigerators, which are at least as dull as cubes. However, he has enough imagination to care about them and thus can treat them well photographically. The ability to care imaginatively is very important to the professional, because the majority of his or her subjects are actually not very interesting. So if you intend to become a professional, learning to care about cubes will be good practice for you.

*Preparing the Cubes.*   To do this project well, you need one cube that is a pristine white, and one that is a rich, smooth black — no bubbles, dirt, paint drips, scratches, or fingerprints. Since you have to paint the cubes yourself with spray-can matte paint, it means that you have to do a very neat job of it. Follow the instructions on the paint cans carefully. To avoid paint drips, give each cube three or four light coats of paint, waiting about fifteen minutes between coats. If you get a drip, carefully wipe off the whole side with a rag soaked in turpentine, then spray it again. If it doesn't wipe off clean, let it dry and smooth it with fine sandpaper before repainting it.

After your meticulously painted cubes have dried, handle them only with clean cloths or paper towels so as not to get fingerprints on them. Oddly, the black cube requires the more careful handling; marks or dirt of any kind show up badly.

Fortunately, the work of painting the cubes will help to make you care about them. Having contributed considerably to their appearance, you can imaginatively feel that the cubes are your own creation, even if you did buy them at a store. Taking good care of them after they are painted will have the same effect. (Note: if you put a hot photoflood light too close to a plastic cube, the cube will soon melt, so make sure that doesn't happen to you.)

*A Single Light Source.* In this project you will use just one light source, a photo-flood lamp in a reflector. No other lights should be turned on in the room so that you can be sure that you are fully responsible for everything that happens to your cubes. Knowing that you are the cause of what lies in front of you is an important part of learning to see. Furthermore, it will help arouse your feeling of respect for your cubes, help you care about them.

Offhand, it would seem there is little one can do with just one light source, but that is far from the truth. If you work twenty years in photography, you will still be discovering things that a single light can do. You will discover many of them while you are working on this particular project.

Whatever you do, don't permit yourself to feel penalized by being restricted to a single light source. This is a highly necessary simplification — you are simply not ready to see what two or more lights do when they are used together. Indeed, if you were to start out with more than one light, you might never learn the things I am trying to teach you.

Among other things, you should learn that light doesn't necessarily make cubes look like cubes. Whatever your cubes decide to look like, remember that it is important to make every picture a good one, although in some cases rather weird.

*Lighting Procedures.* Though you are limited to one light for this and some of the following projects, you can use light reflectors to lighten shadows or light absorbers to darken them. You can provide yourself with both by buying 16″ × 20″ mount boards that are black on one side. Six is about the right number. Keep them spotlessly clean, for they will be in some of your pictures.

You can set up a lighting, or change from one lighting to another, in the following ways:

1.  Move the light stand.
2.  Move the light source up or down on the standard.
3.  Tilt the light source up or down.

4. Swing the light source left or right.

5. Shade off part of the light source with a piece of cardboard.

6. Use the reflector side of a mount board to lighten shadows.

7. Use the absorber side to darken shadows.

8. Use any combination of the above. Together, they give you a rather large number of possible moves.

At first you will have trouble becoming aware of what you are making light do, so use the seeing tricks discussed in Chapter 12. In the beginning you won't really understand what you are trying to do with them, but it will come to you in time.

Always look at your photographic subject with just one eye (or with both eyes squinting) whenever you change the position or aim of a light source in any way whatever. The period of change will create a brief movement of tone on the subject, giving the eye something that it can easily fix on. Sometimes it is a good idea to run through the same change several times in order to see better. This trick was mentioned in Chapter 12, but it needed repeating here.

*The Basic Image.*   There is one basic image that shows up in all the accompanying illustrations. The lightings and the color of the cube change, but the basic image does not. Follow this basic image closely. It will give you a taste of what professional photographers do when they are asked to follow a layout with great exactitude.

The dimensional requirements are given in the caption for the basic image. It will take you a while to get the image just right, but you will find it well worth the bother. Notice that in the final prints the basic image was cropped somewhat.

*The Basic Shooting Setup.*   For shooting you need a light source, camera, tripod, cable release, a large sheet of white background paper, tape to put it up with, two cubes, several mount boards, a table, and a cardboard carton. For a camera that focuses no closer than three feet, use a +1 close-up lens.

In the setup for the basic illustration, the cube was two feet in front of the background paper, as it was for most of the pictures. In the case of the disappearing white cube, however, the background was touching the cube. The background (black this time) for the vanishing black cube was also touching.

In all cases, one corner of the cube touched the far edge of the cardboard upon which it rested. To shoot the basic illustration, a white cardboard reflector was placed to the left of the cube, thus lightening the left side of the cube somewhat.

*Exposures.*   Simple as they are, the cube lightings offer some fairly tricky exposure problems. If you use gray-card or incident-light readings (see Chapter 14), you will get exposures that aren't too bad. If you select

White cube on a black mount board with white background two feet behind. Cube looks white. Top of cube is white, right side light gray, left side medium gray.

*Setup*: Lighting is from upper right, pointed at the cube. White board to left of cube makes that side lighter gray. *Exposure*: Reflected-light reading off left side of cube.

White cube on a black mount board with white background two feet behind. Cube doesn't look especially white. Top of cube is white, right side medium gray, left side black.

*Setup*: Lighting is from upper right. Left of cube is fenced in by black side of mount boards to make it black. *Exposure*: Reflected-light reading off right side of cube.

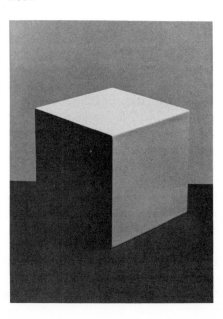

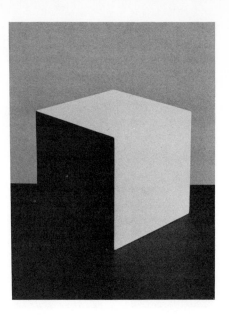

White cube, same as bottom left, page 168. But note tonal merger of top and right sides. Cube is less real. Top of cube is white, right side white, left side black.

*Setup*: Light is aimed at background with spill hitting cube. Black mount boards at left make that side of the cube black. *Exposure*: Exposure for right side of cube multiplied by five.

White cube on a black mount board with white background two feet behind. Note merger of top and right sides with background. Top of cube is white, right side white, left side black.

*Setup*: Light is lower at right, aimed directly at the cube. Black mount boards at left make that side of the cube black. *Exposure*: Five times the exposure for the right side of cube.

White cube on a black mount board with white background eight inches behind. Form, space, and reality are destroyed. Top of cube is white, right side white, left side also white.

*Setup*: Light is above and behind camera in line with cube. Take careful aim to be certain that cube is evenly lighted. *Exposure*: Five times the exposure for either side of the cube.

Black cube on a black mount board with white background two feet behind. Cube looks gray, not black as it really is. Top of cube is medium-light gray, right side darker, left side black.

*Setup*: Light is aimed at background with spill hitting cube. Black mount board at left makes that side of cube darker. *Exposure*: Reading off top (light gray) side of cube.

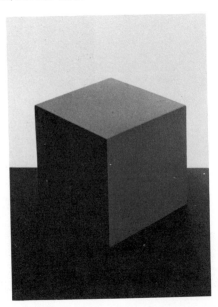

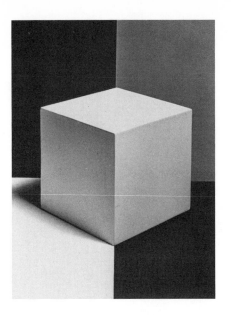

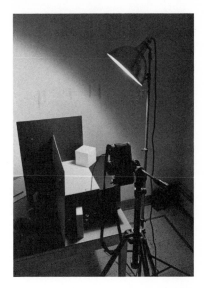

White cube on a split white and black foreground and background. The cube looks gray. Top of cube is white, right side light gray, left side medium gray.

*Setup*: Lighting is from upper right. Left of cube is fenced by black board to make it darker. Note the half-black background. *Exposure*: Reading off left (gray) side of cube.

Black cube and white object on black mount board. White background is two feet behind. Cube was exposed, printed to look black. Top is dark gray, right side very dark, left side black.

*Setup*: Lighting is from upper right. Left side of cube is fenced by black board to make it reproduce darker. *Exposure*: Reading was made off the top side of the cube.

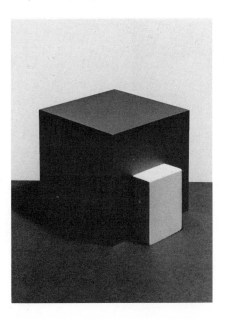

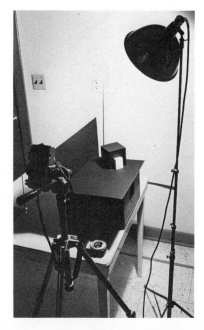

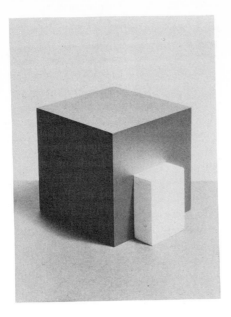

Black cube and white object on black mount board. Same setup as in others except this cube was exposed and printed to make cube lighter. Top of cube is light gray, right side medium-light gray, left side very dark gray.

Black cube on a white mount board with black background eight inches behind. Cube is lost in the black background. Top of cube, right and left side are all very dark gray.

*Setup*: Light is above and behind camera in line with cube. Take careful aim to be certain that the cube is evenly lighted. *Exposure*: Reading off either side of cube, divided by two.

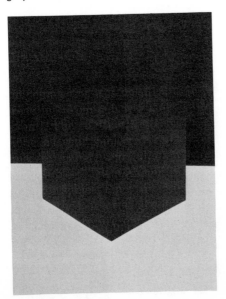

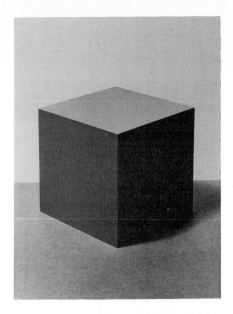

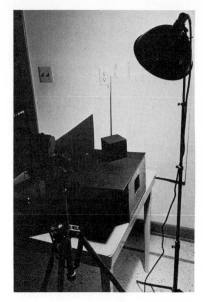

Black cube on a black mount board with white background two feet behind. Cube looks gray. Top of cube is light gray, right side medium gray, left dark gray.

*Setup*: Lighting is from upper right. Left of cube is fenced by black mount board to make it reproduce darker. *Exposure*: Reading off top side of cube.

Black cube on a black mount board with black background eight inches behind. Cube looks white. Top of cube is white, right side light gray, left side dark gray.

*Setup*: Light is from upper right. Left of cube is fenced in by black mount board to make it reproduce darker. *Exposure*: Reading off left and right side, then averaged.

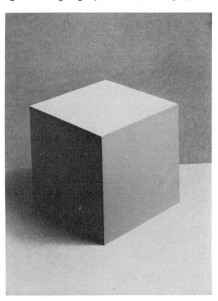

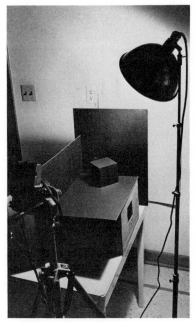

the average gray in each case, you will do even better. In the caption for each cube picture, I tell you what part of the scene to read. They are reflectance readings, of course.

*Printing.* If you have done everything correctly you can make excellent prints with a minimum of dodging and burning in. In doing this project, be sure to make good prints, because the printing is the point at which you can really see what you have been doing.

Oddly, the wrong point of view can make it difficult to print white and black cubes. If you insist on the white cube's *looking* white, you will get into trouble. If you examine the illustrations I have provided, you will find that the cube looks however it looks and that whiteness per se is strictly a relative matter. Similarly, you shouldn't insist on having the black cube look black. Follow the illustrations and you won't have insurmountable difficulties. Even so, you will probably find this the most difficult printing project you have ever done, despite the great simplicity of the images, in fact because of it.

To dodge the face of a cube and get the tone to come out flat and even is almost an impossibility, and burning in is equally hard. Try it and see. I therefore suggest that you confine your dodging and burning in to areas *around* the cubes. Some of the illustrations were burned in, incidentally — usually just one corner for each picture.

*Perspective Correction.* Notice that in the illustration of the basic image the vertical edges of the cube aren't parallel but instead tend to converge somewhat toward the bottom. They have been made parallel in the final pictures by a technique called perspective correction: the top end of the enlarging easel was raised and propped up on books.

This method throws part of the image out of focus when the lens is wide open, so you have to focus on the center of the picture and stop all the way down to get everything sharp again. Since the top of the image is closest to the enlarger head, it gets more light than the bottom. Therefore, it should be dodged somewhat during exposure.

Getting the dodging right makes the printing considerably more difficult than it would otherwise be. So you might consider forgetting about perspective correction — unless you are already an excellent printer. The important thing to understand is that you can learn about lighting just as well from uncorrected prints. You might consider perspective correction as a nice but unnecessary flourish or as an interesting challenge. If you are shooting these projects with a view camera you will, of course, do the correction with the camera back — no problem at all.

*Expect Some Difficulty.* These drills with the cubes are a good deal more difficult than they appear to be. You probably won't get your shots right the first time and will have to try again. For your own sake don't give up — there is much you can learn about seeing from this project.

Don't let the great simplicity of the cubes fool you, for they are actually fine teachers. Remember that thousands of professional photographers got their start in learning to see light from this very project.

## PROJECT 2: WHITE-ON-WHITE

For this project I want you to photograph one or more all-white objects in an all-white environment. Everything in the camera view finder should be white — without exception. Through lighting you will create tone and contrast and, I hope, prove to yourself that light as such is the source of both. I repeat: light, and nothing else, causes both.

The white-on-white project has been used in the arts for hundreds of years as a means for teaching people to see. Among photographers the drill has been popular for perhaps fifty years. Artists have traditionally learned to draw from white plaster casts, which is very much like photographing white-on-white. Though the practice is now not as common as it was, the idea is still as sound as ever.

*Preparing Objects.*   Since relatively few things are all white you may have to coat a few things with spray paint. For human faces and bodies, which of course shouldn't be painted, use a theatrical makeup called clown white. Lighten hair with ordinary corn starch.

*Finding Suitable Objects.*   Finding objects to paint isn't all that easy, so invest a little time in the process. The objects should have interesting or handsome shapes and should be expendable — paint isn't very good for some things. To give you a lead concerning what to look for, I can tell you what some of my former students have painted: glassware, wine bottles, grapes, apples, bananas, artichokes, boiled lobsters, parts of a discarded television set, children's blocks, stuff from junk yards, shoes, flowers, leaves, hands, feet, and dolls and other toys.

At this point you should understand that one of the photographer's main problems is to find suitable things to photograph and that to find them may be hard work. Please accept this fact and invest the energy necessary for finding things worth painting and photographing.

*Lightings.*   In this project you should once more restrict yourself to a single light source. Remember, that will help you see better what the light is doing; using more than one light will surely confuse things for you at this point in your career.

In every setup there should be some kind of idea involved — you try to make a picture that will do this thing or that — and there should also be lighting ideas. That is, you use light to create certain effects that presumably go along with the main idea of your picture.

Unless you are very experienced, you cannot think up lighting ideas and have them work out as you anticipate. Instead, you must *discover*

your ideas by experimenting with your light source and your subjects. The basic approach is to do everything you can think of with your light source just to see what happens. In so doing, you will make lighting ideas virtually pop up in front of you. Your problem is to differentiate between the good ones and the bad ones. That takes a while, but you will soon master the art if you work very hard.

Though the cube project will have given you some ideas about lightings, you are probably still at loose ends concerning what to do with a single light source. So try some of the following things to see what effects you get:

1. Feather (edge) the light either in front or in back of your subject.
2. Lower the light source so that it is below the level of your subject.
3. Cross light your subject.
4. Back light your subject.
5. Use bounce light — from a wall, the ceiling, the floor, or from reflector cards.
6. Use light to make your subject disappear.
7. Use your light source to cast shadows onto your subject.
8. Turn your subject into a silhouette.
9. Make a cross lighting in which the main shadows of your subject are strongly visible.
10. Use a low-key lighting.

With a given subject, only one or two of these lightings is likely to be good, each subject having different lighting requirements. With every setup, however, you should try them all, just to see what happens. At first this will take quite a bit of time — you have to *see* what you are doing, understand — but after a while you will be able to do all these things in, say five minutes. They are the kinds of things that an experienced photographer automatically does when sizing up a setup to see what lightings would be best.

*Aiming Your Light.*    By now you should have surmised that it is not necessary to aim your light source right at your subject. For some subjects it works, but for many it is the worst thing that you could do. If you are concerned about getting enough light on your subjects to make your pictures, stop worrying. So long as a still-life subject is barely visible, you can successfully make a picture. That is, the amount of light isn't critical — so do lots of experimenting.

*Snoots and Barndoors.*    You may still be feeling restricted, using just one light source, but you shouldn't be. As I said earlier, you can spend many years finding out what a single source can do. It is easy to modify a light, for example, and make it do things it wouldn't ordinarily do, two of the easiest and fastest modifications being snoots and barndoors made with paper, aluminum foil, or cardboard and fastened with masking tape. The object of a snoot or a barndoor is to change the

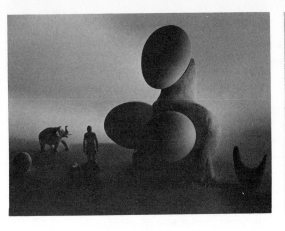

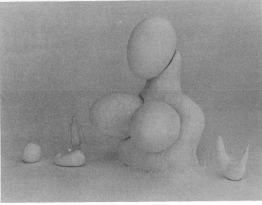

It is hard to believe that everything in this picture is white, but that is so. The dark tones were all created by lighting. They suggest that light—and light alone—is responsible for tone.

This is the same subject with most of the tone taken out by means of a flat frontal lighting. You can see that everything is indeed white, though it is printed gray here for visibility.

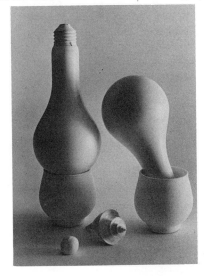

All the things in this picture were spray painted white. As you can see, the lighting (side bounce) gives them tones ranging from white to a very dark gray.

light pattern — a snoot will give you a circle of light, a barndoor shade off a portion of the light falling on a subject. A snoot has to be carefully shaped and cut out, but a barndoor can be made with almost any strip of paper, aluminum foil, or cardboard.

*Shadow Casting.*   You can cast a distinct shadow onto a setup if you like, or simply cast a blur of tone to darken an area. How sharp and distinct a shadow will be depends on the distance of the shadow-casting object from the light source; the greater the distance the sharper the shadow.

With ingenuity and very little effort you can make cardboard designs that will cast any shape of shadow you like. Many times you can prop such things up on the table, just out of camera range. For propping

purposes it is convenient to use chunks of modeling clay; it sticks nicely to both the table and the shadow caster. To avoid an oily spot, put some aluminum foil under the clay.

*Disappearing Things.* You should surely make one shot in which your objects disappear entirely or come extremely close to it. Start out with either a direct or bounce lighting from behind the camera position, then move the light source around until the objects disappear. Make the disappearance as complete as possible, using every trick that you can think of to make it happen. You will prove to yourself that light can both create tone and contrast and take them away again, and it is important that you understand this from personal experience.

In trying to make your objects disappear, you will be experimenting with so-called high-key lightings in which things are mostly very light in tone but still distinguishable as objects. If one of these lightings looks good, shoot a picture of it, then go on to make the objects disappear if possible. You may not be able to go all the way, but you can go a lot farther toward their complete oblivion than you think — so keep on trying.

*Handsome Pictures.* This project is more than just a lighting drill, for it can provide the methods for making very handsome pictures. Indeed, you should have handsome pictures as an objective from the beginning because you need the promise of beauty to help motivate your efforts to see. That is, the anticipation of ending up with something good will provide you with the energy required for doing the very hard work of learning to see well. Without such motivation the work is simply too hard for the average person.

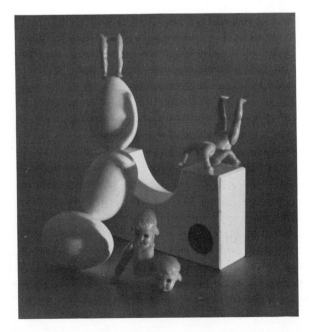

Though the predominant tone in this picture is a rather dark gray, everything except the black spot is actually white or very close to it. Direct light from the right side.

Dragon feasting—whelk egg cases, which are off-white. The scene was lit by small candles from behind. The "sky," which was white, has turned black.

## PROJECT 3: BLACK-ON-BLACK

In this project you photograph one or more all-black objects in an all-black environment, again using a single light source. Everything in the camera view finder should be black in nature, with no exceptions. Through your efforts you will prove to yourself that black is merely relative and that a subject that starts out as black doesn't have to end up that way in a print. Indeed, some of your prints may look as if they had originated with white-on-white setups, a result that will surely surprise you.

This project will help you come to terms with black, which is a much more interesting color than you might suppose. In prints, black can reproduce itself in a range all the way from the darkest nothingness to medium gray and even white. Giving black this improbable range is an interesting thing to try. Furthermore, the results will not be what you expect, no matter how hard you try to anticipate them.

*A Repeat of White-on-White.* In a sense, this project is a repeat of white-on-white, so you can use all the instructions that were given there: find suitable objects, paint them, try different things with your lightings, reveal your objects well, make them disappear, and so on. Above all, strive for handsome pictures. Remember that the hope of creating beauty will give you the strength to carry on.

*Matte or Glossy Paint.* It makes considerable difference whether you use matte or glossy print in preparing your objects, the matte being preferable for the purposes of this project. It will permit you to get prints simulating gray or even white more readily than a glossy surface will, and for good seeing, you should have that experience. However, **179** the matte picks up oily fingerprints and is generally hard to keep clean.

A glossy, black surface will pick up white highlights, making an object glitter in places. This characteristic makes it easy to print the object to look black, but that is only a marginal concern in this project. In other kinds of projects it may be important. Fingerprints can easily be removed from a glossy surface with a soft dry cloth. Though they can be washed off a matte surface with soap and water, it is harder to do a neat job of it.

*Seeing Black.* Because it is so dark, black is hard to see — so be sure to use the seeing tricks discussed in Chapter 10. The peep sight trick is especially good for seeing black. One of the things that you should see in a black setup is that only the darkest shadows are actually black and that everything else is gray. That is, light turns black into gray or even white, just as it can turn white into gray or black. Thus whiteness and blackness are relative according to the lighting geometry. It is even possible to make a setup in which white things come out black and black things come out white — just pour lots of light on the black objects and block it off entirely from the white objects.

Certain things that you won't notice in your black subjects will show up very clearly in your prints — scratches, fingerprints, dust smears, and the like. For this reason you should work very, very clean. Odd as it may seem, the cleanliness problem is even greater with black than with white. The fact is, your camera sees better in darkness than you do. If the exposure is long enough, the camera will clearly pick up things that you can't even see.

Basic setup for a black-on-black picture. Everything in the camera view finder has a black surface. The lighting is mainly from the photoflood light, though the window light makes a small contribution.

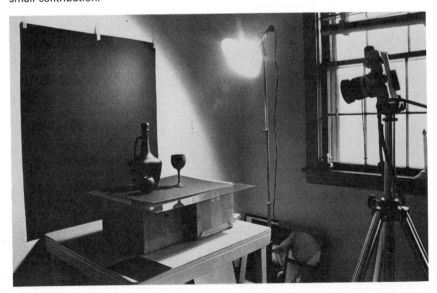

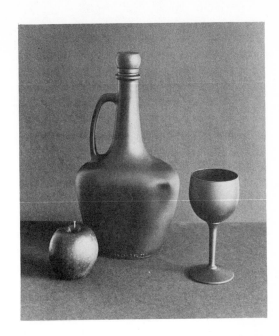

The black-on-black setup printed light to make it appear as if the things in it are actually white. Here it is important to see that black can photographically be turned into white.

The setup printed to look medium gray—but not black.

In order to make the black things look really black, I dropped in a white background. Silhouetted against the white, the objects do look really black. This step is not a part of the project given, but you can try it if you like—using whites to make blacks look blacker.

The setup printed to look black. Actually, it mainly looks dark gray. Getting black things to look really black turns out to be quite a problem.

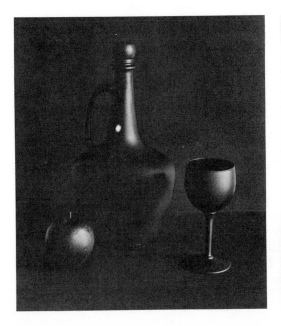

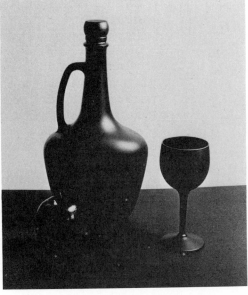

One reason for the interesting surprises that go with this project is this ability of film to record things that you can barely see at all. You should try to anticipate how your prints will look, of course, but don't be surprised if your success is minimal.

*Making Things Disappear.* You undoubtedly found that the hardest part of the white-on-white project was to make things disappear into whiteness. Making things disappear into black is also hard, but you should give it a try as an important part of this project. The disappearance trick in both projects will help you learn a lot about fine discrimination in seeing.

*Exposures.* Exposing for black requires a little know-how, which I will provide for you. If you have a super-sensitive meter, such as the Luna-Pro, you can take direct reflectance readings and do very well. Incident readings are out, because they would lead to serious underexposure. Built-in meters and ordinary separate meters aren't much help, either, because they just aren't sensitive enough to give good readings from black in many lightings. However, this problem can be solved if you use a white card and also bracket.

For the white-card reading divide the film speed by twenty (instead of by five) and set the result on your meter. Take your reading and use the indicated exposure as your normal exposure. Then bracket two shots on each side of the normal, making your exposures one stop apart. Combining the two methods will almost certainly give you one negative with exactly the right exposure. Remember that in cases like this you should regard film as dirt cheap and not hesitate to use it up by bracketing.

*Printing.* When you start your printing, you are due for some great surprises. First of all, your black things probably won't look black, unless you make your prints so dark that nothing at all is visible. But while they are still easily visible, they will look gray — mainly because they *were* gray, right in front of your camera. This is an opportunity for you to observe that the blackness of an object is not an absolute. It is relative to a lighting geometry and to the tone of things surrounding the object. In photography, that is a useful thing to understand. We see blackness (or grayness or whiteness) in something by comparing it with other things. Visual perception as such is largely a comparative process, you see.

In your lighter exposures, your objects may be a delicate gray, though your prints may still appear to have good quality. In some, the objects may even look white. This only goes to show that you can make a white-on-white print by using black-on-black subject matter. Quite surprising, don't you think? In photography you can make even a lump of coal look white and a pile of snow look black. A few paragraphs ago I told you how to do it.

# PROJECT 4: WHITE EGGS

This is an extension of Project 2 but with a specified subject: white eggs. Like the cubes lesson, the eggs project is famous in American photographic education — literally thousands of people have done it in their efforts to see better. The project instructions are simple enough: make five or six shots of white eggs on white paper. Everything in the camera view finder whould be white until other tones are created by lighting.

*Eggs as Art.*   For thousands of years, the egg has been considered a prime example of sculptural art. The egg is a perfect piece of sculpture — in the eyes of sculptors and other artists. Our dumb little chicken friends have been creating artistic masterpieces without ever giving them a thought.

Ordinarily, first-rate examples of sculpture aren't available to students of photography. If a teacher asks them to photograph fine sculpture, which is always a good thing to do, they just don't know where to get it; and they often come up with sculptural monstrosities that are better left unseen and unphotographed. Fortunately, the grocery store offers a fine source of good sculpture: eggs. Though a few are somewhat deformed, the large majority are first-rate art.

Possibly you are unimpressed by the egg as art, thinking of it only as something cheap and edible. If so, doing this project is an opportunity to awaken your artistic sensitivity. It is unlikely that the artists of the world should all be wrong in such a matter, so you can take it on faith that the egg is actually genuine art. When you personally begin to see it as art, then you will know that you are getting somewhere.

*Easy to Light.*   Because of their sculptural perfection, eggs are extremely easy to light — a boon for a student. Everyone needs to do

White eggs sitting on white paper. Edge light from the right side.

Direct light from slightly below the table level. It has turned the white paper a rather dark gray.

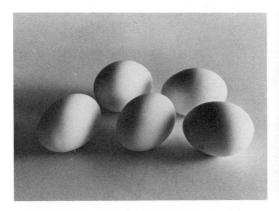

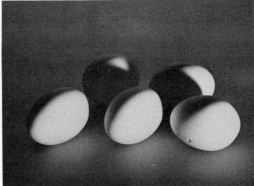

an easy project occasionally, for that gives encouragement. Even so, you should try all of the lighting tricks that you have read about so far and try to make your pictures exciting as well as beautiful. Beauty is easily enough created in this case, but excitement is something beyond that. And though it will be difficult with such severe restrictions, try to make your egg pictures surprising.

It won't be easy for you to set up a lighting that completely destroys the beauty of pristine white eggs, but you can do it if you try hard enough. And you should, for one of your shots, for its ugliness will help you see the natural beauty of eggs. For the rest of your pictures try to set up lightings that will show off the beauty of your eggs in the best way possible.

*Cooking the Eggs.*   Though you can work with raw eggs, you run the risk of breaking them, which can make quite a mess. Boil them first, unless you enjoy taking chances. To avoid cracking them in cooking, start them out in cold water over a low flame. When the water is steaming turn the burner up higher. Boil the eggs for ten minutes, then pour off the water.

*No Cop-Outs, Please.*   In this project you are supposed to use whole white chicken eggs and white paper (or cardboard) and nothing else — no cracked eggs, broken egg shells, sliced hardboiled eggs, chicken feathers, baby chicks, dishes, cutlery, or whatnot. If you are fussed about not having an idea for your pictures, just stop worrying. The idea is there, ready-made: it is that eggs are beautiful and that photography can bring out this beauty. You need no more of an idea than this for the project.

Two direct lights from well below the table level. They have turned the white background paper black.

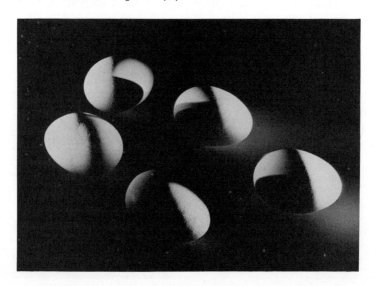

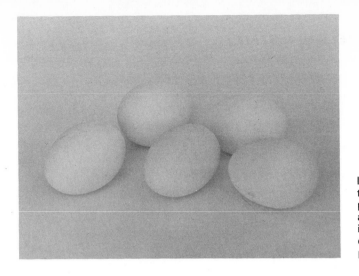

I used a bounce frontal lighting to make the eggs nearly disappear. Actually, I could have gone all the way, but you would find it hard to believe that there are eggs in a seemingly empty picture.

*Things to Try.* You can use several kinds of light sources, but you should use only one at a time. Following are some things you might do:

1. Try top light, side light, and back light, either direct or bounce.
2. With front light, direct or bounce, do your best to make your eggs disappear.
3. With a homemade spotlight, see what effects you can get.
4. Tape barndoors onto your floodlight reflector so that the light pattern is a narrow band; see what you can do with that.
5. Position your light source below table level and see what effects you can get with edge light.
6. Using light absorbers on the opposite side of the table from your light source, see if you can get black shadows with a side bounce or an edge lighting.
7. Try casting shadow patterns onto your eggs.

*An Extra Project.* If you are of an adventurous nature, you might like an extra project, which starts out where the white-egg project leaves off:

1. Set up the lighting that you like best for the white eggs.
2. Replace the white paper with black paper.
3. Paint the eggs black and put them exactly where they were when they were white.
4. Using the lighting already established, shoot a picture of the black eggs; bracketing would be advisable.
5. Using the black-egg negative, try to make a print that will exactly match the one made from the white-egg negative.

# PROJECT 5: SCALE, SIZE, AND DISTANCE

Still working with only one light at a time, we now move on to a project in which the objects and background don't have to be the same color. Indeed, they can be a mixture of colors and tones, just as things are in the everyday world. Our objective is to use miniatures (toy soldiers, scale-model trains or cars, and the like), suitable props, and effective lightings to simulate reality as closely as possible. In order to be successful you will have to create the right feeling of scale, size, and distance. I am asking you to function somewhat like the special-effects department in a motion picture company. From small things you must create the feeling of largeness.

*Finding the Miniatures.* The miniatures can be far from perfect — there are ways of disguising defects — and you ought to have no trouble coming up with one or two, which is all you need. Do you know a child who has a Barbie-type doll or toy soldier? Borrow them. Or investigate a toy department.

You can even make miniatures by rubber cementing small figures from magazine ads onto light cardboard, then cutting them out. I have seen many pictures made with such figures.

Miniature furniture for doll houses has lots of possibilities — you don't even need dolls to go with it. The plastic furniture they make nowadays is very detailed and scaled down quite accurately. Or you may want to work with a miniature airplane, an animal figurine, or a plastic duck.

*Props.* Except for doll things, miniature props are rather hard to come by — unless you turn to nature. There you can find good props in abundance because many small objects can look much like larger ones. For example, the top of a rotted post may look like a cliff, a weed like

Insects have turned these leaves into lace, making them look somewhat like trees. I produced the silhouette effect by confining the light entirely to the background. The tonal gradation in the sky was created by burning in.

White paper shapes and two white figurines from Crackerjacks boxes. Direct light at a low angle from the right side. Permit your imagination to work, and you will see a rather large scene.

The tonal gradation makes the "sky" look large, which in turn makes the fingers appear monumental. Bounce light from the right side.

The devil fish and the piece of bone behind it are backlit by small candles. Because of its shape and position in the picture the bone looks very large, which in turn enlarges the devil fish.

a tree, a freestone peach pit like a large boulder, a pebble like a huge rock. There are thousands of kinds of cliffs, trees, rocks, and the like, so it just isn't all that hard to simulate them. Furthermore, people don't really know what such things should look like, so the simulations don't have to be very accurate.

**187**

There are also things in your home that will work. A plain wool blanket can be turned into a hill, a mirror into a lake, a partly used bar of soap into a large abstract sculpture, a piece of torn sponge into a rock — and mashed potatoes: you can create lots of effects with them.

In looking for suitable props — you only need a few — you should turn your imagination loose. I have already given you the key to success: look for small things that look roughly like large ones.

*Sand.* For creating miniature scenery the handiest medium is fine sand: you should clean it by putting it through a flour sifter. Dry sand will make hills, valleys, roadways, and so on. The trick to getting the sand forms to come out smooth as velvet is to drift the sand down to the table through your fingers, moving your hand all the while. If an area isn't quite smooth enough, blow on it, and that will do the job. You can also smooth sand by pressing on it with cardboard.

Wet the sand to make sculptured shapes, forming it with a flat stick or spatula. Make walls, carved roadways, cliffs, buildings, abstract sculptures, and so on. If you take sand from the bottom of the bucket of water you can make dribble shapes, which look like wind-worn boulders from the American West. Though sand can be messy if it is really wet, you can do a lot of things with it. Then you can just let it dry out and use it again in the future.

*Horizons.* Before doing this project you should reread chapters 3 through 6, paying particular attention to what was said about horizons in Chapter 6. A horizon in a picture will do much to establish a feeling of distance and space. Make your setup on one piece of paper or cardboard, and use another piece about two or three feet behind it for the sky. It is best if the sky is either lighter or darker than the setup and you can manage that with lighting or through the choice of color of the sky paper or both. Your horizon shouldn't be too far from the main part of the setup; for most shots twelve inches would be the maximum. You should shoot stopped down to f/16 (f/32 if you have a macro lens) and in order to get the horizon line sharp. If it is fuzzy in your print it won't look like a real horizon. In contrast, the sky should be well out of focus, which will eliminate any telltale texture or marks on the paper.

The fact that objects and the horizon are actually fairly close together won't prevent the horizon from appearing to be at a distance. The important thing is that it look like an edge, the jumping-off place between the earth and the sky. Only very small things should be positioned close to the horizon, for they are supposed to appear extremely distant. Larger things should be closer to the camera. In your review of chapters 3 to 6, pay close attention to the idea of size gradients.

*Selective Obscurity.* I have pointed out that selective obscurity can be an important part of the photographic art. That is, you may need to

Imagine the elephant to be real, and you will see quite a spacious scene, the face on the tie pin turned into a monument and the marble many feet high.

Let us say that this is a real baby elephant. It makes the peach pits look like large boulders. Ask your imagination to help you see things this way.

hide some things, partially or totally. The most usual way is to lose them in dark tones or in black. You can also lose things by having them out of focus or making their tonality exactly like that of their surroundings.

Since your miniatures are not likely to be perfect, you will need some degree of selective obscurity to disguise that fact. Shooting them as silhouettes would probably do the job well in many cases, but you don't always have to go this far in consigning surface detail to total oblivion. A moderate amount of oblivion is often enough.

The lighting is very important in establishing partial obscurity — cross or back lightings (bounce, feathered, or direct) usually being the best bet. In comparison, a front lighting reveals everything, which is hardly what we want. Please don't get carried away with the idea that your miniature is so precious that it should be totally revealed. Think of it as a beautiful woman who is beginning to age; with a little less light we show her beauty more.

If intricate surface details make your miniature look somewhat phony, a very diffuse lighting will blur them somewhat. Thus a bounced-back or cross lighting would be called for, though heavy feathering will do pretty much the same thing. In some cases it might be best to forget the surface of the miniature altogether and to use a rim light.

In printing, you can control selective obscurity to some degree by such things as cropping, burning in, dodging, or local diffusion. Or you might want to print a picture in a low key and lose unwanted elements in that manner. In a high-contrast print you will also lose certain things.

*Lightings for Solidity and Space.* Fortunately, the lightings that are good for partial obscurity are also good for making objects look solid and for establishing a feeling of space. In addition you might try the tonal stepping stones mentioned in Chapter 7; you can make them by casting long shadows (made with narrow strips of cardboard) lengthwise across your setup.

Cross lightings, feathered or bounced, are also wraparound lightings, which create the surface gradation of tone (form shadows) that make objects look solid or three-dimensional. At the same time they create space between things. In comparison, low front lightings, especially bounce, tend to obliterate solidity and space by eliminating the form and cast shadows that are needed. They also reduce contrast, which further diminishes solidity and space.

*Why Tabletop Photography?* Remember that you are trying to learn to see better, which means to become aware of what light does to things and what things do to light. Since the size of things doesn't matter in this respect, it is convenient and economical to use small things in the learning process. It is a way of condensing your experience with lightings and making it more intense. What you learn about seeing light will apply to lightings on all things, no matter what their size. In simplest terms, if you know how to see you know how to see.

Another factor is that you are in complete control of your lightings, which means that you can trace the causes for all the lighting effects that you get. No longer are you in the position of accepting gratuities from available light without having to ask yourself what makes it work so well. The lightings you do are the lightings you get — you yourself are responsible. Having this responsibility will help you pinpoint what light does, which is basically what this book is all about. Working mainly with tabletops will help you do this in the quickest way possible.

A Stonehenge made of bread slices. To see it this way you have to accept the little men as being real and normal size.

# PROJECT 6: VERY SMALL OBJECTS

The objective for this project is to photograph a very small object — about the size of a quarter — so that it fills up most of the film frame. Photographing things on this scale will extend the range of your vision, making hard-to-see things very clear, and will open up a whole new world for you. Most people find close-up photography very exciting. Though there are a few problems connected with it, it is not especially hard to do.

*Close-up Lenses.* In doing the preceding projects you have probably had to use the close-up lenses mentioned in chapter 11 and thus have

The head is about 5/8″ high. Shot with close-up lenses on a 35mm camera.

The paper clips were silhouetted by confining the light entirely to the background. The tonal gradation in the background was created by burning in.

191

An eye painted on a table tennis ball. Bounce lighting from the right side.

a good idea of what they do. As you have seen, they are dead easy to use. They work quite well, and there is the additional advantage of low cost. Used singly or screwed together, the lenses in the recommended diopter range — +1, +3, and +5 — will permit you to get quite close to things with the normal lens on your camera. They can also be used with wide-angle, zoom, and telephoto lenses.

It is possible to give you quite a bit of unnecessary information about close-up lenses, but I will refrain from doing so. The thing to do is simply to put one on your camera and start using it, though I am assuming here that the camera is of the very popular SLR (single-lens reflex) type. Rangefinder and twin-lens reflex cameras aren't recommended for these projects, but if you do use either of them, you can solve the problems you will surely encounter by consulting *The Tiffin Practical Filter Manual,* an excellent book by Robb Smith (Garden City N.Y.: Amphoto [American Photographic Publishing Co.], 1975). Smith's writing is on the basic level and quite easy to follow.

*Macro or Macro-Zoom Lenses.*   If you are lucky or affluent you will have a macro or macro-zoom lens, which is even better than a close-up lens. Usually it will permit you to completely fill a 35mm frame with the image of a quarter, and that is really getting quite close to things. These lenses are extremely easy to employ — you just start right out using them — and they will give you somewhat better quality than close-up lenses.

*Extension Tubes.*   For many cameras you can get extension tubes, which can be used in lieu of close-up lenses or macros. A tube extends the length of a lens, permitting the lens to get closer to subjects and still be sharp. Tubes often come in handy sets, allowing you to vary the lens extension for objects of different sizes. In using tubes, you have to increase the amount of exposure, the necessary increase being indicated in the information that comes with them. If you forget the amount of increase required, you can simply bracket in one-stop increases from the exposure indicated by your meter. A built-in meter is used directly — it takes care of the increase. The quality you get with extension **192**   tubes is generally quite good.

*Limited Depth of Field — Selective Focus.* The closer you get to a subject, the less depth of field you have, until you find yourself working with fractions of an inch. With SLR cameras you can see rather well how the depth of field decreases. If you have a depth-of-field preview setting you can also see how much the depth is increased by stopping down, even though the image is usually very dim. Ordinarily, you should stop your lens down all the way. Even so, you won't get everything sharp unless your subject is quite shallow.

On many subjects you have to settle for using selective focus. That is, you select one or two things to be sharp and let everything else go soft. Except for your selection, you may have no choice of sharpness. You can think of the area you focus on as being in a plane vertical to the lens axis; other things in that plane will also be sharp. Things on receding or advancing planes will get progressively less sharp.

It is perfectly all right to have fuzzy, out-of-focus things in your pictures, but where they are placed makes a difference. Most people prefer to have them behind the main subject rather than in front. However, you may not have a choice, so there is no point in worrying about it.

Many photographers like to use selective focus, whether they have to or not. Out-of-focus tones or colors can be very pretty, and fuzziness is a way of toning down and blending together subject matter that may

Pins with clay tops.

This piece of driftwood is about two inches high, though it looks much larger.

Small marble and coral. Bounce light from right. The marble looks like a rather mysterious jewel.

be distracting or discordant. It also makes things lose all or part of their identity, so that they become abstract shapes.

*Move Your Subject.* In close-up photography a small change in the position of either the subject or the camera will often completely change the picture. Frequently, you have to jockey things around to get your picture the way you want it — but moving the tripod and camera can get to be a nuisance. It is often easier to move a subject around — propping it up on boxes or books, pushing it forward, back, sideways. You can even make yourself a cardboard posing platform and fasten it to the top of an adjustable light stand. That is going a bit far, but for extreme close-ups it may be the best and most convenient method.

*Lighting.* You should light very small objects in exactly the same way that you light larger ones. Period.

*Exposure Readings.* If you are using a built-in meter and your subject nearly fills the frame, a direct reading is usually easy and accurate. If the subject is small in the frame but approximately the same tone as its surroundings, it is still a good bet. However, if a small subject is considerably lighter or darker than the background but average in tone itself, a white- or gray-card reading would be better, provided that the card gets the same light as the subject.

With a separate meter, which is better for indoor work, an incident reading is usually good if the subject is about average in tone. If it is not, use a reflectance reading or bracket. Remember, when in doubt, bracket — that is the professional way.

Any object smaller than the palm of your hand is too small to take a reflectance reading from — you read too much of the background at the same time. This doesn't matter, however, if the object and background are the same general tone; the exposure for the object or for the background would be the same. If there is a considerable tonal difference, take a substitute reading (see Chapter 14). With small objects, this kind of reflectance reading is very useful.

Cantaloupe seeds. Direct light from lower right.

*Checking Focus and Depth of Field.* If you are using your light bounced or feathered, it may not be bright enough on your subject to permit you to focus accurately or to check your depth of field with a depth-of-field preview button or setting. In that case, move the light source very close to the subject and point it right at it, make your checks, then return it to its former position. You need quite a bit of light in order to focus and a great deal of it for checking depth of field when you are stopped down all the way.

# PROJECT 7: POLISHED METAL

In this project you will photograph a polished metal object with the intention of making it look smooth, clean, handsome, and bright. One would think that such an object would look this way in almost any lighting — because it *is* polished — but that is far from the truth. In ordinary lightings a polished metal object tends to look very disreputable indeed. For this project you can use one or more light sources.

*Ordinary Lightings.*  In an ordinary lighting, polished metal often picks up specular reflections, which are simply mirror reflections of the light source(s) and other bright areas. As such they are bright enough to cause serious lens flare or to make dark spots on negatives that are impossible to print through, even with extensive burning in. The resultant white spots on prints usually make the metal object look cheap and tawdry, which is not what you want. Ordinary lightings also emphasize all the minute scratches that a metal object tends to pick up and that make it look as if the object had come from a junk shop. In a proper lighting the scratches and the specular reflections simply disappear.

*Controlled Reflections.*  Photographically, the problem with polished metal is that it can reflect anything, including the photographer and the camera. Though this can lead to some very interesting effects, it is not what people want when they have their polished metal objects photographed.

The solution to the reflection problem is careful control of what the metal reflects. The usual procedure is to make a lighting tent: surround the object with plain, unbroken white surfaces made of paper, wooden panels, or matte acetate. You make sure that there is only whiteness to reflect, and reflecting only this whiteness, the metal looks like clean pewter, which has a diffuse rather than specular surface. To make it look like polished metal again, you simply introduce into the tent a few carefully selected things for the object to reflect.

*Tents: Translucent and Reflecting.*  The word "tent" is a misnomer in a sense, because a lighting tent doesn't have to look anything like a tent. A lighting tent is simply an arrangement of plain white surfaces set up to control light. It may be a foot or two high, or you can turn the whole room into a tent. Outdoors on an overcast day the whole sky is a tent, for it acts like a large white surface reflecting light. There are two general types of tents — translucent and reflecting — which we will get to in a moment. The point is that a tent can look like almost anything at all, as long as it surrounds an object with plain, reflecting surfaces.

A translucent tent is usually made of white paper or matte acetate, often in the shape of a cone or cylinder, sometimes in the form of a box,

**196**

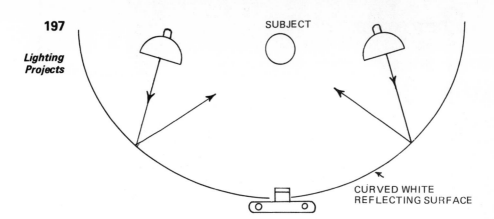

SUBJECT

CURVED WHITE
REFLECTING SURFACE

CAMERA WITH LENS SHADE

Drawing of a semitent—for high-key lightings and for some
types of objects with polished surfaces.

and may entirely surround or encase the object being photographed.
The light is directed at the tent from outside and is thoroughly diffused
as it passes through the material on its way to illuminate the object.
One or two sheets of material can be suspended near the object to serve
as reflectors. What distinguishes this type of tent is that the light
passes through it.

A boxlike tent. A separate light
is directed at each of the sides
and the top. The front can also
be covered with paper or matte
acetate, leaving a single hole
for the camera lens.

Translucent walls and ceiling made of paper
or matte acetate

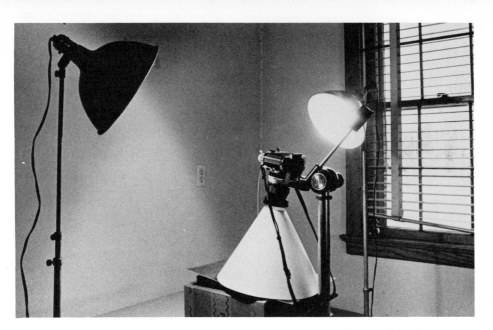

The conical paper tent with which I shot all of my polished metal objects for this book.

The cone or cylinder tents are generally quite small because the matte acetate and thin paper used for making them doesn't usually come in sizes that will make large ones. And making the cone or cylinder cuts the size down quite a bit. Thus this type of translucent tent has to be used for photographing small objects. However, boxlike translucent tents can be made fairly large because the paper size isn't lessened.

With a reflecting tent, bounce light is used. The light sources are put inside the tent and directed outward at the inside tent surfaces. Since the light sources are inside, the tent has to be fairly large, of course. It is often made with no-seam paper, which generally comes in nine-foot widths, and it is usually necessary to construct some kind of a rack for supporting it in the required shape.

*For This Project.* As you may suspect, making a large reflecting tent can turn into quite an engineering problem. In terms of what this project is supposed to do for you it isn't really necessary to make one. Just photograph a small object — a piece of jewelry perhaps — using a conical or cylindrical translucent tent. You will learn just as much from the project working on a small scale. The idea is that you are supposed to see what some of the visual problems are, and small things work just as well as large ones for this purpose.

*Dark Reflections: Intentional or Otherwise.* When you are tenting a polished metal object, there are generally some dark reflections in it

**198** that you would like to get rid of but can't determine the source of. That

is because curved surfaces distort reflections so much. Try this trick: start waving your hand over the object and follow its moving reflection. When the reflected hand enters a dark area on the object, you can be sure that your hand is positioned directly in line between this dark, unwanted reflection and the thing being reflected. Then you can identify that thing and use white to block it off.

On the other hand, sometimes you want to add dark reflections. I have pointed out that tenting makes polished metal look like pewter but that reflections will make it look like polished metal again. For example, you may have an electric toaster reflecting a slice of toast and a dish of butter. For a more romantic look you might use a rose or gardenia. For a more abstract effect you might have the toaster reflecting strips of black paper taped to the inside of your tent in appropriate places. To position them, move them around until the reflections look right in your polished metal, then tape them down. They will usually be out of focus in your print, so that they won't look like cutout paper.

*Lighting Your Translucent Tent.* With a translucent tent one light source is often enough. Striking the tent from one side, it will cast very diffuse but directional light on your object, and the directional quality

Scissors, untented and tented. Note that the minute scratches disappear in tenting as does much of the texture in the background paper.

Silverware, untented and tented. Note that the tented silverware looks much more luxurious and expensive—one of the main points in tenting.

Jackknife, untented and tented. In the untented pictures the blades look rusted or made of cheap metal. The tented picture helps us believe that this is actually a new and very expensive knife.

will contribute to a feeling of solidity in the object. For various reasons, however, you may wish to use two lights. If you do, use the on-and-off trick discussed in Chapter 12 so that you can see what your second light is doing, if anything.

For a white, shadowless background for a small object, put the object on a light box and then put your translucent tent around it. Of course you may not have a light box, but it is good to know what you could do with it if you did. If you intend to make a career of photography, you may have one in due time.

Sometimes a polished metal object will have incised decoration or printing on it that you want to make visible but that may disappear in a tent lighting. In such a case, apply black shoe polish liberally to the incised material, then rub it off the surrounding areas. Very easy to do.

As an alternative to tenting, which isn't always convenient or even the best answer, you can use dulling spray, carried in most large photographic-supply stores. When you spray it on, it gives a shiny object a soft, matte surface, which diffuses the light thoroughly. After shooting you wipe it off.

Though lighting polished metal is a commercial technique, I have asked you to do it as a part of learning to see light.

## PROJECT 8: GLASSWARE

In this project you will photograph one or more pieces of clear, white glassware. The objective is to see what glass does to light, and vice versa, and to explore the type of lighting that is used commercially for glassware photographs. You may use several light sources, though one is usually best.

*Specular Reflections.*   Like polished metal, clear glass has a mirror-like surface that picks up specular reflections of light sources and other bright areas, a situation that can lead to lens flare and pictures in which glass looks cheap and tawdry. You can avoid the reflections by keeping all light from anywhere on the camera side of your setup from striking the glass. This can be done by turning out all lights but one in your working area and by tenting in the glass with black light absorbers. The light that is left is used for lighting the glassware — from behind.

*Light From Behind.*   The one light should be behind your glassware, off to one side, and pointing at a white background. Thus the glassware is transilluminated by light bouncing off the background. That is, it is lit only by the light that passes through it. Only the back surface of the glass has light (reflected) striking it. As we have seen, the front surfaces are protected from light by light absorbers.

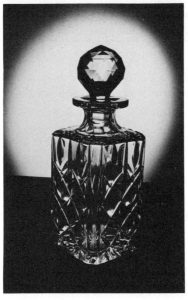

A setup for a white-background shot and the picture made with it. Before shooting, all the lights were turned out except the makeshift background spotlight, which worked very well. Note the strong blacks in the part of the decanter that was in front of the light.

An alternative is to use a translucent background of thin white paper or matte acetate and to put the light source directly behind it. This way, you get a little more control over the shape of the light pattern than with an opaque background, which must be illuminated from one side.

Either type of background should be at least two feet from the glassware so that any defects in the paper or acetate (grain, marks, creases, fingerprints) will be well out of focus.

Though this lighting technique is a trick it is extremely easy to do. It creates handsome black outlines around glassware, making even the cheapest glass look good. It doesn't seem to bother anyone that the glass doesn't look especially glassy. Unfortunately, when glass is lit to look most like glass, it usually photographs very badly. Because of its

**202** transparency, a given piece of glassware will almost disappear into the

background when photographed by lightings other than the one suggested here.

*Highlighting or Shading with Paint.* Even with the correct lighting, part of the contour of a piece of glassware may disappear into the background. It can often be brought out again by smoothing some artist's oil paint on it — use either black or white, depending on how you want the contour to show up. Use the paint right out of the tube without diluting it. To cover large areas, you can use spray-can paint. For this project you don't have to go as far as painting, but you ought to know that it can be done.

*Background Shapes.* You can control the tones you get by putting black or white paper or cardboard behind a piece of glassware, far back

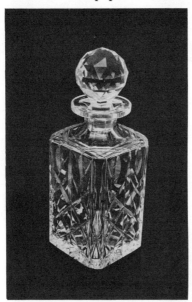

A black background picture and the bounce light setup used for making it. The lighting you see here was actually used for the shot.

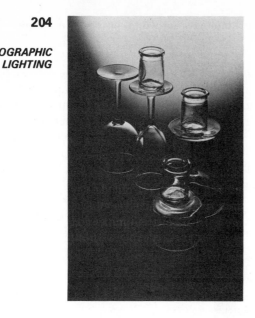

A proper glassware lighting makes even cheap glass look good.

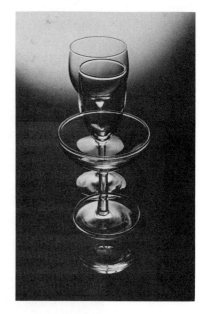

If you look for them you will see several visual illusions in this shot.

I strung rubber bands around this glass in order to get a more linear effect less useful for advertising purposes.

enough to be well out of focus. The paper or cardboard should generally be cut into the same shape as the glass, but for special design effect, you might use another shape.

If your cut-out is white, you can use a black background instead of a white one, if you prefer. The light reflected from the shape will illuminate the glassware from behind. Though it is hard to get the shape exactly the right size and in the correct proportions, you can get some interesting effects with it.

*Posing Shelf.*   A convenient way to photograph some kinds of glass-ware, such as brandy snifters, goblets, tumblers, and cruets is to pose them on a glass shelf. The shelf should be of double-strength glass, about five inches wide and three feet long and can be propped up at either one or both ends with books, blocks of wood, or bricks. For your project you surely needn't go to the trouble of getting a shelf, but it is nice to know about this standard gimmick in the photography business.

Cut glass usually photographs well.

To make this shot I put the glassware on a light box. The picture looks like a semiabstract drawing.

An electrical insulator comes out looking like an expensive piece of glassware.

*Black Tenting.* Tenting to absorb light instead of reflecting or transmitting it is very easy and a useful technique when photographing glass. Using the black sides of 16″ x 20″ mount boards, make a little structure around your glassware. The back side facing on the background should be open, and there should be an opening in front for the camera lens. Since it doesn't have to do anything but absorb light, such a structure can be thrown together in three or four minutes.

A black tent shuts off specular reflections on the surface of the glass and makes the dark tones and lines on it blacker. If there is much light bouncing around your work area, you should consider black tenting a necessity. In any case, include it in your project.

You can do lots of interesting things with broken glass, including cutting your fingers. This rather abstract picture looks quite good, don't you think?

*Exposure.* Remember that your basic lighting is simply light shining on or through a background. Take a reflectance reading of the brightest part of the background visible to the camera, then double the indicated exposure. Nine times out of ten this procedure will give you the correct exposure right on the button. To be doubly safe, however, you might bracket by one stop on each side of the exposure presumed to be correct. Thus you would make three shots altogether.

*Light Box.* A small glass object can be put on a light box and photographed directly. Take a reading from the light and double the indicated exposure. If you want tonal gradation and a spotlight effect, burn in the edges and corners of your print.

## PROJECT 9: DEVELOPMENT CONTRAST VARIATIONS

So far you have done only still lifes and have been primarily concerned with lightings and lighting contrast. Now it is time to take a picture of a person and also to investigate the kind of contrast that is achieved in film development. Contrast is simply contrast, but you can get it in various ways: through the innate contrast between parts of your subject (some being dark things, some being light things), through lighting, through development, through the contrast of the film being used, through choice of printing-paper contrast grade, and so on. This time you will investigate development contrast. Lighting will still be important in the project, but it will be subordinate to other things.

You will shoot three rolls of film on exactly the same pose and lighting. On each roll you will shoot a bracket series of exposures on your model. If you like, you can also shoot a series on something else — a still life, for example — because there will be plenty of film for it. Each roll will be given a different developing time. From the results you will see how exposure and developing time affect contrast, grain, negative density (degree of darkness), and effective film speed (the usable ASA rating).

The reason for a change from still life to live subject is that it is easier for a relative beginner to judge the quality of a negative or print if it has a person in it. You already have a considerable number of ideas concerning what people should look like, and that helps you judge photographs. For example, you have notions concerning pretty skin that will help you judge skin quality in a photograph. Many photographic judgments are based directly on what pictures do to the people that are in them.

*Background, Pose, and Lighting.* Use a medium-tone background, gray for example. The pose should be full front, with the model's head and shoulders filling the frame. Use a side bounce lighting with about 1:4 lighting ratio. You will recall that the lighting ratio is a description

of lighting contrast and that 1:4 means that the light side of the face is four times (two stops) brighter than the dark side.

With a side bounce lighting you can control lighting contrast in three ways: (1) use a light reflector to lighten the shadow side of your model's face or a light absorber to darken it: (2) swing your light back and forth until the contrast is right; or (3) move your model closer to the reflecting wall to increase contrast or away from it to lessen contrast.

Your model should be sitting at least two feet in front of the background so that there won't be any background shadow to affect your judgment when you are examining the test results. For the same reason you should ask your subject to hold exactly the same pose for each shot and to look at the camera quietly with a serious expression, for facial animation might bias your evaluation of your tests.

*Film and Exposure.* Use Tri-X Pan film rated at ASA 400. I ask you to use this particular film because I know what the results will be and that you can glean the required information from them. If you use some other film there might be variations that I can't anticipate.

On each of your three rolls you should make an identical series of bracketed exposures — two stops apart. This exposure difference can be expressed in terms of stops, the ASA speed at which the film is being exposed for each shot, or the number of times the normal exposure (e.g., ¼ normal or 4 × normal) that you are using for a shot. For your information, we will group all these data together. For each roll the series should be as follows: four stops underexposed ($^1/_{16}$ normal, ASA 6,400), two stops underexposed (¼ normal, ASA 1,600), normal exposure (1x normal, ASA 400), two stops overexposed (4x normal, ASA 100), and four stops overexposed (16x normal, ASA 25). This will give you five exposures on each roll of film.

If you are loath to waste film, you can use up the rolls by shooting duplicate exposure series on other subjects, still lifes, for example. Have them set up and lighted in advance so that you don't waste much of your model's time. Have the exposure figures worked out, too. If you have any doubts about what you are doing, use the same lighting for both your model and your setups; you can then use the same exposure figures. Since side bounce lighting works well on many things, you wouldn't be taking much of a risk of ruining your pictures.

*Developer and Development.* Develop your film in straight D-76 at 68F, agitating for five seconds every minute — except with one roll. On the roll with the shortest developing time you should agitate every thirty seconds. The developing time for the three rolls should be four minutes (½ normal development), eight minutes (normal development), and sixteen minutes (2x normal development).

*Examine Your Negatives.* You will find some surprising things on your negatives. For example, the contrast varies with both developing

time and exposure. The negative density also varies with both. A negative with 1/16 normal exposure and 2x normal development is still printable (barely). A negative with 16x normal exposure and ½ normal development is very printable. And so on.

I don't suggest that you should use such exposure-development combinations as an everyday thing, yet you should see some of the possibilities of the film. For example, you can shoot Tri-X at ASA 6,400 if you have to (e.g., in very dim light), but the results won't be particularly good. However, in many cases poor results are better than none.

*Printing.* Unless you are an expert at reading negatives, which is unlikely at this point in your career, you should print some of the test negatives to find out how good (or bad) they are and to see graphically how much the contrast is affected by differences in film developing time. Print at least the normal negative and the exposure-development extremes. With the others you can fairly well guess what they will do.

Make the best prints you possibly can. Otherwise, your tests won't really tell you very much. Among other things they will show you the extremes at which you can work and still get acceptable results. If your prints aren't your best, you won't know which test results are actually usable — some of them really aren't, you see, but you have to identify them. If the tests didn't go beyond the range of acceptability they wouldn't be proper tests.

# PROJECT 10: PERSPECTIVES

In this project you will make some pictures using the information in Chapter 6, which shows how geometry affects our awareness of space. The objective is to see for yourself that the concepts actually work and to make interesting pictures in which space is greatly falsified in an undetectable way. You can use the illustrations in Chapter 6 as a guide. Shoot enough pictures to be sure that you know what is happening. If you are working in a class situation, your instructor will tell you how many to do.

*Skewed Regular Shapes.* Review Chapter 6, paying particular attention to the material on skewed regular shapes, which you will use in this chapter. Note the following: (1) a trapezoid is a skewed rectangle; (2) an ellipse is a skewed circle; (3) intersecting lines or edges are skewed parallels (or perpendiculars); and (4) an S curve with a small top and large bottom (or vice versa) is a skewed regular S curve.

When one of these skewed shapes shows up, it tends to distort the space that it occupies. It may extend, compress, tilt, or completely invert space, the effect being especially strong in photographs in which contradictory space cues have been minimized.

This little picture is actually upside down, of course. It shows how far you can go to distort the truth when you play with pres-kewed regular shapes. Some of the pictures in Chapter 7 illustrate this project.

Though this picture is actually rightside up it will look just as normal if you turn it upside down.

This picture is actually upside down. The provers (coffee cups) show this. However, no matter how you turn it you will find one of the coffee cups hanging in the air.

For this project cut one or several of these shapes out of heavy paper. It is easiest to construct skewed rectangles (trapezoids) or shapes with skewed parallel edges (V shapes). To make accurate ellipses you need an ellipse template available from an artists' supplies store.

*Skewed Checkerboard.*   Even without any special artistic talent it is quite easy to make a skewed checkerboard. Such a board can really make picture space jump through hoops. It combines the qualities of a space gradient with the powers of skewed regular shapes (the "squares"). You can draw the lines for it with a ruler and a ballpoint pen, then fill in alternate squares with a marking pen that has a small point. The longest dimension (the front) should be about 12 inches. (See the illustration in Chapter 7.)

*Assumption of Size Constancy.*   One good experiment with space is to take a number of objects that look almost exactly alike but are of different sizes, from quite large to very small, and arrange in gradients from large to small or vice versa. Viewers will assume that they are actually the same size, especially when they see pictures of them. Having made this assumption, they will then perceive greatly falsified space as real. Space in your pictures will be extended, compressed, tilted, or even inverted.

Perhaps the easiest way to get shapes of this sort is to make a bunch of smooth clay balls — ten or fifteen of them, varying in size considerably. Stones picked up at the beach are also good, provided that they are smooth and look a lot alike. Seashells of all sizes are also good. Though small ones generally don't look much like larger ones, nobody will notice the difference. When things are relatively unfamiliar, they don't have to look very much alike in order for us to make the assumption of size constancy. Remember, we have a natural tendency to assume that things alike in some ways are alike in all ways.

*Horizons.*　You will probably need a horizon in most of your pictures. You can make one easily by partly covering a light piece of paper with a darker one, the light piece serving as the sky. Or you can have the two papers (or cardboards) in different planes, with one horizontal and the other standing vertically behind it. In either case, the line of apparent juncture between the two will form the horizon.

*Manipulating Space.*　A horizon plus one or more skewed regular shapes plus variable-size look-alike objects will help you to extend space considerably and at the same time tilt it back. By juggling the positions of these three main elements you can also compress, completely destroy, or invert space. For example, with a horizon in the wrong place, a paper trapezoid turned wrong end to, and objects in the wrong place and arranged in the reverse order of size, you can turn space upside down in a photograph. This verbal description won't help you much, but you will see what I mean when you begin juggling the elements.

Sometimes you may create strong space distortions and not be able to see that you have done so. To minimize this problem, carefully check each arrangement through your camera view finder, where the distortions will work best. Because it is selective, the view finder excludes many of the contradictory space cues in the environment surrounding your setups, thus making your false cues stronger.

*The Picture Idea.*　Naturally, you want your pictures to be built around ideas — but what ideas should you embody in your space manipulations? When you think about it, the answer is absurdly easy. Your pictures should simply express the idea that pictorial space can be manipulated or changed around. And this can be done in such a way that people are forced to see that something fishy is going on, even while they are accepting the falsified space data. Finally, such things can be done in well-composed and well-lighted pictures.

*Provers.*　As you will soon see, falsifying pictorial space data is really quite easy. For example, it is easy to make a space ten inches deep seem to be three feet deep — try it and you will see. And sometimes that ten-inch space will even seem like ten feet, believe it or not. Once you begin to manipulate space cues, all kinds of interesting things can happen.

Unfortunately, merely juggling space around won't make a picture. Most pictures have space of some kind — so what? Space is just something that we expect a photograph to have. Thus a picture in which space has been successfully juggled may look just like any other picture, so nobody will notice what has been done.

The trick is to see falsified space as real and at the same time provide strong clues that everything is actually haywire. That is, you want to juggle space and at the same time prove that you have done so. For this you need "provers" of some kind to show what space was doing before it was juggled. My favorites happen to be glasses of milk or cups

The preskewed rectangle makes the shell seem distant, though it was actually close by.

When the elements are switched around, everything seems to be flying through the air, though the picture is still right side up. However, it may look more reasonable to you upside down.

of coffee. If one of my pictures shows a glass inverted and still containing its milk, you can be sure that space itself has been inverted and that the picture is actually upside down, though it seems to be upright. Thus I deliberately use contradictory space cues — false ones and real ones (the provers).

There has to be a balance between these real and false space cues. Neither type should overwhelm the other but on the contrary, there should be a continuous conflict going on in the eyes of the viewer between accepting the real and the false. This conflict is what makes a space-distortion picture interesting and should be considered a basic.

Oddly, it is much easier to distort space in a picture than to include proof that you have done so. Though such proof is not always necessary, you should attempt to put it into all the pictures that you do for this project. It will help you to see what you are doing with space. It is not enough to juggle space, which is easy to do — you should also know the what, where, why, and how of the things that you are doing.

**213**

*Lightings.* For most pictures of this type, side bounce lighting is best, though side lightings with direct light can also be good. Side lighting tends to make objects look solid, and with this apparent solidity you get the feeling of empty space between things. You see, you have to create space in order to juggle it, and lighting is one of the chief tools for this purpose.

To take the space out of a setup — which you may also want to do sometimes — use low-front bounce lightings (bounce the light from the wall behind the camera). They tend to destroy the solidity of objects and the space between them. Please understand this: in order to understand space distortion you should destroy space as well as create it. Understand further that the things you do artificially often happen in nature and are frequently seen in pictures if you know what to look for. Some photographers find them happening all the time.

*Shadows.* Sharp-edge shadows, which are made with direct light, tend to strongly define everyday three-dimensional reality. Thus they are liable to contradict efforts to falsify space. Unless they are used carefully, they may give the trick away, so to speak.

Soft-edge shadows, which come from diffuse lightings such as bounce light, also define everyday dimensional reality but in a much less specific way. Thus when space is juggled, the shadows are much less likely to give the deception away. Indeed, you can use soft-edge shadows to get almost any kind of pictorial space you want.

*Purpose of the Project.* The concept behind this project goes beyond merely playing with space, though that is a good thing in itself. The project is designed primarily to help you understand the geometry of space and how it works in everyday perception. It is therefore an extension of Chapter 6, which has the same purpose. There are reasons why we see the way we do, and it is possible to uncover and understand them.

## PROJECT 11: CANDLES

In this project you will make a picture by candlelight, using one or more candles. It can be either a still-life setup or a portrait. Though they don't give off much light, candles are excellent light sources for photography — doing the project should convince you of this. You may see that you don't have to have hundreds of dollars worth of lighting equipment in order to make good pictures. Indeed, some of our best photographers get along with very little of it.

If you wish, you can use supplementary light sources, though the candlelight should dominate in your pictures. For example, when photographing a person, you may use candlelight in the foreground and light the background with a 25-watt bulb.

A candle, a melted plastic egg, and two sheets of cardboard.

White wood blocks and metal washers embedded in paraffin. The candle is behind the washers, of course.

This plastic bottle was blasted with a blowtorch. There is a small candle behind the left side of it. I used the sand to create a little landscape.

Luminous eyeball with two candles.

It doesn't matter what kinds of candles you use, so you might as well buy the cheapest ones you can find. Get a bunch of them while you are at it because they get used up very fast.

There is a special advantage to candles in that you can put them in and behind the things in your setups, which is often very difficult to do with other types of photographic light sources. Since the light they cast is relatively dim, it doesn't hurt to have them this close to things. The important fact, however, is that you can get very interesting pictorial effects with this kind of placement.

*Film and Exposure.*  For this project you should use a fast film like Tri-X (ASA 400). Even with this speed you may get some long exposures, especially if you stop down very far. At these long times you must consider the exposure correction for the reciprocity effect (see Chapter 12).

With a separate meter it is probably best to use an incident reading. The average meter will give you good readings at a candle-to-meter distance up to six inches, which is usually enough. With a very sensitive meter, such as the Luna-Pro, you can read from distances up to three feet or more. However, exposure times are very long with a candle that far from a subject.

Most built-in meters aren't much good for reading candles, because they cease to function at low light levels. They simply aren't sensitive enough, or the coupling range isn't long enough. You can get around this problem by using the exposure chart (Chart 14.1), which I made from data obtained by reading a candle with a Luna-Pro. The speeds of

At first, all the candles were burning at once, which generated a lot of heat, melted many of them, and set the cardboard afire.

Perhaps this would be good for a Christmas card.

Chart 14.1

**Lighting Projects**

| Candle-to-subject distance | Exposure chart for ASA 400 film with candlelit subjects (figures include corrections for the reciprocity effect) | | | | | | | |
|---|---|---|---|---|---|---|---|---|
| | f/1.4 | f/2 | f/2.8 | 1/4 | f/5.6 | f/8 | f/11 | f/16 |
| 3 in. | 1/60 | 1/30 | 1/15 | 1/8 | 1/4 | 1/2 | 2 | 5 sec. |
| 6 in. | 1/15 | 1/8 | 1/4 | 1/2 | 2 | 5 | 10 | 25 sec. |
| 1 ft. | 1/4 | 1/2 | 2 | 5 | 10 | 25 | — | — |

one second or longer are already corrected for the reciprocity effect, so that you don't have to bother with figures.

At such slow speeds you will probably have to use a tripod, especially if you stop down much. Of course, you have probably been using one all along.

*A Further Project Objective.* Besides proving to yourself that you can make effective pictures with candles, you will have a particular kind of experience with light when you do this project. Also, it will promote your love affair with light, surely a good reason for doing a lesson of this type.

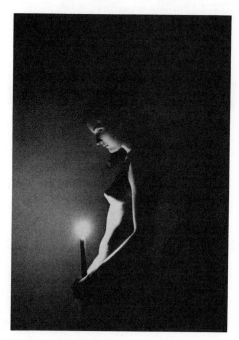

Though the candle flame is small it can light rather sizeable subjects.

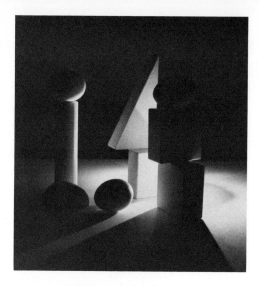

White blocks, white eggs, and the light from two candles behind the blocks.

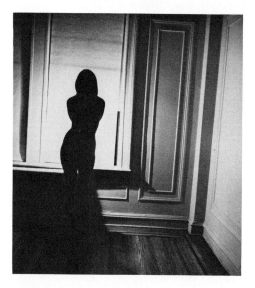

The entire end of this room is lit by the single candle behind the woman.

A separate candle behind the doll provided the illumination for this rather strange picture.

## PROJECT 12: PAINTING WITH LIGHT

In this project you will make pictures by painting with light, a classic technique in photography. The objective is to see some new things that you can do with light, using a method that can produce some unusual results. For light sources you will use two flashlights; though they are inexpensive they are excellent photographic light sources.

**218**

*The Gist of It.*   Make a still-life setup and focus the camera on it. Then turn out all the lights, so that the room is pitch black, and open the camera shutter ("B" setting) and keep it open. Turn on a flashlight and begin tracing a light pattern around your subject at a light-to-subject distance of, say, one to three inches. The traced-light pattern will record on your film and will look something like a painted track, hence the name of the technique. When you are finished with the pattern, turn off the flashlight, close the camera shutter, and turn on the room lights.

As you see, the flashlight is handled as if it were a paint brush. Wherever the beam touches your subject it will record on your film. If you are tracing a linear path, you will get a line of the same shape as the path taken. If the light is held stationary, you will get a more circular or elliptical shape. By going back and forth with the light, you can paint in whole areas.

*Preparing the Flashlights.*   You need two flashlights, one with two AA cells, the other with two D cells, and in order to get satisfactory results, they have to be prepared in a special way. If you use a flashlight without modifying it, the pattern of the light beam may show up in your pictures. (The pattern comes from the filament of the bulb.) Also, you will have to contend with an appreciable amount of light that shines sideways. You don't want that light because it will strike your film and spoil your pictures. Both problems can be solved easily.

Light position for painting with light. Notice that the penlight is hooded and that it is within the picture area.

The sculpture was painted from two positions, the portrait from one.

Remove the pattern by taping a transparent matte plastic tape, such as Scotch Magic Transparent Tape, over the end of the flashlight. The matte surface of the tape diffuses the light, making it very even.

To mask off the light that shines sideways, tape a two inch-cylinder of black paper to the end of the light, thus making a little snoot that converts your flashlight into a small spotlight. With the snoot in place you can have your flashlight in camera range (within the picture area) while you are doing your painting. If the flash is angled slightly away from the camera, no light will go directly from it to the film. Instead, the film will see only the light reflected from your photographic subject. The fact that you can do your painting within camera range gives this technique great flexibility.

*Necessary Dark.*   Your painting must be done in a totally darkened room because the camera shutter will be open for quite a while. The open time may range from ten seconds to ten minutes or more, depending on the size and complexity of the thing you are painting. Don't worry about this: in total darkness the shutter can be open for days and the film still won't get exposed.

With your flashlight turned into small spotlights, you can shine them here and there around the room without exposing your film. As long as the light pattern doesn't fall within camera range, the film is safe. Even if a small amount of light does reach the film, it won't matter, for it takes quite a bit of light to have much of an effect. The fact that you can shine the light around the room will keep you spatially oriented to your subject matter, so that you can tell which parts of it you wish to illuminate. When your eyes are adjusted to darkness, they are much more sensitive to light than your film is, especially when the lens is stopped down quite a bit, as it should be for painting with light. Thus there is less chance of inadvertently exposing your film than you might suppose.

*Holding the Shutter Open.*   Of course you need a camera with a shutter that can be held open. It will probably have a "B" or bulb setting. To hold it open you need a cable release with a lock on it for this purpose. The several inexpensive types that are available seem to work equally well.

*Painting Patterns and Practice Runs.*   Your film will record any patterns that you make with your lights — straight lines, circles, parallel lines, or whatnot. Use your large flashlight for large patterns — for example, one end of a room. The penlight will usually be better for still lifes.

If you switch a light on and off without moving it, you will get a spotlight effect in your picture. Or you can do this several times, with the light in a different position each time, and get the effect of having several spotlights.

I ran the penlight all around the edge of the doll at a very low angle. There is absolutely no way of getting this kind of lighting with a stationary light.

Using linear patterns, you can easily get effects that are impossible to duplicate with stationary light sources. Thus you find yourself in an entirely new realm of photography. Indeed, flashlights have unique possibilities as photographic light sources.

Since you are using moving light patterns, there is no way of telling exactly how your pictures will come out. However, you can make informed guesses by making practice runs before you open the camera shutter. At least you will know the things that the light will touch on and those things that will be left in the darkness. For a still life you will probably find that the best lighting patterns will come from having your flashlight within two or three inches of the surface being lit. A good starting point is to trace it around the contours of objects in a setup; without half trying you will usually get an interesting result.

*Another Reminder.*   It seems a good time to take a short detour and remind you of the main themes in this book. It won't hurt you to know what you are expected to get from it, though it is easy to forget as you go from chapter to chapter. The main propositions in this text are as follows: (1) light creates the visible world and is in fact the only thing that you can see; (2) the most important part of becoming a good photographer is learning how to see; and (3) this in turn means making yourself acutely aware of what light does to things and what things do to light. I hope you have been aware that this is what your book is all about. For example, the main purpose in all of the projects is to help you teach yourself to see. When you have learned to see, you will have little need of teachers like myself.

I remind you again of your necessary love affair with light — let us hope that it is progressing well. Working with minispotlights (your flashlights) in a darkened room should give it a tremendous boost forward. Falling in love with light is much more important than the fact that you can also get interesting pictures with this technique.

I ran the light around the edges of these pictures, then zapped the center of each one. This effect could not have been obtained with a stationary light.

I painted the left side of the picture, then stood in front of the door and painted that.

*Exposure.* In shooting still lifes, you should expose at f/16 most of the time. It will give you good depth of field and exposure times that are long enough for painting — from one to four seconds for each area painted.

It is easiest to take an incident reading. Decide how close to your subject you are going to hold your light, then use that distance as the flashlight-to-meter distance. This distance is all that counts — your meter doesn't have to be held in your setup. The readings should be made in a darkened room, of course, with only your flashlight providing illumination.

You can also use reflectance readings. If the flashlight-to-subject distance is more than three or four inches, you may have to use a white card (see Chapter 14). With a built-in meter, move in close enough so that you are reading nothing but the light pattern. If the light is not bright enough for a built-in, use the chart which follows.

**222**

Indicated and adjusted exposure times at f/16 for an ASA 400 film, with two different types of flashlights at various distances

| Light-to-subject distances | | 3 in. | 6 in. | 1 ft. | 2 ft. | 4 ft. |
|---|---|---|---|---|---|---|
| Flashlight with 2 AA cells | Indicated exposure times | 1 sec. | 1 sec. | 18 sec. | 12 sec. | 1 min. |
| | Adjusted exposure times | 2 sec. | 2 sec. | 13 sec. | 25 sec. | — |
| Flashlight with 2 D cells | Indicated exposure times | 1/15 sec. | 1/4 sec. | 1/2 sec. | 2 sec. | 7 sec. |
| | Adjusted exposure times | 1/15 sec. | 1/4 sec. | 1/2 sec. | 5 sec. | 20 sec. |

*A Flashlight Exposure Chart.*   If you don't have an exposure meter sensitive enough for work with flashlights you can still do this project. You merely use Chart 14.2, in conjunction with exposure bracketing. It is intended for a film with as ASA speed of 400, such as Tri-X. Indicated exposures are those that were determined by meter readings when the chart was being constructed. Due to the reciprocity effect (see Chapter 12), they were not accurate for exposure times of one second or longer. The adjusted exposure times are the ones you should use because they are corrected for the reciprocity effect.

The times are given for f/16 because you will probably use this aperture setting most. However, if you wish to use your lights at quite a distance, you can open up your aperture and get a reasonable exposure time. For example, an indicated exposure time of one minute at f/16 (for a 2 AA cell penlight used at a distance of four feet) would convert to an indicated one second at f/2. The adjusted exposure would then be two seconds.

To obtain the charted data I made incident readings with a Gossen Luna-Pro. The batteries were all Ray-O-Vac Alkaline Energy Cells that had never been used prior to the test. Both flashlights had black paper snoots and were diffused with Scotch Magic Transparent Tape.

I ran the light around the side of my fingers, then brought it across the back of my hand.

The closer you come to duplicating these conditions, the more accurate your exposures will be when you follow this chart.

Unfortunately, flashlight cells fade rapidly, so you should consider using exposure bracketing as a safeguard. Use it in conjunction with the chart. When your batteries are brand new, you probably won't need bracketing, but after they have been used for three or four minutes you should start doing it. Do all of your bracketing on the side of overexposure. For example, get your normal exposure from the chart, then make two overexposures one stop apart. Since you know that the batteries are fading, there is no point in making underexposures.

*Exposing for a Moving Light Source.* If your adjusted exposure time is two seconds, it doesn't mean that your flashlight should be turned on only for that period of time. Indeed, if your light is moving, it may have to be turned on for a much longer time. The two seconds refers to the amount of time the light should fall upon each part of the setup. Since the light is moving, it is hard to gauge this time accurately, but guesswork usually works well enough. In practice runs count the seconds under your breath to help you decide how fast to move your flashlight; then use that speed of movement when you make your exposure. Don't worry about the guessing — everybody who paints with light has to do it. It was before your time, but there was a very long period in photography when nearly everything was guesswork.

*Other Subject Matter.* For your convenience, I have suggested that you do your light painting with a still-life setup, but there is otherwise no reason why you should limit yourself. With your large flashlight you might like to paint all the furniture in a room, or you might like to go outside on a dark night and paint your whole house with stripes or polka dots. Painted portraits can be fun. Instead of moving the flashlight, just turn it on and off, hitting a different part of the face during each on period. You will thus get a series of individual exposures on one piece of film. For an interesting effect you might have your model move slightly between exposures.

224

Perhaps the most important thing is to enter into this project with a spirit of play. So keep that in mind and permit yourself to have a good time.

## PROJECT 13: LIGHTING INFORMAL PORTRAITS

In this project you will shoot a series of pictures of one person, using a different lighting for each shot. Though you should try to make pleasing informal portraits, your main objective should be to see what the various lightings do to your subject's face. As you will see, the effects will be quite different.

*Lightings That You Care About.* One of the problems in learning to see light is that it falls on many things that you simply don't care about. Thus you find it hard to be interested in what light does to them and vice versa. For example, light does things to a rock, and a rock does things to light — but do you really care?

For your portrait subject choose someone you like. If you do, it will be much easier to care about what light does to him or her. You will want your portraits to be good, and that will depend a lot on the lightings. Not all of them will be appropriate for the particular person you choose, and you will be concerned that some lightings don't work well and pleased that others do. As a result, you will find yourself readily caring about lightings as such.

*Controlled Light.* Like most photographers, you have probably already shot a lot of informal portraits by available light (see Chapter 15) and have had most of them come out well. In most of the situations in which people shoot portraits, available light works out exceptionally well. Without even thinking about it, you get good lightings. This happy situation will no longer prevail when you start using light fully under your control.

In truth, some of your controlled lightings will be awful, which happens to be a very good thing. Their very awfulness will lead your attention to what light does to a face. It makes a face visible, of course, but it does a lot more too. It can make a face handsome or ugly. It can make it look fat or thin, rough or smooth, regular or distorted, masculine or feminine. Without light you see no face at all; with it you can get almost any effect.

For this project don't try to avoid lightings that don't work on your model, but instead explore them to see what makes them that way. Though there are people who look good in all lightings, that is not true of the average person. And it will help you because you are trying to learn all the things that light does, not limit yourself to its handsome effects. In order to see the beautiful you must learn to see the ugly as well.

Broad lighting: the broad side of the face is illuminated, casting a nose shadow on the narrow side.

Narrow lighting: the main light strikes the narrow side of the face. The fill light is fairly close, making this a lighting ratio of about 1:3.

*Tricks for Good Seeing.* While you are doing your portrait lightings, you should be using the seeing tricks mentioned in Chapter 10. In fact, you should be using them in all of your projects, for they are very useful tools for your craft.

Make frequent use of the one-area-at-a-time trick, paying particular attention to form and cast shadows on the face and neck. For example, with a high front or butterfly lighting you should see definite shadows under the eye sockets, nose, upper and lower lip, and chin and jaw. Check the lightings out one at a time and decide whether you like them that way or would prefer some other way. You may wish to change them, for example, when a nose shadow extends down to the upper lip, giving the effect of a harelip.

One trick to good seeing is to have enough things to look for and wonder about. In the case of portraits, look for the shadows already mentioned and other shadows under the eyes, along one or both sides of the nose, in the laugh creases beside the nostrils, under the edge of the hair, in hollow portions of the face, and in wrinkles. Look for these shadows and wonder whether you would like them changed or not. Experienced photographers spend quite a bit of time making themselves aware of skin, looking for such things as sheen, texture, pits, lines, smoothness, the feeling of liveliness and health, and so on. They note these things, then wonder how they can make improvements. Of course they move their lights around a lot to see what difference it makes, which is usually quite a bit.

You should also think about hair — how it is combed or arranged, how it joins with the brow, face, and ears, what light is doing to it (e.g., making it look dull or shiny). Look for signs of stress or tension in the brow, mouth, or neck. Above all, see what the pose, expression, and lighting are doing to the eyes.

Until you have become quite expert at informal portraits with controlled lightings, you should perform this area-by-area analysis of your subjects. Since staring at people can make them nervous, you should forestall possible anxiety by simply telling the subject what you are doing. For example, you can say, "I am looking at your face one part at a time in order to see what light is doing to it. I want the light to emphasize your best features." When people know why you are staring they don't mind it. However, it helps if you make little affirmative exclamations like "yes" and "fine" while you are doing your looking.

*Classic Lightings.* The lightings in this project are all classics. That is, photographers as a group have been using them effectively for many years. In this connection, there is no value whatever in novelty — the basic lightings that work well on faces were discovered long ago, and that's it. Indeed, the great painters discovered them long before photography was invented. But don't despair — this fact won't limit your creativity.

Rembrandt lighting: a kind of narrow lighting that creates an inverted triangle of light on the near side of the subject's face. The lighting ratio is about 1:4.

High front or butterfly lighting: notice the butterfly shadow under the nose. Both lights are very close to the subject-to-camera axis.

*Main and Fill Lights.* In portraiture, a light source is called either the main or the fill light, depending on what it is doing. The main light is closest to your model and establishes the main pattern of light and shade on the face and body. What the picture will look like is chiefly determined by the main light, hence its name.

The main light may create dark shadows, which you may or may not want. If you want to lighten them to some degree, you use a fill light — it "fills" the shadows. In so doing it makes the things within them more visible. Filling the shadows also reduces the lighting contrast, which can vary (according to the amount of fill) from very high to very low. This establishes a shadow-to-highlight brightness relationship, usually called a lighting ratio. The most popular lighting ratio is about 1:3, which means that the highlight side of the face is about three times as bright as the shadow side. You can measure the difference with an exposure meter.

Professional portraitists usually restrict the lighting ratio to about 1:3 in order to make sure that the skin in the shadow areas of the portrait will still look like skin. With a higher ratio it may start losing the quality of skin altogether, though that doesn't always happen. And a very high ratio can make a face look hard and rocklike. Using a fill light will prevent this effect.

The fill light is usually positioned close to the subject-to-camera axis to limit the number of obvious double shadows (combination shadows cast by the by the main and fill lights working together from different angles), which are not considered attractive. The fill light should be fairly high on its standard and feathered downward.

*Feathering.* As you probably remember, to feather a light means to point it past your subject rather than right at him or her. In this way only the edge of the light pattern strikes the face. Feathering brings out facial detail and skin tone very well and avoids blinding your model with the full glare of a very hot light source. For these reasons you should do a lot of feathering with your portrait lightings.

A number of lighting terms apply particularly to portraiture. We have already discussed them but will review them here and elaborate on their use and effect.

*Broad Lighting.* The model is in a three-quarter pose, with the side of the face (the *broad* part) nearest to the camera. The main light, which may be feathered, strikes this side approximately at a right angle, thus completely illuminating it. The subject's nose casts a shadow on the far side of the face. If a fill light is used it is usually the opposite side of the camera from the main light. Broad lighting is especially good for fattening up faces that are too thin and gaunt. If diffused, it minimizes pimples and pock marks on the side of the face. It is not good for people who are chubby or fat.

Side bounce lighting: the light bounces off the wall onto the young man. It is a very soft lighting.

Overhead bounce lighting: the light bounces off the ceiling onto the subject. This is the easiest lighting of all to use.

*Narrow Lighting.* The model is in a three-quarter pose. The main light, which is off to one side, strikes only the front of the face (the *narrow* part when viewed from the camera position). The broad side, which may be illuminated by a fill light or reflector, is usually substantially darker than the narrow side. If a fill is omitted for dramatic purposes, it may be very dark indeed. Narrow lighting gives a head a good feeling of solidity and realness. It makes chubby or fat faces look more slender. It is not very good for thin or gaunt faces, unless you wish to emphasize these characteristics. Narrow lighting tends to emphasize blemishes along the line between the side of the face and the front, though diffusing the light will lessen this problem.

*Rembrandt Lighting.* A narrow lighting in which the main light source makes a small inverted triangle of light on the frontal area of the face nearest the camera. The side of the nose, the upper lip, the chin, and the broad side of the face are illuminated only by a fill light or reflector. A lighting ratio of about 1:4 is popular for this lighting. Used mainly for men, especially so-called character portraits, it tends to make them look more rugged. If the subject has a long nose or deepset eyes this lighting is difficult to use. The idea for it was borrowed from portraits by Rembrandt.

*High Front or Butterfly Lighting.* The model faces the camera. The main light is directly in front of the face and somewhat above it. The eye sockets, lower eyelids, nose, upper lip, lower lip, chin, and jaw cast shadows directly downward — if no fill light is used the effect can be quite dramatic. Though frontal lightings usually reduce the feeling of solidity and space in a picture, this one produces a good dimensional quality.

In the golden years of Hollywood, this lighting was often used for glamour pictures of actresses because it emphasized facial features considered beautiful. For faces that are less than perfect, this lighting is usually not a good bet, because it deepens eye sockets and shadows under the eyes, delineates unbecoming muscular structures just below the corners of the mouth, and emphasizes facial blemishes along the jaw line.

*Low Front Lighting.* The same as a high front lighting, except that the main light is relatively low on its standard. The effect, however, is quite different. The eye sockets and eye shadows are filled in, so to speak. So are the structures under the corners of the mouth and blemishes along the jaw line. A diffuse lighting of this type is often good for faces that are lined, rough, or badly pock-marked. Though this type of frontal lighting flattens a person out quite a bit, it flattens out blemishes at the same time, which is a good thing. Anyway, a flat lighting on a portrait never seems to bother anyone except photographers.

Ghoul lighting: the light from directly below the chin makes a person look rather like a ghoul and is certainly not very flattering.

*Side Bounce Lighting.* The pose may be front or three-quarters front. The subject is crosslit by light bounced from one side. This lighting gives a very good three-dimensional quality. Since the light is bounced from the wall or some other reflecting surface, it is diffuse and soft and flatters the skin, minimizing blemishes. The lighting approximates available light, outdoor light from open shade, and indoor bank lighting, all of which are popular with experienced photographers. Because the cast and form shadows all have soft edges, the lighting generally makes faces look very good. On account of this softness it is often used without any fill light. This builds up a feeling of solidity without doing injustice to the model's face.

*Overhead Bounce Light.* This lighting will work with almost any kind of a pose, which is why it is used frequently with electronic flash. With flash you can't predict the effect that a lighting will give you, but with overhead bounce you can be pretty sure that it will be all right. The light is bounced from the ceiling or from a horizontally suspended reflecting surface.

If the light stand is near the model, the dimensional effect will be quite strong, though the eyes may be shaded too much by the eye **232** sockets. For a flatter effect — for example, for a high-key picture — the

light source is moved back behind the camera. This position is exceptionally good for faces that are badly lined or blemished. If the light stand is about six or eight feet from your subject, you don't really have to worry about what light is doing to the face but can pay attention to other things, such as pose and expression.

*Ghoul Lighting.* This lighting is popular for making people look like Halloween monsters. You put the light source on the floor so that the light comes up right underneath your model's chin. Put a stack of newspapers under it so the floor won't get scorched and warn your subject not to touch the hot reflector. You ought to try this lighting just to see what light will do. Since it makes most people look horrible, I need say no more about it.

*The Easiest Lightings.* Side and overhead bounce are by far the easiest lightings to work with because you don't really have to see what you are doing with them. Just about everything that happens in front of your camera is likely to be flattering to your subjects. That is because the lightings are extremely diffuse and create cast and form shadows so soft that they hardly look like shadows at all. In lightings where the light sources are pointed directly at your subjects, the resulting shadows can give you a tough time, because they are very plainly there and often not doing what you want them to.

*Harder Lightings Are Better.* With broad, narrow, Rembrandt, high front, and low front lightings you point your lights at your models (though you may feather them somewhat) and thus create clearly discernable cast and form shadows that you must handle to make your pictures come out well. Unhandled, these obvious shadows can wreak all kinds of havoc with faces. For example, a nose shadow of a certain kind can make the nose look broken or pushed over to one side. And a sharply defined shadow under a chin can look like a slashed throat. So you see that you do have to pay close attention when you use these lightings. However, that is to your advantage.

Consider yourself lucky when shadows cause trouble because then you *see* them — which is what this book is all about — *seeing!* If you don't see these ill-formed cast and form shadows while you are shooting, you will surely see them in your prints, where they will probably be messing things up with glee. After one or two disastrous experiences you will be on the alert for shadows *while you are creating them,* which is the way it should be. Then you can make them work *for* you instead of *against* you.

So be thankful for the few terrible pictures you are almost sure to make. They will help you see the difference between "goodness" and "badness" in your lightings and thus do much to promote your understanding of light and what it can do.

For this project you will make some figure photographs, preferably abstracts rather than full figures. An abstract is a part of a figure, presumably photographed for its interest or beauty. A part of a figure is much easier to photograph well than is the whole figure. It is also much easier to analyze in terms of its purely aesthetic qualities.

When you work with the human body you are examining the very source of human aesthetic ideas, many of which are involved with concepts of beauty. That is, we base our aesthetic ideas almost entirely on ourselves. In doing figure photography you are thus confronting in a direct way the very foundation upon which art is built. It provides you with a solid basis for ideas concerning both beauty and ugliness, particularly if you work with figure abstracts. Work with figures helps you see both qualities as tangible so that you can learn to create either one at will, not only in figure studies but in all of your photography.

Wherever they are found, both beauty and ugliness are made up of specific elements — lines, edges, tones, textures, colors, and so on — and figure work will help you see what they are. When you learn to see such things in figures you will be able to see them elsewhere, too.

*Seamless Backgrounds.* It is difficult to find good environments in which to do figure studies, mainly because of ideas concerning pornography. In most places that are convenient to work in, pictures of nude men or women come off as pornographs, basically because the public doesn't think that nudity per se is nice — especially if it is displayed in an everyday environment.

A more artistic objection to everyday environments is that they can be too distracting in pictures. For example, the decor in a living room may make it impossible to display a nude figure appropriately. The furniture may insist on looking too prosaic, middle class, and homely. It may also symbolize things that you don't happen to want in your pictures. In any case, it distracts from what you are trying to do.

The answer to these problems is the seamless paper background, especially for beginners. When you use it for figure work, it makes it quite obvious that your intentions are artistic, not pornographic. People will give you credit for trying to produce art, partly because such a background helps you divorce figure work from anything that relates to everyday life. The public idea is that anything that is supposed to be artistic shouldn't involve such ordinary things as sofas, TV sets, beds, washing machines, and so on. Art is supposed to be above and away from everything, and the seamless helps create this illusion. This idea is pure hogwash, to be sure, but people do believe in it.

In terms of eliminating visual distractions the seamless is excellent. Except for your figure model, all you see through your camera view finder is a paper tone that doesn't even look like paper — it looks like pure grayness or whiteness.

Overhead bounce lighting.

Though seamless comes in many colors, you should stick to gray and white for figure work. Chromatic colors are too distracting; black is psychologically oppressive for both the model and the photographer. Gray is easiest to work with, but you should also try white.

*Poses.*    The best way to pose models is not to pose them at all — just tell them to stand, sit, or lie down and make themselves comfortable, then wait to see what they do. When a person is comfortable, the pose is good more often than not because people naturally arrange their bodies gracefully when given the opportunity. Comfort is graceful, you see.

Giving too specific posing instructions or pushing models' arms and legs around usually results in uncomfortable, awkward poses that very seldom look good in pictures. This is because a body gets off balance when only one part is moved at a time.

The poses used by sculptors are usually the best, so you should study figure sculpture whenever you have the opportunity. Avoid so-called glamour poses — they usually look ridiculous in pictures. They also tend to look pornographic because glamour is a deliberate projection of sex. It is all right to have a picture project sexuality, so long as you do a good and honest job of it, but a failure in this respect nearly always comes out as pornography. Thus it is better to skirt overt sexuality altogether.

*Direct Lightings.*    Unless you really know how to use lights you shouldn't point them directly at a model, for they tend to create shadow patterns that make a figure look all chopped up. Since you are trying to learn about light, however, you can break this rule — just to see for yourself that direct light creates problems. For your own enlightenment

Side bounce lighting from the left.     Side bounce lighting from the right.

Side bounce lighting from the right.

you should try to find out what these problems are — there are other problems besides getting shadow patterns that seem to mutilate figures. For example, the skin often doesn't look very appealing under direct

light.

**237**

*Bounce Lightings.*   Side or overhead bounce lightings nearly always flatter the human figure because they are so soft and diffuse. For a sculptural effect, which is generally a good idea, a side bounce lighting is the best bet. It gives a body good volume or solidity and at the same time treats the bones, muscles, and skin very gently.

Overhead bounce lighting.

Overhead bounce lighting.

A double exposure in the camera. Side bounce lighting.

Direct light from overhead. A top lighting.

One advantage of using bounce light is that you don't have to be acutely aware of what your light is doing to your model — you can safely assume that everything is looking pretty good. Thus you can concentrate on other things, such as pose, cropping, camera angle, exposure.

*Which Camera?*  The best camera for exploratory abstracts of nude figures is a 35mm single-lens reflex (SLR). With it you will tend to make a lot of pictures, which will provide you with a broad visual experience with figures. It is best not to use a tripod, because it slows you down. For this project using a view camera is definitely not recommended, because it slows you almost to a halt. Furthermore, you will find yourself shooting poses that aren't the best and asking your models to hold their poses so long that they get strained and tired.

## PROJECT 15: CREATIVE COPYING

For this project you will make some copy pictures, using one or several creative techniques. You should also make some straight copies just to see how the process works. You need some photographic prints to copy, preferably your own. As long as you have something to work with, however, it doesn't really matter who made the prints.

*Straight Copying.*  The traditional way to copy a picture is to tape it to the wall, then light it from both sides with photoflood lamps in reflectors, each of them illuminating the picture at an angle of 45 degrees. Each should be about four feet away from the picture and aimed slightly past it; the aim is designed to get the lighting on the picture even. Take a meter reading from the wall near each of the picture's four corners to see that the lighting is even. If not, adjust the aim of the lights.

**238**

Use your camera on a tripod, taking care to get the picture framed exactly in the view finder. Use a gray-card reading for determining the exposure, which you should make with a cable release. To guarantee best results, bracket one stop on each side of the indicated exposure. Use a long-scale film such as Tri-X and develop it normally. These procedures should give you a good negative.

For a quick method of copying a lot of prints, tape them up in a row at eye level on the shade side of your house, then walk down the row taking a snap of each with a hand-held camera. The framing won't be exactly as it would be with a tripod, but later you can make the frames rectangular by cropping the pictures a little bit.

*Copy with Shadow Pattern.* Using just one light, place an object or pattern cut out of heavy paper so it casts a shadow on your picture; then photograph it. This will give you a final picture with a dark shadow in it. To lighten the shadow any desired degree, use a second light as a fill. The amount of shadow fill will depend on the distance of the second light from the picture.

*Copy with Still Life.* Create a small still-life setup around your picture. Light and shoot the setup as you would normally.

*Double-Exposure Copy.* This exercise requires a camera with an override system that will permit you to recock the shutter without advancing the film. Such a system will allow you to make two or more exposures on the same frame.

An unusual way to copy a
picture.

A photographic print double exposed onto an abstract sculpture.

A photographic poster double exposed onto an op art painting.

One after the other, photograph two prints on the same frame, or photograph first a print and then an object or three-dimensional scene. Of course, you can also photograph two scenes, but that gets us away from the idea of copying a print.

**240** Ordinarily, exposing a frame twice will overexpose it. However, you

can cut each individual exposure in half and come out with a normal exposure in the end. Two half exposures make a whole, you see.

*Direct-Montage Copy.* Making a montage usually requires more than one step. The double-exposure copy, for instance, gives us a kind of montage. Montages can, however, also be made in one step with a single exposure. Simply light your print with a slide projector that has a color slide in it. If you wish to weaken the projected part of your montage image, point a fill light at your print.

With your projector turned on, take your exposure reading directly from the projected image, making sure not to read the dark surrounding areas, too. If you are using a fill light, have it turned on when you make the reading.

*Color Slide and Solid Object.* You can make a black-and-white copy of a color slide by projecting it onto a screen and photographing it. A more interesting thing to do is to project your slide onto something three-dimensional—a still life, a person, an egg—and then photograph it. There is no end to the number of things that you can project a slide onto.

*High-Contrast Copy.* You can convert an ordinary print to high contrast by photographing it on a special high-contrast film such as Kodalith Ortho Type III or Kodak High Contrast Copy Film both of which require special developers. Kodalith Ortho is processed in Kodalith Developer, High Contrast Copy in D-19. The developing instructions come with the films.

The armpit inspector. A photographic print double exposed onto a painting.

A photographic print and a creative copy. In the copy the light
was painted on with a penlight with three passes of the light.

High-contrast films have very short exposure latitude, which means
that you can't miss your exposures by much and still get printable
negatives. This being the case, it would be wise to bracket all of your
exposures.

*Painting with Light.*    You can copy pictures by painting them with
light (see Project 12). Only your ingenuity will limit the number and
kinds of light patterns that you can use. However, it is a good idea to
keep them rather simple.

# Index

# Index

## A

Adams, Ansel, 162
Afterimages, 105–7
Apparent size, 127

## B

Basic equipment:
  cable release, 133
  camera, 133
  cartons, 134
  close-up lenses, 133
  gray card, 134
  separate exposure meter, 133
  tripod, 133
  work table, 134
Beauty, problem of, 108–09, 126
Binocular vision, 39–41
  difference in retinal images, 40
  eye dominance, 40
  eye muscles, 40
  trick to practice, 41
Black and white scale, 102

Black-on-black (photographic project), 179–82
  as repeat of white-on-white project, 179
  disappearance, 182
  exposures, 182
  glossy paint, 180
  matte paint, 179
  perception of black, 180
  printing, 182
Bracketing, of exposures, 42

## C

Candles, 214–17
  exposures, 216–17
  film, 216
Chroma yellow and blue scale, 103
Clarity, 126
Color:
  advancing vs. receding, 110–11
  aggressive vs. passive, 109
  as attribute of light, 113
  chroma, 91
  codes for, 92, 109

Color:(*cont.*)
combinations, choosing, 105
complements scale, 102–03
constancy, 114
dechromatization, 94
expanding vs. shrinking, 113
gray adaption, 90–91, 93–95
hue, 91
and judgment, 113–14
mixing drills, 97–98
palettes, 98–99
pigments, 98
tools, 98
value, 91
warm vs. cold, 110
wheel, 92–93, 101
Color awareness tests, 95–96
color memory, 95–96
color reflection, 96
color slides, 96
color TV, 96
dreams, 95
light streaks, 95
neutrals, 95
shimmering, 96
skin colors, 96
stars, 95
Complexity, 126
Composition, 125
Contrast, 49–53, 59
absence of, 51–52
and emotion, 59
excessive, 52–53
geometry, 50–51
light absorption, 50
and tones, 50
Contrast push, 88
Contrast variability, 57–58
optimal visibility, 58
psychological visibility, 58
Copying, creative, 238–42
color slide, 241
direct montage, 241
double exposure, 239–41
high contrast, 241
painting with light, 242
with shadow patterns, 239
solid objects, 241
with still life, 239
straight, 238–39
Corrections, for reciprocity effect, 143
Cubes (photographic project):
caring, problem of, 165
difficulties, 174–75
effect of light on, 163
exposures, 167, 174
image, basic, 167
learning through imitation, 163, 165
light source, 166
lighting processes, 166–67
perspective, correction for, 174
preparation of, 165–66
printing, 174
shooting set-up, basic, 167

**D**

Development, contrast variations in, 207–09
development, 208
exposure, 208
film, 208
negatives, 208–09
printing, 209
reasons for, 207
set-up, 207–08

**E**

Eggs, white (photographic project), 183–85
as art, 183
black eggs, 185
cooking of, 184
cop-outs, avoidance of, 184
lighting, 183–84
things to try, 185
Electronic flash, 132
Energy, 127
Exposure, 137–38
meters for, 138
*Eye, Film, and Camera in Color Photography,* Evans, 118
Eyes, respect for, 118–19

**F**

Figure photography, 234–38
backgrounds, seamless, 234–35
bounce lightings, 237
camera, choice of, 238
direct lightings, 235–36
poses, 235
Film, 8
action of light on, 8
and developer, 8
structure of, 8
Film speed, 138
Fine detail, 58
Focus, selective, 85–86
Frame effects, 88–89

**G**

Geometry, and space, 60–89
and world, 61, 63
and skewed images, 63
space perception, parts of, 63
Glassware (photographic project), 201–07
black tenting, 206
background shapes, 203, 205

Glassware(*cont.*):
exposure, 207
light box, 207
light from behind, 201–02
paint, uses of, 203
posing shelf, 205
specular reflections, 201
Glossary, 145–61

## H

Hand readings, 140
Head movement, 41–42
and retina, 41
Highlights, 128

## I

Informal portraits, lighting for, 225–33
broad lighting, 229
care about lighting, 225
classic lightings, 227
controlled lighting, 225
easiest lightings, 233
feathering, 229
ghoul, 233
harder lightings, 233
high front, 231
lights, main and fill, 229
low front, 231
narrow lighting, 231
overhead bounce, 232–33
Rembrandt lighting, 231
seeing tricks, 227
side bounce, 232

## K

Kelvin, W.T., 9

## L

Lazy eyes, 123–24
Light:
clocks, 13
controlled, 121
electromagnetic spectrum, 7
emission, 4–5
error in thought about, 4
expression of, 14
geometry, 15
intentional poverty of, 119–21
and nonuniformity of, 15
particles, 7
and pictures, 13
photographic materials, 8
and prisms, 7
quanta, 7–8
and reality, 11–12

reflection, 4
refraction, 15–16
respect for, 118
responsibility for, 121–22
shadows, 15
sources of, 4–5
and space, 14–16
speed of, 5
and sun, 12–13
and time, 12–14
tones, 15
visible, 7
and vision, 3–4
wave/particle duality, 5–6
waves, 6
Light balance, 127
*Light and Vision,* Mueller, Rudolph *et al.,* 118
Lighting contrast, 127
Lighting equipment:
candles, 135
flashlights, 135
light box, 135
light cords, 135
light stands, 135
photoflood bulbs, 134
reflectors, 134
spotlight, 135

## M

Mental operations, 26–38
brain's cancelling of saccades, 27
fovea, 27
foveal vision, 28
internal time, 28–29
projection to outside, 27–28
reality and photographs, 35–36
reality stability, 27
rods and cones, 30
saccades (eye movements), 27
space perception, 31–32
space and photographs, 33–34
and dimensions, 33
empty vs. filled, 34–35
response in brain, 34
and retinal image, 34
unconscious, 32
visual gestalts, 29–30
visual intake, 30–31
Metal, polished, (photographic project), 196–201
dark reflections, 198–99
ordinary lighting, 196
reflections, controlled, 196
tents, cone, 198
tents, lighting, 199, 201
tents, reflecting, 198
tents, translucent, 196–97
Meters, built-in, 141
Mixture checkout, 101
Mood, 127

## O

Objects, solid, 44–48
  appearance of, 45
  association of surfaces, 47–48
  camouflage, 48
  contours, 49
  dimensionality of, 45–46
  solidity, 47
  surroundings, 48–49

## P

Painting with light, 218–25
  exposures, 222–23
  flashlights, 219–20, 223–24
  gist, 219
  moving light source, 224
  necessary dark, 220
  patterns, 220–21
  reminder, 221
  shutter, 220
Perception habits, 65
Perspectives, 209–14
  checkerboard, 211
  horizons, 212
  lightings, 214
  picture idea, 212
  provers, 212–13
  purpose, 214
  shadows, 214
  size constancy, assumption of, 211
  skewed shapes, 209
  space, manipulation of, 212
Pigment checkout, 100
Photosensitivity, 16–18
  ammonia, 17
  colorblind film, 16
  data density, 18
  dyes, action of, 16–17
  extension of in spectrum, 16–17
  film speed, 18
  and gelatin, 17
  hypersensitivity, 17
  latent image, 17
  oil of mustard, 17
  panchromatic film, 16
  silver, grains of, 18
  silver halides, 16
  solarization, 17
  water, 17

## R

Realness, 127
Reflectance readings:
  brightness range method, 139
  gray card, 139–40
  lincident light, 141–42
  substitute, 140–41
  white card, 141

Regular shapes and visual habits, 65–69
  contradictory cues, 71
  convergence, 69
  ellipses, 68
  excessive similarity, 74–75
  experience, 66
  false horizons, 73–74
  gestalts, 74
  main laws of, 66
  pairs of straight lines, 68–69
  provers, 72–73
  quadrilaterals, 66, 68
  right angles, 69
  S curves, 69
  size constancy, 74
  space-compulsive shapes, 71–72
  space gradients, 77–78
  and trick photographs, 72

## S

Samples:
  collecting, 104
  library, 104
  matching, 104
Scale, size, and distance, 186–90
  horizons, 188
  lightings, 190
  miniatures, finding of, 186
  obscurity, selective, 188–90
  props, 186–88
  sand, 188
  tabletop photography, 190
Scales:
  Kelvin, 8–10
  and blackbody, 9
    and color temperature, 9
    continuous spectrum, 9
    and effects of bulbs on film, 10
    and spectrum, 9
  mired, 10–11
    defined, 10
    and filters, 10–11
    and voltage, 11
'Seeing,' 21–25
  awareness, 22
  and brain, 22
  defined, 22–23
  education, 22
  and emotions, 23
  filtration, 22–23
  mechanical, 23–24
  and photographers, 21–22
  and time, 25
  vocabulary of, 24
Separation, 125
Shadows, 78–80, 127–28
  cast, 78
  edges of, 78–79
  form, 79
  painting of, 79–80
  and space perception, 79

**249**

*Index*

Shooting and printing, 124
Similarity squeeze, 54
    absence of space in, 54
Simplicity, 122–23
Simultaneous contrast, 111–12
    eye mixture, 111
Small objects, 191–95
    close-up lenses, 191–92
    depth of field, 193–94, 195
    exposure readings, 194–95
    extension tubes, 192
    focus, 195
    lighting, 194
    macro lenses, 192
    placement of subject, 194
Solidity, 126
Space:
    black, 87–88
    and camera lenses, 83–85
        telephoto, 84
        wide-angle, 83
        zoom, 83
    cues, 39–43
    feeling of, 36–37
        and emotions, 37
    response, increase of, 37–38
    tricks with, 82
Stepping-stone effect, 80–82
Supplies, basic:
    background papers, 135–36
    flour sifter, 136
    light absorbers, 136
    light reflectors, 136
    masking tape, 136
    plastic cubes, 136
    sand, 136
    spray paints, 136

**T**

Three-way push, 57
Time, 127
Tonal contrasts, 54
    contrast push, 54
    overlap, 54
Tonal range, 53–54, 126
    intermediate tones, 53
    similarity to object, 54

Tonal weight, 82–83
Tone, average, 138–39
Tricks, to aid perception, 128–30
    feel around, 129–30
    frame, 128
    on and off, 129
    one at a time, 129
    peep sight, 128
    squinting, 129
    swinging light, 128–29
    viewing filter, 129
Tri-X Pan film, 143–44
Tunnel effect, 87

**V**

Value scales, 101–02
Visibility gradient, 126

**W**

Wedge spectrogram, 18–20
    nature of, 19
    and photosensitivity of films, 20
White-on-white (photographic project),
        175–78
    aiming of lights, 176
    barndoors, 177
    beauty, 178
    disappearance, apparent, 178
    finding suitable objects, 175
    lightings, 175–76
    preparation of objects, 175
    shadows, casting of, 77–78
    snoots, 176
Work, philosophy of, 131–32
Wraparound of contrast, 55–57
    and surface, 55–56

**Z**

Zooming of vision, 42–43